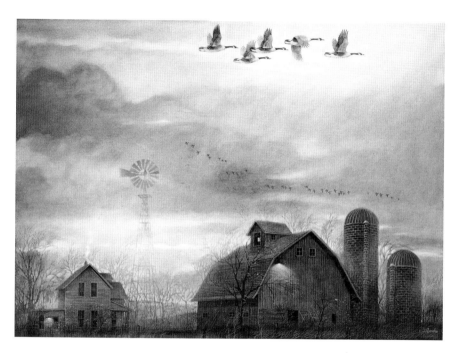

River Bottom. This illustration tells a story of several generations that have lived and continue to live in a typical midwestern farmhouse. Although a move to higher ground is now economically within reach, the family chooses to live along the river on the land that their grandfather homesteaded. *Courtesy of Gene Roncka, Willow Point Gallery, Ashland, Nebraska.*

The American Doorstop Project co-founders and authors gratefully acknowledge the contributions of many individuals and organizations in making *A History of Nebraska Agriculture: A Life Worth Living* a reality. For their financial and in-kind support, we thank the following:

The Montana History Foundation
The Lockwood Foundation
Hall County Historical Society
Nebraska Dry Bean Commission
Kelley Bean
North Platte Natural Resources
 District

Aurora Cooperative
Prairie Preservations
21st Century Equipment
Nebraska Hereford Association
Deines Irrigation

A History of
NEBRASKA
AGRICULTURE

A LIFE WORTH LIVING

Jody L. Lamp & Melody Dobson

THE
History
PRESS

Published by The History Press
Charleston, SC
www.historypress.net

Front cover image, *Sunset on the Sandahl Home Place*, and back cover image *River Bottom* courtesy of Gene Rowncka, Willow Point Gallery, Ashland, Nebraska.

First published 2017

Manufactured in the United States

ISBN 9781467136495

Library of Congress Control Number: 2017931807

As agriculture ambassadors and advocates, we dedicate this book to preserving the historical narrative of our homesteading families before generations removed from the family farm forget their ancestral roots.

CONTENTS

CONTENTS

FOREWORD

It is a most humbling privilege to write the foreword to this book written by Jody Lamp and Melody Dobson. I have known Jody since college and share with her a love for all things farming and ranching. As a team, chock-full of talent and thoroughness in research, Jody and Melody have put together what didn't exist before: a comprehensive look at Nebraska's agricultural past, present and future.

As a gal who comes from a family of farmers and ranchers, I was raised hearing the stories of blizzards, floods and droughts; of the years the wheat crop paid off the land and the equipment; of the trips to the stockyards with loads of cattle; and the stories of neighbors helping one another. I heard many of them, but not nearly all. I wish my grandparents were still around to tell those stories again and share the ones they hadn't thought to tell before.

When I think about those stories from the days when my grandparents were young and compare their work to what we do now, I am awestruck. There is a romantic notion of farming that may not be what we see today as we drive past cornfields watered by center pivots and pig barns offering a comfortable, controlled environment for their inhabitants. However, those of us who "have been there" genuinely appreciate modern farming practices. My grandparents' generation saw and helped to create more change in their near century of living than many people can ever imagine. They went from horse-drawn equipment to crank-start tractors and threshing machines to tractors and combines that have cabs, air conditioning, heat and even monitors and data collection capabilities.

FOREWORD

Agriculture still has the same basic purpose it has had for centuries: provide humans with food and fiber, and now we can also obtain fuel from farm crops. As humans struggle, they find different, and usually better, ways of doing things. They find more uses for crops and livestock, such as carpet made from corn and human medicines from cattle or pigs. In 150 years' time, farming and ranching in Nebraska has been made safer for humans and livestock and does a much better job of preserving and even rebuilding the natural resources necessary for the crops and animals to thrive.

I cannot stress enough the importance of agriculture to all of society. It is critical not only for farmers and ranchers to understand where we have come from, but for all people as well. Every single person is affected by farming or ranching every single day. Yet the vast majorities of those people are three to five generations removed from the farm and have not had the opportunity to "hear the stories," as I did. This book is the perfect avenue to follow the journey of the modernization of agriculture and gain an appreciation for not only where we are currently but also what the future may hold.

I am excited to recommend this book to generations of readers.

DAWN CALDWELL
Head of Government Affairs, Aurora Cooperative

ACKNOWLEDGEMENTS

Writing this book has been a tremendous experience, and without the love, support and encouragement of our families and friends, it would have never been accomplished. Each one of you has a special place in our hearts. We owe a debt of gratitude for everyone who graciously shared their stories and spent time looking through their scrapbooks and albums to find pictures, newspaper clippings and articles. We treasure those times and trust that the walk down memory lane was as pleasant for you as it was for us.

The community hospitality we experienced while being away from our homes and families made us feel welcomed. We love everything about rural America, including Nebraska's small- to mid-size towns' main streets. We feel equally at home in the state's more urban areas and love helping to make Memorial Stadium on Husker Game Day Nebraska's third-largest city—"Go Big Red!"

Thank you to all the librarians who helped us find books, suggested titles, photographed copies and forgave our overdue fines. We implore you to keep sharing your love and knowledge of your local history.

As we enjoyed the many interpretive centers and museums, we want to especially acknowledge their boards of directors, executive directors, staffs and curators as they pulled articles and photos for us. The state and county historical societies provided invaluable insights, informative conversations and encouragement as they discovered our intentions to "write the book!"

To all of Nebraska's agritourism promoters, chambers of commerce, Rotarians, farm broadcasters, agriculture reporters and journalists, agribusinesses and the industry of agriculture itself: your enthusiasm fuels our passion and makes us appreciate advocating for agriculture even more, as we realize that so many have not had the same experiences. As granddaughters of homesteaders, we consider our heritage a privilege and honor and do not take the memories of their hard work and love for granted.

Lastly, a special thanksgiving to our Heavenly Father for His hand of protection while we traveled and the provision of safety over our households while we were working on this project. From the bottom of our grateful hearts, we thank you!

PROLOGUE

Agriculture depends on communication. The industry relies on an effective distribution system where information can be shared instantly and effectively. That wasn't always the case when I joined the University of Nebraska–Lincoln in 1956. After years of dedicated effort, an agriculture journalism major was established and certified in 2003.

Getting the message out about agriculture has never been more important than it is now. Scientists, producers, manufacturers and agribusinesses now have the support that they need at the university level to deliver the latest on new developments, technology, research, market analysis, trends and data that have an impact on the input and output of agricultural production.

Even before the Internet and accompanying integrated social media outlets, "Agriculture Communications" drew many students like Jody Lamp, the co-author of this book, to pursue a career in journalism with an agricultural focus. I had the privilege of teaching and working with many students like Jody in the latter half of this century, when the demand was growing and the need to get information out was rising with technological discoveries and the increasing demand in consumer-based information settings. America's agricultural capacity expanded beyond itself, and agribusinesses, manufacturers and educators began recruiting interns and graduates who had completed the disciplines required to be an ag journalist.

With so much growth in the industry and new developments launching simultaneously, it was imperative for Nebraska to become a leader in real-time agriculture information dissemination. Nebraska was already a leader

in the world of food production, irrigation and invention. Now, there also was the need to document the stories and record the state's agriculture history. In the course of advocating for the Nebraska family farm and ranch, many of our students helped to study and archive these stories.

We can't lose sight of how many of our original homesteaders and children of homesteading families have passed away, along with their knowledge of "how it happened back then." Communicating and preserving Nebraska's agricultural history is the intent and focus of the American Doorstop Project founders and authors. I believe you will find it refreshing to look back as you read the pages of some very significant developments that you may have forgotten about and delight in being reintroduced to some of the folks whose contributions should not go unnoticed. This narrative at the 150th anniversary of the founding of our state is a perfect way to commemorate our agriculture heritage.

RICHARD "DICK" FLEMING
Professor Emeritus, University of Nebraska–Lincoln Department of
Agricultural Leadership, Education and Communication (ALEC)

INTRODUCTION

Rural America often is criticized for not crediting or appreciating the urbanite's work in advancing our society and culture. Or is the reverse a truer statement? Perhaps urbanites don't appreciate their ancestral roots and rural heritage of their pioneering forefathers. Has the mixture between Nebraska's urban and rural communities changed or remained the same over the last 150 years? In his book, *The Town Builders: The Historical Focus of Stuhr Museum*, Robert N. Manley, senior historian at the Stuhr Museum, noted that during the nineteenth and into the twentieth centuries, historians and novelists repeatedly belittled "town builders" and bestowed their blessings on the people who made farms.[1]

The "tiller of the soil" became the symbol of pioneer America. Manley cited a quote from America's third president, Thomas Jefferson: "Those who labor in the earth are the chosen people of God, if ever He had a chosen people, whose beasts He made his peculiar deposit for substantial and genuine virtue."[2]

One of Nebraska's greatest assets is its caretakers' ability to produce food in and on its nutrient-rich soils. With the advent of irrigation systems, Nebraska has become an even stronger agriculture-based state, contributing to the national and global economy today. As we celebrate Nebraska's statehood for years to come, we honor all who contributed to Nebraska's agriculture advancement. This Nebraska agricultural history book is not all-inclusive of farming, ranching or the significant role Nebraskans have played in the success of technological and biological advancements in the

past 150 years. But it is with utmost integrity and desire that we bring attention and recognition to what we refer to as the "SPICE" (spaces, places, inventions, commodities, events) and the *people* of the Cornhusker State who helped us to narrow and identify the stories that were selected for the pages of this book.

Let us remember the words of the Honorable George W. Frost in an address he delivered two years after Nebraska became a state on September 30, 1869, at the Nebraska State Fair in Nebraska City, in which he described the life of farmers in Nebraska at that time. Here are excerpts of his address taken from the *Central Union Agriculturist*, November 1869:

> *I am to address to-day the Farmers of Nebraska on one of the most important of all subjects, the production of the earth. Soil, Climate and Productions…*
>
> *In the hurry of business, especially at the great commercial centers, we are apt to forget or overlook the important work of the quiet, unassuming husbandman. He labors on the grassy plains or the shadowy hillside, "far from the haunts of men," and sometimes he almost concludes that his work is of little importance, and that he is unknown in the great, busy, bustling world. But like the forces of nature, which work silently and unseen, and yet accomplish such grand results, so his work is felt throughout all classes of community…*
>
> *Trade and commerce, and the arts, and cities and towns, and more than all, human life, depends upon his exertions and his success. It is not, then, only of the first importance that we have farmers, but that they be educated for their work. The tiller of the soil wants not only muscle, but brain, and the old idea that any one will do for a farmer, is entirely exploded by the light of the present day.*[3]

To appreciate Nebraska's agricultural history, the authors first believe that you, the reader, must understand the value and study of "history," which often meets at the crossroad of "too busy living in the present/ worrying about the future" to care about the past. We feel compelled to bring history, especially the roots of our agriculture history, to the forefront in today's fast-paced, drive-thru life. As Peter N. Stearns has said, "History should be studied because it is essential to individuals and to society, and because it harbors beauty."[4]

If you happen to be born and raised in Nebraska, a sense of pride may flow from your veins, and you'll smile and say, "I'm a Nebraskan." If you're

not from here, you'll quickly learn how you may be connected or, more importantly, how you are connected to agriculture. Next time you sit at your table, there's a pretty good chance that your life is being affected by Nebraska's agriculture through innovation or invention revolving around food, fiber, feed or fuel. Quietly centered in the heart of the nation, this "breadbasket" state continues to lead the way by growing and helping to provide the world's safest food supply. Nebraska also will help carry the landmark conversations for sustaining generations for years to come. So, whether you're from, lived in or been to Minden or Minatare, Ashland or Alliance, O'Neil or Ogallala or any of the communities in between, you'll gain a better understanding and, we hope, an appreciation of why there's no place like Nebraska!

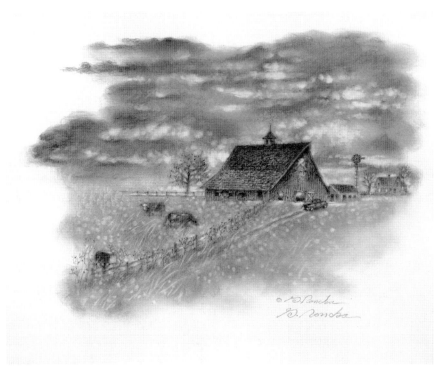

Down on the Farm. Courtesy of Gene Roncka, Willow Point Gallery, Ashland, Nebraska.

NEBRASKA "LAND"

The sun is lower in the sky
As the many years go by
A review of the past
May be a pleasant task
—*Bayard author, historian and local pioneer Leon Moomaw,*
Pioneering in the Shadow of Chimney Rock *(Courier Press, 1966)*

Our Story

Standing in the middle of the Bob Kerry Pedestrian Bridge, the mighty Missouri River passes easily below the three-thousand-foot-long walkway. The lofty vantage point provides an elevated view of Omaha's downtown skyline. Also within sight is the Lewis and Clark National Historic Trail headquarters, surrounded by an impressive garden of native plants, grasses and interpretive signage to share the stories of early travelers and inhabitants to the area. Face the west and the light breeze prompts a gentle reminder of Nebraska's prairie winds and the realization that we are at a natural confluence of time, immediately fueling the imagination. It beckons the questions: Who traveled through here? What was the purpose of their journey? Where were they going?

Our curiosity focuses on agriculture and the contextual narrative of the agrarian discipline. Like many who arrived before us, our relatives were

immigrants and homesteaders. We've heard the stories from family members and read the letters, diaries and tales of who came, how, when and if they were able to make a go of it. As eager apprentices, agriculture ambassadors, historians and authors, we've quickly gained perspective and appreciation for settling the land west, as it was not an easy task. And certainly, we remain indebted to those who ventured before us, for our existence would be different today had the state of Nebraska been settled and developed any other way.

What makes this narrative unique, distinct and compelling? It's the subject. Our story is Nebraska. It's the story of a state that affects the nation. Nebraska has an anthology that is America's history. The frontier wagon trains left deep ruts and trails that pulsed like veins as the nation moved west and pioneers found reassurance and solace in the state's famous landmarks and resources. As one begins to move through the pages, an understanding begins to emerge of what it means when someone says, "I'm a Nebraskan" rather than saying, "I'm from Nebraska." The two are totally different. You'll smile when you recognize it.

The task of telling this story is to not get in the way of it but to recognize the landmarks. Nebraska's agriculture significance connects the state to the rest of the world, sustaining and nurturing its rich heritage. The land shouts as loud as its native novelist Willa Cather in *O Pioneers!* She described her love of Nebraska when she penned, "There is so much to say and only a lifetime to do it."

Those who came and those who passed through provide basic ingredients for our story, but it is those who stayed and returned who kindle a seasoned discourse that shaped the state's history. Nebraska's harmonious connection to its landscapes tugs on its native sons and daughters even if they've ventured away. But with a flutelike melody of the western meadowlark ringing across a field, it provides a reason to listen and beckons them home once again.

Now, 150 years of statehood since 1867 is built on a solid foundation of contribution, cultivating a rich, diverse and distinct heritage and relationship with the land. There isn't enough room in this book to share everything about Nebraska's agriculture history, but we'll offer a review and reconnection to stories of significance that shaped Nebraska into what it is today and how its number-one industry connects us all. From the original first farmers to settlers and pioneers, from explorers to inventors and from educators to politicians, you'll get a glimpse of the anatomy and biographical genealogy of the state's space and place, as well as a review of the past that produces landmarks for the future.

Early Exploration and Agriculture

There are early insights that are foundational cornerstones for our conversations. After our country was established, events took place that changed America. In April 1803, President Thomas Jefferson had the opportunity through negotiations to acquire what is known today as the Louisiana Purchase. Napoleon Bonaparte, emperor and military leader of France, was eager to sell land in North America, fearing that the area would fall into British control. For $15 million, the United States acquired 562,330,240 acres of land for about three cents per acre, deeming the Louisiana Purchase one of America's greatest achievements.[5]

The land deal with France brought new commitments for exploration up the Mississippi River to the vast regions of the Missouri River and its tributaries and, eventually, to the headwaters near Three Forks, Montana. The Lewis and Clark Expedition from 1804 to 1806, commissioned by the U.S. Congress, provided journals that would become road maps for fur traders, explorers and the western migrations of immigrant pioneers. Among the first fur traders was Manuel Lisa, who established Fort Lisa

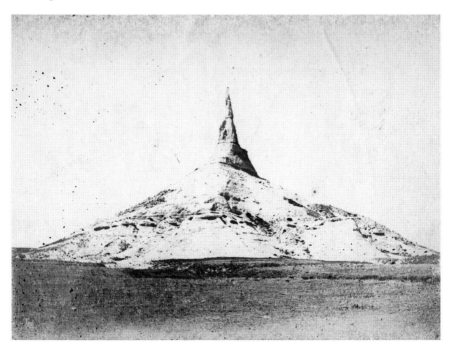

Early photo of the most iconic landmark in western expansion and western Nebraska: Chimney Rock. *Photo donated to authors; photographer unknown.*

in 1812 north of where the city of Omaha is today.[6] Other explorers, like Robert Stuart, kept journals of travels back to St. Louis by way of the Platte River Valley from the Columbia River; Stuart's group had established Fort Astoria for John Jacob Astor, owner of the American Fur Company. Stuart recorded setting up a winter camp near the Chimney Rock area, making the frontiersmen some of the first white men to make mention of what would become western Nebraska.[7]

Perhaps the most iconic symbol in western expansion and western Nebraska is Chimney Rock, a prominent geological rock formation three miles south of Bayard. Rising nearly 480 feet above the surrounding North Platte River Valley, the landmark reaches 4,226 feet above sea level. Visible for miles, Chimney Rock played an important role of quietly greeting those coming, those going and those staying during the exploration and the settlement of the western frontier. Designated as a National Historic Site in 1956, Chimney Rock is still one of the most visited and recognized landmarks along the Oregon Trail on Nebraska Highway 92.

Recognition of this landmark was well recorded, stated historian Merrill Mattes after examining more than three hundred journal accounts from those traveling the Oregon Trail, the California Trail and the Mormon Trail, which wound its course to the north side of the edifice. "Chimney Rock was by far the most mentioned landmark," he noted, "although no special events took place at the rock, it held center-stage in the minds of the overland trail travelers."[8]

Early Agriculture

The Lewis and Clark "Corps of Discovery" and other expeditions were eager to record the vegetation, flora and fauna growing on the plains of the Missouri River country. People lived and cultivated Nebraska's soils centuries prior to its statehood. Before there were explorers, fur traders, surveyors and railroads, there were seed-bearing crops in the United States that were planted, tilled and harvested by its local native Indian tribes. These first farmers bore testimony to the fertile lands near the river valleys.

The Loup River was known as the *Its Kari Kitsu*, or "Plenty Potatoes River," by the Pawnee Indians, and the South Loup River was called the *Pomme de Terre*, or "Apple of the Earth," due to the early French influence. The names were derived for the edible tubers that grew wild in the sandy soils fed by natural springs. The Pawnees historically were believed to have

inhabited the Platte and Loup River Valleys as early as the 1540s, when Francisco Vásquez de Coronado explored the northern plains. Since forest growth was limited, their shelters were earthen lodges made from a frame of timbers thatched with prairie grass and covered with earth. They hunted for food and planted corn for both substance and tribal rituals. The corn was harvested while it was still green and boiled; kernels were cut from the cob, dried and stored in leather hides used as caches. The fields were tilled with digging sticks and scraping tools made from a buffalo's scapula or shoulder bone. Other vegetables known in their regimen included beans, pumpkins, squash and wild potatoes. Before the western expansion, Native American agriculture on the Great Plains differed little from farming practices east of the Mississippi River.[9]

The Mandan and Hidatsa tribes of the north, as well as the Pawnees of the central plains, cultivated successful harvests of surplus by clearing and cultivating terraces on the floodplains. The women were expert geneticists, planting smaller family fields of corn, squash and beans no larger than four acres.[10] Buffalo meat and hides were often traded for vegetables by the nomadic plains tribes who depended on hunting and gathering food native to the lands.

Many of the plains tribes like the Pawnee, Omaha, Ponca, Dakota, Winnebago, Otoe and Missouri had an understanding of the environments in which they lived. The ability to cultivate seeds or harvest food from roots, native plants, trees or bushes growing naturally in their terrain sustained them. Survival was related to a strong relationship with the land. "Maize," or "Indian corn," was regarded as "mother" and was cultivated by all the tribes of Nebraska. It was a large part of the food supply for those who grew it.[11] All types and varieties were available: dent corn, flint corn, flour corn, sweet corn and popcorn. They maintained the purity of these varieties from generation to generation by selecting typical ears for seed and by planting varieties at some distance from one another.[12]

As resident tribes of the plains traveled from the mountainous regions to the valleys of the west, the eastern Great Lakes and the southern Rio Grande, plant migration was a natural result. Visiting tribes shared different seeds and knowledge. Many of Nebraska's pre-European plant varieties were probably of Mexican origin, comprising squashes, pumpkins, gourds and watermelons; fifteen varieties of garden beans; corn in five general types with fifteen to twenty varieties; and tobacco.[13]

Melvin R. Gilmore studied under Nebraska's most famous botanist, Dr. Charles E. Bessey, at the University of Nebraska and learned the methods

of anthropology from Addison E. Sheldon, the first ethnographic field worker for the Nebraska State Historical Society. In 1911, Gilmore was appointed curator of the State Historical Society Museum.[14] Born in 1868, he had seen the changes of the plains and was forever the student of prairie vegetation, engaging in their traditional uses and adaptability. By 1914, Gilmore had published his thesis, "Uses of Plants by the Indians of the Missouri River Region." The study was the result of the contemporary belief that the historic, archaeologic, ethnologic and botanical study of plants used by the original native Indian tribes would provide invaluable data and enlarge the list of plants available for additional uses.

Gilmore believed that the dominant character of the vegetation of a region was an important factor in shaping the culture of an area. He advocated that agriculture and horticulture should constantly improve the useful plants that already existed while discovering and seeking others.[15] Understanding the customs, past traditions and different usages of the native and cultivated plants contributed to the welfare of developing the land and provided insight to the soil conditions, climatology and natural resources of the new frontier.

Steps to Statehood

In 1820, Fort Atkinson was established on the recommendation of Captain William Clark, who noted the site in his journal during the 1804 Lewis and Clark Expedition. The fort's main purpose was to support America's fur trade, and at one time, it had more than one thousand residents. Operating until 1827, trade efforts were moved south to the Platte River.

The first farming practices and traditions by white men in what would eventually become the state of Nebraska were started at Fort Atkinson from 1820 to 1827.[16] A sawmill and gristmill for grinding flour were built, as well as the first school and library. It would be more than twenty-five years before that same area would open for settlement. Increased activity near the confluence of the Platte River on the Missouri brought a trading post supporting small farms nearby. Employees of the post and their families formed the small community that later became the city of Bellevue, the oldest original settlement of Nebraska.[17]

Missionaries were early settlers who came to set up mission outlets and schools for the Indians in 1833. The fur trade continued on the Missouri to its headwaters at Three Forks, the Yellowstone River and the tributaries to

the Columbia River. By the 1840s, more military forts had been founded to manage the growing traffic from pioneers just beginning to travel west and the beckoning of gold fields on the West Coast.

On May 30, 1854, President Franklin Pierce signed a bill creating the Nebraska Territory, officially opening it to white settlement.[18] The territory encompassed a large area that today is Nebraska, Wyoming, South Dakota, North Dakota, Colorado and Montana. The railroads and other companies began advertising in the eastern United States, as well as Europe, about the land available and the good life in Nebraska.[19]

Early Days and Settlements

Westward expansion was prevalent in 1854 with the organization of the Nebraska and Kansas Territories. In Congress, commerce and construction weighed heavy on lawmakers' agendas, especially when it came to building railroads. Towns and settlements were being platted, set up and officially organized. As thousands migrated west, goods and services were in constant need and high demand. The young nation needed a transcontinental highway to connect itself. What had been merely talked about for more than three decades was all about to come to fruition, and our country would never be the same. By May 10, 1869, the job of building a transcontinental railroad was complete, historically deemed one of the most ambitious projects to ever be undertaken. Next to winning the Civil War and abolishing slavery, building the first transcontinental railroad from Omaha, Nebraska, to Sacramento, California, was the greatest achievement of the American people in the nineteenth century.[20] The railroad literally put America on track, as historian Stephen E. Ambrose has noted:

No other project required so much of the young nation. It could not have been done without a representative, democratic political system; without skilled and ambitious engineers, most whom had learned their craft in American colleges and honed it in the war; without bosses and foremen who had learned how to organize and lead men as officers in the Civil War; without free labor; without hardworking laborers who had learned how to take orders in the war; without those who came over to America by the thousands from China, seeking a fortune; without laborers speaking many languages and coming to America from every inhabited continent; without the trees and iron available in America; without capitalists willing to take high risks for great profit; without men willing to challenge

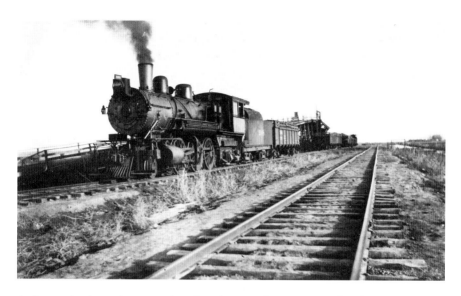

As thousands migrated west, goods and services were in constant need and transported by rails through Nebraska. Early towns and settlements were platted by surveyors and engineers. The railroad put America and agricultural goods on track. *Courtesy of the Jim Duncan family, Morrill, Nebraska.*

all, at every level, in order to win all. Most of all, it could not have been done without teamwork.[21]

Nothing changed America liked the railroads, and leading the charge were two key individuals who knew the sacrifice and commitment it would take to accomplish such an endeavor. When Grenville Dodge met Abraham Lincoln for the first time in Council Bluffs, Iowa, on August 13, 1859, Dodge was a young engineer, only twenty-eight years old, and Lincoln was the United State Republican presidential nominee. Lincoln was one of the railroad's strongest advocates and knew that it would bring and keep the country together. When Lincoln heard that Dodge knew more about railroads than any "two men in the country," he eagerly listened.[22]

Dodge had seen the country along with many other surveyors and engineers and was convinced that the road would carry most of the emigration heading west. He believed that it would and should be built on the north side of the Platte River from Omaha to the Rocky Mountains on the Forty-Second parallel. Work began during one of the most tumultuous and industrious times of American history. The railroad brought opportunity and the people. Make it to Omaha, and you could

find the way to your claim, find a homestead or secure a job until you were able to develop your plans.

Homesteader Stories

Stories are the harp strings of history, transforming the past into melody and rhythm.

—Addison Erwin Sheldon, Nebraska historian

Ask nearly any Nebraskan fourth-grade student during the fall semester where the state capital is and most will easily tell you it's in the same town as Memorial Stadium and the Husker football team. And as in most states and according to the Nebraska State Board of Education, fourth grade is when classroom social studies expands from students learning about merely their own local community to identifying Nebraska's historical foundation and the events that led to the formation of their state's government. If the students live in Lancaster County and can visit the state capital in person, they also may even learn how the city got its name.

Boy Feeding Chickens. Courtesy of Gene Roncka, Willow Point Gallery, Ashland, Nebraska/

The city of Lincoln was founded in 1856. Once known as the village of Lancaster, it was named after the assassination of President Abraham Lincoln on purpose by those hoping to distract people and dissuade legislature from moving the first capital city in Omaha to south of the Platte River. Before becoming a state on March 1, 1867, the Nebraska Territory capital had been Omaha since its creation in 1854, although most of the territory's population lived south of the Platte River. The village of Lancaster was near the east bank of Salt Creek, attracting first settlers to the area due to its salt flats and marshes.

Local historians recount that although many of the people south of the river had been sympathetic to the Confederate cause, they threatened annexation to Kansas. Realizing the population loss, the legislature voted in favor of moving the capital city from Omaha to the township of Lancaster. It was renamed Lincoln with the incorporation of the city of Lincoln on April 1, 1869, two months after the University of Nebraska was established on February 15, 1869, by the state with a land grant of about 130,000 acres.[23]

The connection between Abraham Lincoln and Nebraska's capital city goes beyond sharing the same name. Our nation's sixteenth president shares commonalities with many of Nebraska's homesteaders as they traveled here from Illinois—known as the "Land of Lincoln." When Illinois entered the Union in 1818, the site of its future capital city and its county seat remained untouched. The Elisha Kelly family moved to the area from North Carolina to establish a small settlement in the Sangamon River Valley in 1821.[24] Named after the Pottawatomie Indian word *Sain-guee-mon*, meaning "where there is plenty to eat," Sangamon County and the city of Springfield "sprung up."

By 1830, a young, skinny lawyer named Abraham Lincoln and his family began their two-hundred-mile journey to Illinois from Kentucky, where they settled on uncleared land near the Sangamon River. Soon after, Lincoln made his first political speech in favor of improving navigation on the river. By 1837, Lincoln had helped get the Illinois state capital moved from Vandalia to Springfield. Lincoln remained in Springfield and married Mary Todd in 1842. The couple made their first home and started their family in Springfield. The railroads arrived in 1852, which led to an increase in economic activity. By the time Lincoln was elected sixteenth president of the United States and took office in 1861, the population in the state had risen to nearly ten thousand people.[25]

Daniel W. Keethler

The co-author of this book, Jody L. (Price) Lamp's maternal great-grandfather, Daniel Webster Keethler, was the second of eight children of Alexander and Meranda Reeves Keethler. He was born on April 14, 1862, in Springfield, Illinois, a month before the newly elected President Lincoln signed into law an act of Congress establishing the United States Department of Agriculture (USDA) on May 15, 1862. Two and a half years later, in what would be Lincoln's final annual message to Congress, he called the USDA "the People's Department." At that time, about half of all Americans lived on farms, compared to the less than 2 percent today.[26]

Five days after establishing the USDA, President Lincoln signed the Homestead Act into law on May 20, 1862, creating a method of westward expansion that would exist for the next 123 years and eventually be responsible for the settlement of more than 270 million acres of the American landscape. When it went into effect at one minute past midnight on January 1, 1863, the Homestead Act represented the first ever instance of the U.S. government being willing to transfer large tracts of the public domain to individual settlers. Each settler filing a claim was entitled to up to 160 acres (a quarter section) of unappropriated federal land. Prospective homesteaders had to be either heads of households or single persons over the age of twenty-one years.[27]

Once the claim had been filed and accepted by the appropriate land office, the homesteader had to begin actual residence on the property within six months and could not be absent from the claim for more than six months during any given year. Homesteaders also were barred from establishing legal residence anywhere other than the claim. Over the course of the next five years, the homesteader had to build a living structure of certain dimensions and cultivate a percentage of the property for agricultural purposes. At the conclusion of the five-year residency period, homesteaders were required to publish their intentions to take final possession of their properties from the government. If no one disputed the claim and all requirements of the act had been fulfilled, the settler received the deed to the property from the General Land Office.[28]

The Homestead Act became the catalyst to shift settlement and development of the United States from the city confinements of the East Coast to the western lands of the Great Plains and Rocky Mountain region, which was included in the previously purchased 820,000 square miles of the Louisiana Territory made by Thomas Jefferson, who greatly

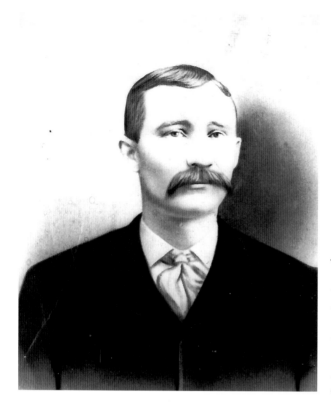

Portrait of co-author
Jody L. Lamp's
maternal great-
grandfather, Daniel
Webster Keethler,
who homesteaded
to Sheridan County,
Nebraska, at twenty-
two years old in 1884.
*Courtesy of Doris and
Elwin Lawrence, Rushville,
Nebraska.*

influenced the history and future of the Homestead Act while serving as president (1801–9). After helping to write the Declaration of Independence and toiling the soils at his home, Monticello in Virginia, Jefferson, whose vision for America was that of a nation of small, independent farmers, wrote a letter to John Jay, America's first chief justice, in August 1785: "We have now lands enough to employ an infinite number of people in their cultivation. Cultivators of the earth are the most valuable citizens. They are the most vigorous, the most independent, the most virtuous, and they are tied to their country and wedded to its liberty and interests by the most lasting bands."[29]

Historians refer to the "Jeffersonian Ideal" of a society and economy based on agricultural pursuits to be the roots that laid the foundation of the Homestead Act. Certainly, it must have been the idea and the pursuit of free land that inspired a twenty-two-year-old Daniel W. Keethler of Springfield, Illinois, to board a train in Chicago bound for Omaha and walk more than four hundred miles to northwest Nebraska and claim his homestead three miles west of Rushville in Sheridan County.

Keethler homesteaded and settled what was known as a "tree claim" at SE ¼ S25, T32NR45W, P.M.[30] He lived in a dugout while building a log house from timbers that arrived by the train and were hauled to the land by wagon loads. While building his home, the Timber Culture Act of 1873, which was designed to promote tree planting in the treeless areas of the West, including Nebraska, required Keethler and other "tree claimants" to plant 40 acres of trees on 160 acres. Introduced by U.S. Senator Phineas W. Hitchcock of Nebraska, the act was later amended to reduce the requirement to 10 acres, to be planted according to the following guidelines:

> When 160 acres were claimed, at least five acres were to be plowed during the first year. During the second year, this plowed acreage was to be cultivated and a second five acres plowed. In the third year, the initial five acres was planted to trees and the second five acres cultivated. The fourth year required the planting of trees on the second five acres, making a total of 10 acres in trees. Not less than 2,700 trees were to be planted on each of the 10 acres, or a total of 27,000 trees. If less than 160 acres were claimed, the acreage of trees was reduced proportionately. Non-compliance with the tree planting procedures made the timber claim subject to cancellation after one year. Certain exceptions or extensions were allowed in the event of destruction of the plantings by grasshoppers or the failure of seeds or cuttings to germinate.[31]

At the end of eight years from the date of entry, settlers could make final proof if the necessary conditions had been fulfilled. Five additional years were allowed to make proof or a total of thirteen years from the date of entry. The claimant had to prove that the trees had been planted and cultivated and that not fewer than 675 living trees per acre had survived. An affidavit or "timber culture proof" had to be completed by the claimant and two witnesses.

Making the date of entry six years after arriving to the Nebraska Sandhills by foot, twenty-eight-year-old Keethler "proved up" his 160-acre tree claim homestead at the Sheridan County Courthouse on November 29, 1890. Ellen Macfarland, the assistant secretary, signed the document, and J.M. Townsend, recorder of the General Land Offices, served as witness. Although the Timber Culture Act was repealed four months later in March 1891,[32] Keethler's homesteading hard work was recognized and honored more than one hundred years later when his oldest daughter,

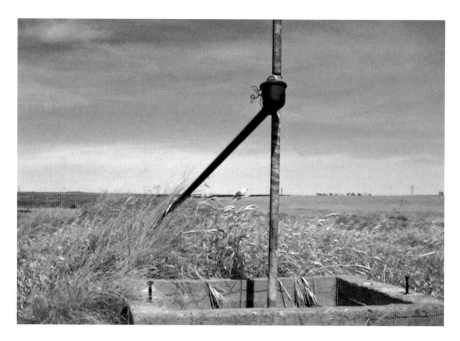

A rusted water pump is all that remains today of the Daniel W. Keethler homestead farmhouse three miles west of Rushville in Sheridan County. The Knights of AKSARBEN recognized the Daniel Keethler Farm for long and meritorious service to agriculture, as exemplified by continued ownership within the family of the same Nebraska farm for one hundred years or more. *Photo taken by co-author Jody L. Lamp.*

Jessie Keethler Ross King, then owner of the original homestead, and family received a special plaque and letter from the Knights of AKSARBEN. With the help of descendants, Doris and Elwin Lawrence of rural Rushville, the application was submitted and featured in the *Nebraska Centennial Families and Farms* book. Provided by Jessie's youngest daughter, Eva Mae King Johnston, the plaque reads:

> *Nebraska Pioneer Farm Award: The Knights of AKSARBEN honored to recognize the Daniel Keethler Farm for long and meritorious service to agriculture, as exemplified by continued ownership within the family of the same Nebraska farm for 100 years or more. Nebraska has been enriched by the courageous pioneer spirit and loyalty to the land exhibited by members of this family down through the years. Knights of AKSARBEN Omaha, Nebraska*[33]

William Stolley

During the summer of 1874, heavy swarms of the migratory grasshopper (Rocky Mountain locust) clouded most of Nebraska's eastern and central skies, obscuring the sun and destroying entire crops from Omaha and west of North Platte. The State Grange, with subordinate granges in every county in Nebraska,[34] appointed a relief committee, with William Stolley of Grand Island serving as chairman. He was to ask for aid from eastern states, organize private donations and secure the use of a $50,000 bond that had been voted by the Nebraska legislature to purchase seed grain in stricken areas. In addition, Stolley represented his constituents in Washington, D.C., to present and secure a $150,000 appropriation bill, which was passed by both houses of Congress and signed by President Ulysses S. Grant, to direct the distribution of food and condemned army clothing to needy grasshopper sufferers in Nebraska.[35]

After succeeding in Washington, D.C., Stolley traveled to New York City to plead the Nebraska farmers' case to Jay Gould, America's leading railroad developer and speculator, for free transportation of the goods over his Union Pacific Railroad. Stolley appealed to Gould's vested interest in the landholdings sold to the settlers who still owed a large share of payments: "Unless it is made possible for us to extend these people the needed assistance, so they can live there for another year and harvest their crops, they will soon be forced to abandon the State of Nebraska....They will all return to the eastern states and say, 'Nebraska is the damnedest land that the sun ever shone on.'"[36]

With no further explanation, Gould was said to have written a notecard to Stolley granting him permission to seek all the free transportation of goods of relief aid to Nebraska on the Union Pacific railways he was asking for from the East. Gould's gesture persuaded the other three railroad companies—the Chicago, Burlington & Quincy; the Chicago & Northwestern; and the Chicago & Rock Island—to equally adhere to Stolley's request.

Stolley, the author of the *History of the Hall County Settlement*, was born on April 6, 1831, in Segeberg, Germany. At eighteen years old, he sailed on a two-month voyage from Hamburg, Germany, to New Orleans with two of his four brothers. Two brothers had already come to America earlier to become a carpenter and teacher. After traveling three years with his brother George and some seventy other German immigrants throughout Iowa, Illinois, Missouri, Arkansas and Tennessee, Stolley eventually became a partner in a mercantile firm in Davenport, Iowa. He

would become the leader of the Holstein Colonization Company, a group consisting of German immigrants, and become the first settler in the area of Hall County, which would become Grand Island. In 1859, Stolley filed the first squatter's claim in the county and built a two-room log cabin on the homestead in 1859. He added a second story and a wing onto the cabin in 1894. Stolley remained a leading citizen in Grand Island until his death on May 17, 1911. The Nebraska legislature later designated the claim as Stolley State Park in 1927.[37]

Now owned by the City of Grand Island, the Stolley House is the oldest continually lived-in house in Nebraska. It is managed by the Hall County Historical Society—Nebraska's oldest county historical society. After the cabin had sustained many years of occupancy and abrasion, William Stolley's grandchildren felt a need to restore the house. His grandchildren—siblings Grace Palmer Carmody, Lillian Palmer Lappe and Richard Palmer—knew that the building needed renovation and repair and a tenant who would appreciate its historic significance. Grace and her family established a fund at the Nebraska State Historical Society Foundation to support the repair, renovation and maintenance of the historic property.[38]

Under the supervision of the Nebraska State Historical Society, the Hall County Historical Society and the City of Grand Island worked together to restore the house. The Hall County Historical Society holds its monthly meeting and other special events at the house throughout the year. Featuring some of the Stolley family's original furnishings—including William's original desk, a settee and two chairs—the house is available to rent for small events.

Samuel Clay Bassett

Fifty years ago it was not believed generally that Nebraska was or could be made an agriculture state....As a people, we have not shown due appreciation of the value of such achievement.
—Samuel Clay Bassett, of Gibbon, Nebraska, founder and first president of the Nebraska Dairymen's Association, speaking before a meeting of the Nebraska State Horticultural Society on January 19, 1916

One of the original members of the Soldiers' Free Homestead Colony, Samuel Clay Bassett and other Union army veterans settled in Buffalo

County near Gibbon in April 1871. Among the more common variations of the homestead law were the benefits granted to the Union soldiers who had served in the Civil War. A soldier with at least ninety days of service, or his widow and minor children, was entitled to deduct his time of service from the five-year residency requirements. If the soldier had been discharged due to wounds or service-connected disability, he could deduct the whole period of his enlistment rather than the period actually served. In no case, however, could the homestead residency requirement be reduced by more than four years. In making proof, the individual had to give evidence of his military service.[39]

Bassett, a native of New York born on July 14, 1844, in a log cabin in Walton, Delaware County, graduated from Corning Academy in 1861 before enlisting in the Union army's Company E, 142nd New York Infantry, in 1863 at the age of nineteen. His regiment campaigned throughout the South until the surrender. After being honorably discharged, Bassett returned to New York to marry and settle into farming. In 1871, with his wife and two children, Bassett came to Buffalo County, the "farthest west farming community in Nebraska," to take a homestead in the Shelton Township, two and a half miles east of Gibbon.[40]

Nebraska historian Addison E. Sheldon described this Soldier's Free Homestead Colony at Gibbon as "a big, empty, grassy valley, twelve miles from the Platte River north to the loess bluffs, with a slender thread of trees along a stream winding through the vacant prairie; a single railroad track laid on cottonwood ties; a cluster of box cars at a siding and a band of men, women and children pouring out of the cars, feeling the soil and gazing at the distance."[41]

Homesteaders customarily located their homes where the property lines joined in the middle of the section so they could band together for protection, water and companionship. Bassett found an old granary to serve as his family's first home. He lined the lane to the house with trees he had planted as seedlings gathered from the nearby Wood River. Since anyone standing at the end of the lane and shouting toward the house could hear an echo, Bassett named the homestead Echo Farm. Within months of arriving in Nebraska, he met and made "many prominent friends," including Robert Furnas, Nebraska's second governor, who gave him several rare trees to plant on his new homestead.[42]

Bassett achieved prominence himself by teaching school and serving in the state legislature from 1882 to 1885 and again in 1911 when he helped pass a bill that would introduce the teaching of agriculture in the public schools.

Widely known as the "agricultural schoolmaster" among Nebraskan youth and their parents, Bassett became the founder and secretary of the Buffalo County Agricultural and Mechanical Society, as well as charter member and first president of the Nebraska State Dairy Association in 1885. This organization was instrumental in the evolution of Nebraska from a grain state to "cow country."[43] Today, Nebraska ranks twenty-sixth in total milk production, with milk sales accounting for nearly $300 million of the state's agriculture receipts.[44]

He served as the organization's secretary/treasurer from 1888 to 1896 and again from 1889 to 1914. A.E. Sheldon recalled meeting Bassett for the time when he petitioned the Nebraska legislature for $6,000 to establish a Dairy and Farm School on the University of Nebraska Agricultural College Campus. Despite opposition, the money was appropriated in 1897. "There was still abiding a strong prejudice against 'book larnin' on the farm," Sheldon recorded. But with Bassett's help, the Dairy and Farm School "became the foundation of the Nebraska School of Agriculture which furnished scientific farm education to 7,500 Nebraska boys and girls from 1897 to 1929, when the school merged with the College of Agriculture."[45]

Speaking in Lincoln before a meeting of the Nebraska State Horticultural Society on January 19, 1916, Bassett presented a paper titled "A Nebraska Hall for Achievements in Agriculture." His objective was to gather and compile a history of achievements in agriculture in the territory and state of Nebraska and establish a state organization at the College of Agriculture at the University of Nebraska. From the transcripts of the meeting, it was documented that Bassett spoke from his memory while he enumerated a few of the state's previous fifty years of agricultural achievements worth recognizing:

- *Fort Kearney, for keeping a history of annual rainfall record beginning in 1850.*
- *R.H. Daniels, who brought a richly-bred herd of Shorthorn cattle from England to establish a breeding herd on his farm in Sarpy County.*
- *Early Settlers, for the introduction of alfalfa and its successful cultivation.*
- *State experiment stations, where research determined that alfalfa and corn provided a balance ration for livestock feed.*
- *Professors H.H. Nicholson and Rachel Lloyd for their investigations as to the suitability of our soil and climate for sugar beet cultivation.*

- *C.C. White of Crete for determining the milling qualities of Russian varieties of wheat.*
- *J.H. Ruston, George Haskell, Charles Harding and C.A. Clark for originating and developing the centralized method of commercial dairying.*

Bassett reserved his last agriculture acknowledgment for Dr. Charles E. Bessey for discovering an inexpensive and effective method for preventing smut in wheat and oats, as well as for helping enact a 1901 state legislative statute that provided that "the elementary principles of agriculture, including a fair knowledge of the habits and structure of plants, insects, birds and quadrupeds," would be taught in Nebraska's schools.[46] "The prosperity and happiness of our people, a realization of our ideals in civilization, our usefulness to mankind, has depended in largest measure on the development of our agriculture," Bassett appealed, "and as yet

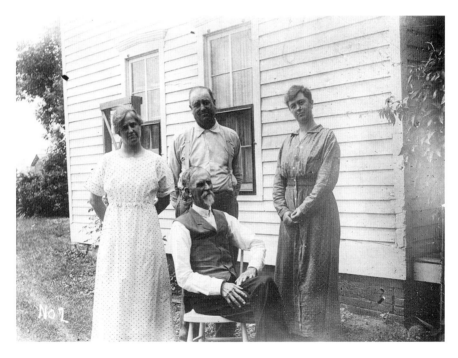

Samuel Clay Bassett sits near his home at Echo Farm, circa 1916. The two women and man are presumably family members but are unidentified. *Photo RG2891-6, courtesy of the Nebraska State Historical Society.*

no history has been compiled and written of the marvelous development of the agriculture of our state, of the achievement of our people in the interests of agriculture."[47]

Before noon that day, the Nebraska State Horticultural Society took formal action to Bassett's conceivable plan. A motion was made and carried to "heartily approve of the proposition as presented by Mr. Bassett here, for the establishment of a hall of agricultural achievement, and ask the board of regents for assistance to build such a hall."[48] Bassett was noted as the founder and the first president of the Nebraska Hall of Agriculture Achievement, which would consist of about fifty men and women, representing all aspects of Nebraska agriculture. They would meet once a

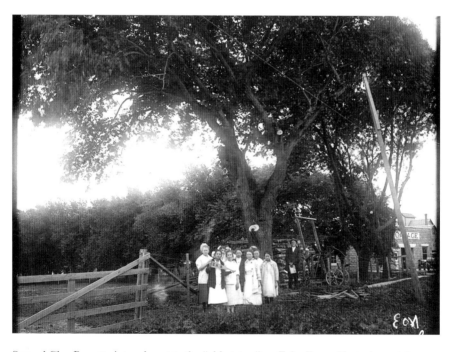

Samuel Clay Bassett pictured next to the "oldest tree" on Echo Farm. He took special pride in his Duchess apples. One day, while climbing a ladder to reach apples for a group of librarians on a visit from Lincoln, he fell and severely injured his spine. He was confined to the farm for the remainder of his life, and his younger children took charge of the farm and the house. Fellow Nebraska historian Addison Sheldon wrote of his friend Bassett's homestead, "Many of us have sat up past midnight within its enchanted, simple surroundings. It was one of the most inspiring homes in all Nebraska." *Photo RG2891-8, print is mirrored. Courtesy of the Nebraska State Historical Society.*

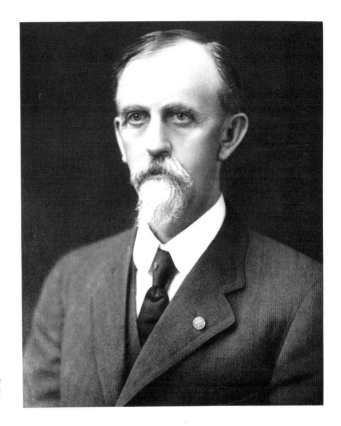

Portrait of Samuel Clay Bassett, a charter member and first president of the Nebraska State Dairy Association in 1885 and founder of the Nebraska Hall of Agriculture Achievement in 1916. This portrait and those of other honorees can be seen on display in C.Y. Thompson Library on the University of Nebraska–Lincoln East Campus. *Photo R2891-2, courtesy of the Nebraska State Historical Society.*

year to honor a deceased Nebraskan for his role in the state's agricultural development. A photograph of the honoree would then be placed on exhibit in Agricultural Hall, College of Agriculture, Lincoln.[49]

The hall's first honorees in 1917 included Richard Daniels, Sarpy County, Shorthorn cattle breeder; Isaac Pollard, a Cass County pioneer livestock raiser, farmer and orchardist; and Thomas Andrews Sr., a Furnas County pioneer shorthorn breeder and importer of blooded stock.[50] Ten more years would pass until Bassett would be honored for his agriculture achievements in the organization he founded. After his death on March 4, 1926, an S.C. Bassett Memorial Meeting was held at the Agricultural College, where friends and colleagues described his many accomplishments as a homesteader, legislator, horticulturalist and dairyman.[51] As an author, he had written a weekly column for the *Lincoln State Journal* called "Echo Farm Musings" and penned two volumes of *Buffalo County, Nebraska and Its People* that were released in 1916.

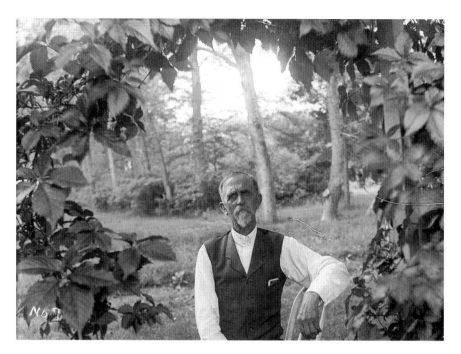

Samuel Clay Bassett sitting at his Buffalo County homestead he called Echo Farm, circa 1916. It was recorded that the lane to the house was lined with trees and that anyone standing at the end of the lane could shout toward the house and hear "an echo." *Photo RG2891-3, courtesy of the Nebraska State Historical Society.*

Addison E. Sheldon spoke generously of Bassett's contributions to agriculture and history. He had been working on "A History of Agriculture" with Bassett and noted the following upon his passing: "As a Historian, he fixed in enduring form the fact and romance of pioneer days…[and he] set a luminous example of painstaking care in finding the truth and telling it clearly and attractively."[52]

Today, the portraits of all the honorees that were formerly hung in the auditorium of Agricultural Hall on the University of Nebraska East Campus are on display in the C.Y. Thompson Library.

To learn more about Nebraska's first homesteaders and the Homestead Act, visit the Homestead National Monument of America, a unit of the National Park System, located near Beatrice, and the place where Daniel Freeman was one of the first people to file a claim under the Homestead Act of 1862.

Freeman was said to have filed his claim ten minutes after midnight at the Land Office in Brownville, Nebraska, on January 1, 1863, the first day the Homestead Act went into effect.

The Homestead Act truly made an impact on nearly every facet of American life from the day it went into effect until the time of its final repeal in 1986. The Homestead Act was responsible for the settlement of nearly 10 percent of all the land in the forty-eight continental United States and Alaska. Film presentations, museum exhibits, an 1867 homesteader cabin, an 1872 prairie schoolhouse and one hundred acres of restored tallgrass prairie can all be enjoyed at Homestead National Monument of America. For further information, call 402-223-3514 or visit www.nps.gov/home. To learn how to become a Friend of Homestead National Monument of America, go to www.friendsofhomestead.com.

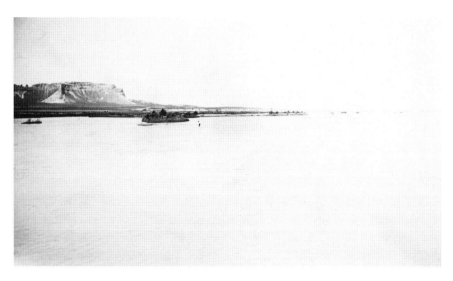

View of Scotts Bluff National Monument and what appears to be an "undammed" North Platte River. Inscription written on back of photo: "Scottsbluff from the Gering bridge across the North Platte River with the water in the foreground. The river is over a half mile wide." *Photo donated to authors; photographer unknown.*

PART II
THE WATER

A Historical Perspective

Water. Nebraska revolves around this five-letter word. The state's agricultural success is heavily dependent on the use of water for irrigation-based production. It is a vital component of the economy. Development of this natural resource has a history worth acknowledging and preserving. The discoveries, inventions and hard work are a tribute to those who combined ingenuity with the technological advancements made over the last 150 years, while factoring in the uncertainties and challenges of each growing season.

When the Conservation and Survey Division, Institute of Agriculture and Natural Resources, University of Nebraska–Lincoln, submitted its resource report in March 1993, titled *Flat Water: A History of Nebraska and Its Water*, it marked the 100th anniversary of the founding of the Nebraska State Irrigation Association in 1893. To provide an understanding of the state's precipitation levels, the report concluded that the state overall averages sixteen inches during the growing season. The eastern portion, with its sub-humid moisture pattern, receives upward of twenty-eight inches on average, while the arid, western half has a dry sub-humid condition and receives considerably less at sixteen inches per year.[53] Based on these levels, water distribution through irrigation became a primary focus in the early years of settling Nebraska and remains so today. Without irrigation, where else would Nebraska's early settlers have ever found enough water for one growing season—in addition to all the seasons to come that would produce the successful crops and livestock herds for viable agriculture economy?

Named the "Great American Desert" by the United States War Department's exploration party led by Major Stephen Long in 1820, the Nebraska Territory's soils and plants were studied and recorded. Within twenty years of Long assessing its findings and describing the area as nothing more than a "treeless, semi-arid country that would never support an agricultural population,"[54] westbound pioneers traveled undeterred by the vastness that lay ahead on their way to California, Oregon, Utah and Montana, as well as other points west. The territory's Platte River system served as a compass providing the directions for navigating their course and for supplying them with fuel, forage and water—"the trinity of the trail."[55]

Establishing the Nebraska Territory in 1854 led to Nebraska's approval for statehood in 1867, bringing hope and competition for settling the arid areas west of the Missouri River. "Town building" brought settlers from different parts of the country who believed that the rivers and surrounding areas would provide good locations suitable for growth, especially along the Platte and Missouri Rivers, and later the tributaries and inland waterways. Without water, Nebraska would have become the great desert some of the earliest travelers believed it was.[56]

Rivers offered transportation and water power, which brought settlement and development. After land, the ability to harness Nebraska's water system became the state's next most valuable natural resource for its settlers, as they soon realized the falseness of the theory that "the rain followed the plow."[57] After statehood and into the 1870s, Nebraska's arterial tributaries feeding the Platte and Missouri Rivers became the focal points for building woolen, paper, flour and other water-powered mills. However, Nebraska's first flour mills were established nearly forty years before statehood, one at Fort Atkinson and the other at the Mormon Winter Quarters, later Florence and now part of Omaha.[58]

While lumber and sawmills along the Missouri River system helped build new town settlements, the steam- and water-powered gristmills helped spur the development and growth of Nebraska's outlying agriculture potential. With increasing settlement, wheat production soared from 147,000 bushels in 1860 to 2,125,000 bushels in 1870.[59] Flour milling became the leading industry in the state, and many towns sprang into existence because of their location along a stream that furnished convenient power for a flour mill.[60] Early population promoters stressed Nebraska's water power potential for economic development.[61] However, temporary dams had been built cheaply and quickly to provide power to the mills and the towns. During the dry season, water levels shifted, and more solidly built structures were needed.

Over time, mill towns began to feel the stress from irrigation's diverting water and the drought of the 1890s. Later, with the advancement of steam engine power, towns like Hastings, Minden and Holdrege, which were not located along good water sources but rather along the main railroad lines, were able to take advantage of the steam technology to create and power their flour mills.[62]

Robert Manley, Nebraska historian, wrote in his article "Land and Water in 19th Century Nebraska"[63] that 144 water-powered mills were running in 1880. By 1889, Nebraska had 279 mills, but only a few were water powered. "The mill operator is a neglected figure in pioneer history," Manley stated. "That is unfortunate, for these businessmen were very important in building towns and encouraging industrial and agricultural development. And let's not forget that the local mill pond was a community's recreational center."

John Wesley Powell, Prophet of the West

Joseph Kinsey Howard wrote in his book, *Montana: High, Wide and Handsome*,[64] that in the 1870s "there came to the Great Plains and Montana a prophet." He was Major John Wesley Powell, chief of the Department of the Interior's Survey of the Rocky Mountain Region, known as the first preacher of western water conservation. Powell was a scientist, and there wasn't much of an audience for scientists at that time. In 1878, he left a report in the Library of Congress that was believed to be "one of the more remarkable studies of social and economic forces ever written in America."[65] It was a plan for the plains that dealt with the issues and facts that were facing the arid West—and, to an extent, still continue today and will into the future.

Powell and his group studied the soil, chemically analyzed and recorded native plants and "dug in the earth to measure the thin rich humus and depth of moisture penetration,"[66] all while charting the weather patterns and laboriously looking into the biological reasons why western nutritious grasses were susceptible to cultivation and grazing. After gathering the data and information, he submitted his report to a nation that was not ready or prepared to listen, take heed, make necessary adjustments or adopt legislation. After analyzing facts, "Powell declared flatly that most of the western Great Plains never could be adapted to intensive crop cultivation because of inadequate annual precipitation and recurrent drouth."[67] Powell further stated that non-irrigable farming could not be carried on west of the 100th meridian, which runs through Nebraska at

the main street of Cozad. Samuel Aughey, chairman of the Department of Natural Sciences at the University of Nebraska, denounced Powell's findings as "bureaucratic nonsense."[68]

Powell opposed the concept and act of homesteading 160 acres, believing that they would be of no value, as the poorest man could not succeed and support his herd. His report suggested that four square miles, equal to 2,560 acres, was the best standard unit per family. Powell stood by his fundamental principle and model that large acreage was essential to support human life on the plains. His reports were largely ignored. "His warning was not heard, and the entire economies of communities, states and a region were erected upon foundations of sand which collapsed in a hot, dry wind."[69]

In favor of the irrigation of dryland sections, Powell warned against "crude and careless" methods. Failure to heed his calling and cautions resulted in erosion and wasteful runoff on thousands of acres, along with soils falling victim to alkali condensation. Even though conditions seemed unsuitable for production, he believed in the necessary installation of dams and irrigation systems. In 1881, he became the second director of the United States Geological Survey (USGS), a position he held until 1894. Under his leadership, the USGS would become the largest scientific organization in the world.[70] For the next twelve years, Powell would lead, supervise and coordinate topographic, geologic and hydrologic surveys.

It was a difficult time, and Powell's guidelines for best shaping development of the West continued to be dismissed. His 1878 *Report on the Lands of the Arid Region of the United States*, simple and straightforward, stated that there was not enough available water in the West and Southwest to support the high-density populations of the East. And concurrently, the same could be said for large-scale agriculture. To spur and sustain growth, he suggested three requirements:

- Complete a survey of the entire region to determine which areas were irrigable.
- Map the West into nested irrigation districts conforming to watershed.
- All development, including dam and irrigation infrastructure, should be financed and constructed by local governments and communities.[71]

Drought Years Bring Regulation and Reclamation

A series of droughts in the late 1880s and 1890s brought our country's land-use issues to the forefront. Powell's best intentions were to conduct the surveys, study the findings and make decisions based on the results of comprehensive land planning. Then, ultimately, they'd release the land back for agriculture purposes. He was met with ongoing challenges for more than five years, as opposition believed that Powell was purposely delaying the inevitability of western expansion and development. Powell battled on the Congressional floor, as his scientific logic would not stand in the way of development. In 1884, he resigned and began to retire from the public light. The U.S. Congress gave Powell the chance to finally prepare an irrigation survey of all public domain lands in the West. For the first time, he put his proposals into action by devising a seven-year plan to survey topographic and hydrographic features and conduct an engineering survey.[72] His research and vision for the future would be met with resistance again in 1890, when Congress reduced the remaining irrigation survey budget, bringing it to an end. Powell died in 1902 at age sixty-eight.

President Theodore Roosevelt knew that water would be the key to developing the West. He understood the dry, arid climate and could attest to the lack of moisture. Known for his many travels and hunts in the West, the "Rough Rider" spent many months at his remote retreat in the Dakotas near the Little Missouri and knew that success would only be guaranteed if the government offered resources. For years, explorers, homesteaders, settlers, town builders and military posts simply diverted water from the river streams, but in many areas, demand outstripped the supply. Lack of funding and engineering skill were the main reasons why private and state-sponsored irrigation ventures for storage continued to fail.[73]

The U.S. government had to begin investing time, energy and resources in water management in the West. The National Reclamation Act passed in 1902 as a federal law and funded irrigation projects in twenty states in America's arid West. Written by Democratic Congressional Representative Francis G. Newlands of Nevada, it became the first major federal water infrastructure act: "The concept was that irrigation would 'reclaim' arid lands for human use. In addition, 'homemaking' was a key argument for supporters of reclamation. Irrigation's supporters believed reclamation programs would encourage Western settlement, making homes for Americans on family farms."[74]

Potential water development projects were studied, and the act set aside money from sales of semi-arid public lands for the construction and maintenance of irrigation projects. Under Secretary of the Interior Ethan Allen, the United States Reclamation Service was created within the United States Geological Survey to administer the program. From 1902 to 1907, Reclamation began about thirty projects in the western states. In 1907, it was separated as an independent organization within the Department of the Interior. In 1923, the agency was renamed the United States Bureau of Reclamation.[75] As the engineering and construction began on these water project dams for irrigation, the states were starting to be able to capture and store the river and stream winter and spring runoffs for later use. The water would be held in a reservoir and released at the different times it was needed during the growing season. Flood control would be the added benefit. Decades after his death, Major John Wesley Powell's vision and theory for "arid land reclamation" was being realized.

One of the most significant Bureau of Reclamation Projects to affect Nebraska is the historical Pathfinder Dam. Located on the North Platte River about three miles below the confluence of the Sweetwater River and about forty-seven miles southwest of Casper, Wyoming, the Pathfinder Dam is one of the earliest reclamation projects and the first dam built on the North Platte River. It is named after one of the first explorers of the area, John Frémont, known as "the Pathfinder." Frémont gave detailed accounts in his journals of exploring the North Platte and the power of the river, especially during the spring runoff season. Construction on the Pathfinder Dam began in 1903 and was finished in 1909 due to remarkable engineering.

Water Distribution

The Pathfinder Dam resides in the historical record for its engineering achievement. The remote location of the construction site provided many challenges that had to be overcome by the workers, who came north from Denver. Extreme weather brought damaging floods and severe storms. Isolation and hazardous working conditions, combined with the intense labor, saw many workers leave before they had worked off their travel advances. There were constant transportation and communication problems, and adding to the situation, there were no benefits of modern machinery. The bureau records share that the dam contains sixty thousand cubic yards of

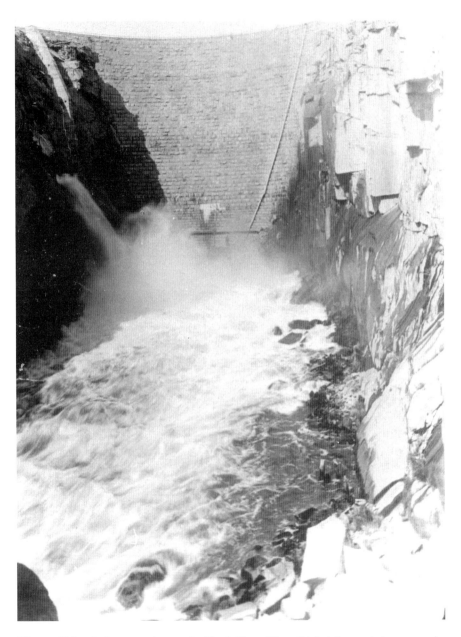

Western Nebraska homesteaders on the North Platte River did their best to irrigate crops in sagebrush country. This photo shows the inaugural release of water leaving the Pathfinder Dam after final construction was completed on June 14, 1909, by the brand-new U.S. Reclamation Service (today's Bureau of Reclamation) for $1.8 million. *Image digitized by the Legacy of the Plains Museum from the Joseph Fairfield Collection.*

stone quarried from the granite located near the dam site. Large boulders, weighing more than a ton, were placed in the dam, and more than fifty thousand barrels of cement and other supplies were hauled in by wagon freight teams from Casper.

The dam was completed on June 14, 1909, and listed as a "Masonry Arch Dam," with a height of 214 feet, a maximum base width of 97 feet and a crest length of 432 feet.[76] Despite all the obstacles, it still remains in full use today. A permanent dike was built later after a temporary one was added to keep unexpected floodwaters from breaching a lower place that could cut a new channel, leaving the new Pathfinder Dam useless. The final cost by 1913, including the dam, dike and tunnels, was $1.8 million.[77]

Serving as the major storage dam for the Bureau of Reclamation's North Platte River Irrigation Project, more than 335,000 acres receive water when needed and required. Pathfinder Dam's main purpose was to assist in turning the arid lands and reclaim them for successful production. Since 1908, the land irrigated by Pathfinder's water resources has produced crops valued at more than $2 billion.[78] The storage capacity of the reservoir is 1,016,000 acre feet, or 331 billion gallons. Just 1 acre foot equals 325,851 gallons, or about enough water to flood one acre to a depth of 1 foot.[79]

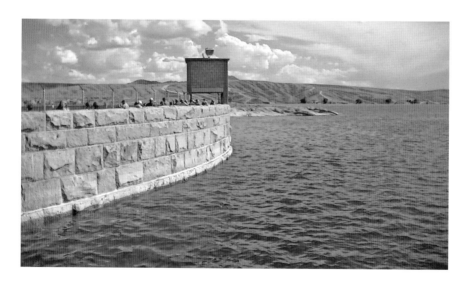

The Pathfinder Dam Reservoir serves as the major storage dam for the North Platte River Irrigation Project, originally constructed from 1905 to 1909. The granite blocks that were quarried from the same stone in the river's canyon walls hold 331 billion gallons of water. About forty-seven miles southwest of Casper, the dam is listed in the U.S. National Register of Historic Places. *Photo taken by co-author Jody L. Lamp.*

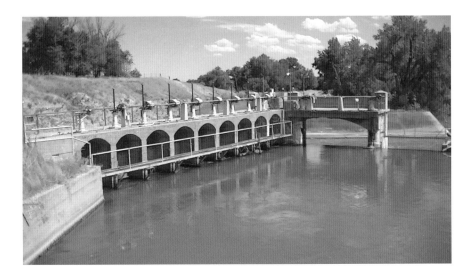

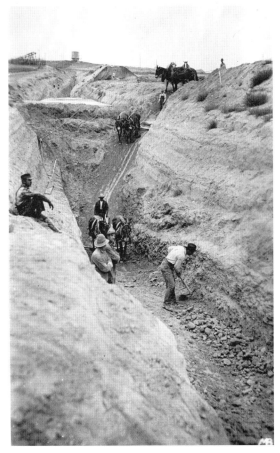

Above: The North Platte River meets the Whalen Diversion Dam near Guernsey, Wyoming, to divert irrigation water through three different canals into Nebraska—the Fort Laramie Canal, Northport Canal and Interstate Canal. *Photo taken by co-author Jody L. Lamp.*

Left: In addition to building the man-made lake, construction crews work on the dam at Lake Minatare, circa 1913. *Image digitized by the Legacy of the Plains Museum. Donated by Lee Reed, descendant of George S. Bedford.*

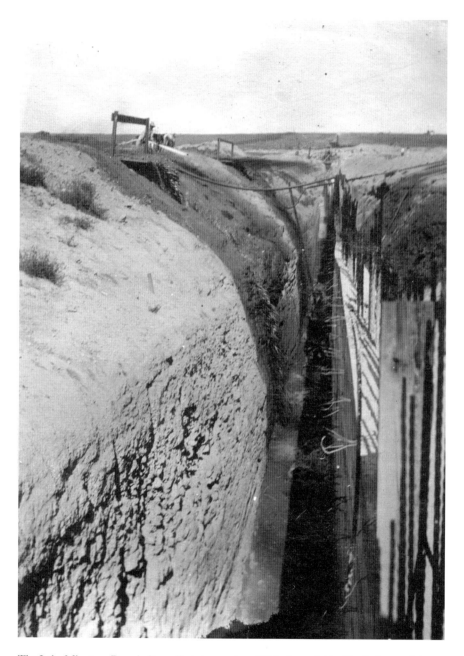

The Lake Minatare Dam in its earliest stages, circa 1913. *Image digitized by the Legacy of the Plains Museum. Donated by Lee Reed, descendant of George S. Bedford.*

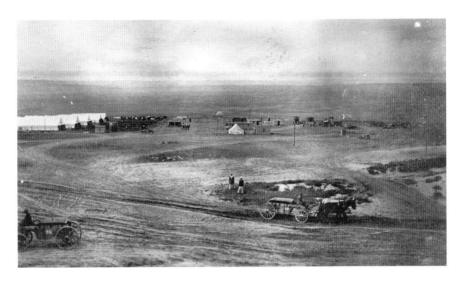

Camp of George S. Bedford and Son at Lake Minatare during the construction of the lake and dam, circa 1913. George Bedford served as foreman. In letters he wrote to family, Mr. Bedford explained that it took a team of twelve mules, thirty-three men, twenty-nine wagons and several hours to move forty-four cubic yards of dirt. Lake Minatare served as the holding spot for the end of the Pathfinder Canal system. *Image digitized by the Legacy of the Plains Museum. Donated by Lee Reed, descendant of George S. Bedford.*

The North Platte Project has other facilities to assist with the distribution of water. The Guernsey Dam and Power Plant was built in 1925. West of Guernsey, Wyoming, the Guernsey Reservoir allows for an additional 45,612 acre feet of storage and hydroelectric power. The Whalen Diversion Dam is about ten miles downstream and diverts the water from North Platte River into Northport, Fort Laramie and Interstate Canals. Each major canal supplies water to project lands in Wyoming and Nebraska.[80]

Irrigation began in 1908 after the first section of the Interstate Canal was completed. To meet the demand for large amounts of water needed during the short- and high-usage periods, three reservoirs were built in connection with the canal. In 1910, the construction for a series of "inland lakes" began in Scotts Bluff County, and by 1913, the reservoirs of Lake Alice, Little Lake Alice and Lake Minatare were able to store seventy-five thousand acre feet of water.[81] The man-made lakes took the pressure off the ninety-five miles of the Interstate Canal, allowing it to be smaller and built more cost effectively. In 1917, Lake Winters Creek was constructed. Pathfinder and Guernsey Dams are operated and maintained by the Bureau of Reclamation. The facilities of the Interstate Canal—including the inland lakes, canals, laterals and drains—are operated and maintained by the Pathfinder Irrigation District.[82]

The Pathfinder Canal System

Equally challenging to building the dams was the construction of the canal systems to deliver the water. From the early days of settling Nebraska, water was diverted from rivers, stream beds, springs, wells and quickly constructed small earthen dams that washed out repeatedly after the spring runoff. A dependable system for the water was needed, and flooding was still threatening communities along the main rivers. The arrival of water to irrigate the parched crops is recalled by families who had lost almost everything as a moment when hope became reality. It was a testimony of completion for a long sought-after vision.

Irrigation districts throughout the state were working in tandem to solve the issues for delivering water at the precise times during the growing season. The North Platte Project extends 111 miles along the North Platte River Valley from Guernsey, Wyoming, to Bridgeport, Nebraska. Today, the project provides full-service irrigation for about 226,000 acres divided into four irrigation districts, with supplemental irrigation service furnished to eight water-user associations, serving a combined area of about 109,000 acres.[83]

The Whalen Diversion Dam diverts the water through the following canals: the Fort Laramie Canal, built from 1915 to 1924, runs 129 miles and serves the area south of Gering; the Northport Canal feeds the 80 miles on the Tri-State Canal for the Farmer's Irrigation District; and the Interstate Canal, built from 1905 to 1915, runs 95 miles of service through the Inland Lakes and area northeast of Scottsbluff.[84]

Much of the canal construction was managed by the United States Bureau of Reclamation. Many of the laborers were from the local area and worked on the projects to gain revenue for their homesteads and businesses. Local farmers even provided equipment and horsepower needed for digging, moving and leveling the dirt to build the ditches. Jim Duncan, from rural Morrill, recalled stories of his grandfather Wayland Clarence (W.C.) Broadbent digging the irrigation canals in Scotts Bluff County with his business partner George Carpenter and their construction team of horses and mules. W.C. Broadbent came to western Nebraska in March 1905 at twenty-three years old to homestead a section of land eighteen miles northeast of Henry called Sheep Creek, near the Wyoming border. He left his home in Joplin, Missouri, at age thirteen to work on the wild horse and sheep roundups in Montana. He returned to Missouri before he and his friend George Carpenter headed west to Colorado

and then to Nebraska. "My grandfather, with everything he owned on his back, walked to his homestead from Morrill where the Union Pacific railroad ended its line," Duncan recollected. "How he and the other homesteaders found their sites is a mystery to me. No guides to follow and only one red shack between Morrill and his homestead."

After building his own shack to live in and "proving up" his homestead, Broadbent traveled back and forth to Pine Ridge and the Black Hills, South Dakota area to cut wood for posts to fence his land, keeping what he needed and selling the rest. Broadbent and Carpenter shared a team of horses and began hauling grain for the Deadwood Construction Company, which also retained all

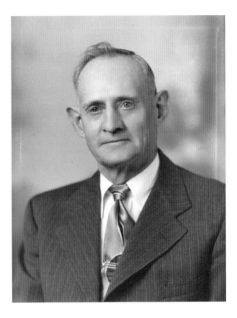

The last portrait of Wayland Clarence Broadbent before his death in 1959. Broadbent's grandson, Jim Duncan of Morrill, recalled that it was "very rare" to see his grandfather in a suit, as his usual attire was outside "work clothes." *Courtesy of the Jim Duncan family, Morrill, Nebraska.*

the contracts for building the Pathfinder Dam canals. By 1914, Broadbent had purchased a new homeplace with his wife, Sobina Elizabeth (Lizzie), north of Morrill on Liberty Oil Road. He built a big red barn to hold up to eighteen horses, with mangers inside and out. The barn still stands today where up to four generations of the Broadbent and Duncan families have farmed and ranched.

When the construction for canals, laterals and ditches on the North Platte River/Fort Laramie Project in Gering began in 1915 and continued through 1924, Broadbent and Carpenter, with their team of horses, subcontracted with the Deadwood Construction Company. The team used horse-drawn equipment with graders to pull the strings of about fifty horses to dig, and the ditches still exist today. During the summer months, Broadbent and his wife, Lizzie, lived with their young children at the digging sites in small sheepherder wagons on wheels, along with a cook shack. The camp's crew consisted of about a dozen men, who slept in tents and worked, fed and cared for the draft horses.

W.C. Broadbent and his team of draft horses begin the process of "moving dirt" with a handheld, horse-drawn walking plow to build the Fort Laramie Canal near Gering. *Courtesy of the Jim Duncan family, Morrill, Nebraska.*

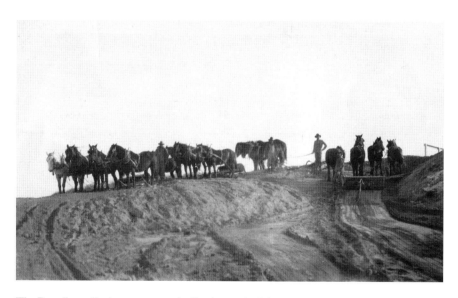

The Broadbent digging crew rests the Percheron draft horse team on top of a borrow ditch, named because the dirt is "borrowed" from the ditch and used to crown the bank. *Courtesy of the Jim Duncan family, Morrill, Nebraska.*

As their business and expertise grew, Broadbent and Carpenter built roads, including the highway between Angora and Alliance. They expanded their business to include land and building a herd of hardy Hereford cattle. Duncan said that his grandfather and Carpenter owned thirty thousand acres of grassland, buildings in Morrill and Lyman and farms throughout the North Platte Valley and leased ranch land in Wyoming and Nebraska. They expanded their Hereford cattle business throughout the 1940s by acquiring bulls from the National Western Stock Show during a time when pedigree cattle were bringing top dollar. They marketed and sold their beef in eastern Nebraska, and the delighted patrons at the famous Johnny's Café, a third-generation family-owned steakhouse that has been located near the Omaha Stockyards since 1922, began seeing "Carpenter-Broadbent Beef" on its menu.

Irrigation Invention and Innovation

For the sake of Nebraska's food, fiber, fuel and feed production, as well as the state's contribution to the national and world economy, it's imperative to pay tribute to those who dedicated their livelihoods to the pursuit of irrigation as a successful means of agriculture. It's hard to imagine what the state would look like today had irrigation not been perceived as a viable means of production. There once was a time when it seemed that rivers and streams were enough to provide the necessary water and hydro power for building and promoting the state for manufacturing.

Constant misunderstandings delayed the early land developers, who wanted to downplay the necessity of irrigation to grow crops in the arid lands. Land agents, selling Nebraska, believed that irrigation would only stand in the way of progress. Speculators continued to preach that if more people moved west, put the land into production and planted trees, precipitation levels would increase. The Timber Culture Act of 1873, which was designed to promote tree planting in the treeless areas of the West, including Nebraska, was hurriedly passed through Congress, encouraging homesteaders to plant a portion of their 160-acre homestead with trees as a solution for more moisture. The arguments and debates continued throughout the settlement of the state.

Support for irrigation was spotty. In the parched West, speculation loomed. But evidence was rising as the South Platte River's level was

lowering each year, and that fact was convincing. Colorado's irrigated districts and crop production had a direct impact on Nebraska's rivers downstream, leaving some streambeds empty in the hot summer months. This continually dried up private and group project canals and stopped manufacturing that depended on water power. Business venture after venture was thwarted by the lack of water.

Even harder was the ability to attract investors to back the digging of ditches and canals when farmers themselves were reluctant to try the irrigation methods. The challenge was not so much in the "growing" as it was in the "knowing"—it was too hard and too risky, and they simply did not know how. Those with experience were convinced that Nebraska would benefit greatly and become a leader as an agriculture state if irrigation were adopted. They showed their belief by investing their money and time and providing their expertise to developing systems that advanced irrigation. Meetings were arranged, and many took to their pens to write, lobby and provide information to dispel the angst and misrepresentation about irrigation.

Town builders were beginning to feel the pressure of the nationwide financial panic of 1857, and several went out of business. Dr. George L. Miller, publisher and founder of the *Omaha Daily Herald*, believed that Nebraska needed a new vision, and he believed he had it. "Nebraska is agriculture, or it is nothing," Miller declared.[85] He devoted time personally and from his paper to implore the settlers and pioneers to begin building farms.

Nebraska's second governor, Robert Wilkinson Furnas, learned about the benefits of irrigation after attending an irrigation convention in Denver in 1873, soon after taking office. He had moved to the Nebraska Territory in 1856 and ran the *Nebraska Advertiser*, a newspaper that publicized the state's agricultural and industrial potential.[86] By 1860, Furnas was serving as president for Nebraska's first Territorial Board of Agriculture, and he submitted the organization's first annual report early that year on January 3: "Nebraska, agriculturally, is a heaven-favored country, and must look principally to her agricultural developments for her future wealth, position and importance."[87]

Nearly twenty years later, he saw firsthand how irrigation would help, especially in arid portions of western Nebraska. Challenged by his peers and constituents, he continued to advocate. After completing his term as governor, he served as an agent for the U.S. Department of Agriculture.

Farmers in various areas in Nebraska began experimenting with irrigation methods to get water to their crops. It is believed that the first irrigation used

in Nebraska was at Fort Sidney.[88] Soldiers built a ditch that collected water from the Lodgepole Creek and created metal syphon tubes leading to water gardens, lawns and trees. In the early 1870s, newspapers carried descriptions of the Fort Sidney irrigation system, and agriculturalists from eastern Nebraska toured the facility and were impressed with what they saw.[89] An additional first-known attempt to mimic today's gravity-flow row irrigation resulted in 1881 when two farmers five miles northeast of Scottsbluff, near Winters Creek Springs, noticed that the oats crop nearest the spring bed remained green while the crop suffered from the summer heat farther away. The team of Will Ripley and Ben Gentry, without leveling equipment, plowed a furrow from the running water source into the oat field. As quickly as the artificial application of water flowed behind the plow, so did the talk of bringing irrigation to the area.[90]

People with irrigation experience began moving into the North Platte River region. Many, like W.K. Akers, came from Colorado and moved their entire families to the area, believing that they could provide leadership. Once settled, Akers and his neighbors formed a canal company in Scotts Bluff County and began digging a ditch in March 1888. They were able to begin delivering water by the middle of 1889. The canal became known as the Farmers Canal.[91] The group officially incorporated the canal and filed to secure its water appropriation. This filing was the first of its kind in Nebraska, and the group was one of the first to practice irrigation for general crops.[92]

Still, with the construction of Farmers Canal and water becoming available, there were those who had migrated to the area to secure their homesteads and who didn't have interest in irrigation or believe it was necessary. A commonly heard phrase from the naysayers was, "If I have to irrigate, I will emigrate instead."[93] Disbelief and disinterest were followed by drought, and soon the question on everyone's mind was whether western Nebraska could ever become a farming country.

With no rain in sight, irrigation—increasingly seen as essential for survival—was starting to win. Groups of men began working in different parts of Scotts Bluff County to construct small ditches. Akers recalled the first public meeting he held at Minatare: "Irrigationists congregated and discussed the question of building a ditch the entire length of the valley on which the Farmer's Canal is now being constructed." The proposition, however, met with much opposition, and the only result of this meeting was the organization of the Minatare Ditch Company, the leading members of which were George W. Fairfield, Theodore Harshamn, A.W. Milles and others. This company moved along with wonderful push, and by the summer

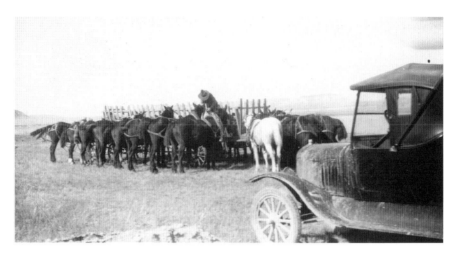

After pulling hand-drawn ditch-digging equipment, Percheron horses gather around the "oat boxes" feed rack at the Broadbent base camp. Before eating, the horses were curried and brushed. Their harnesses were stored underneath the feed wagon. A Model T Ford, circa 1919, sits in the foreground. The vehicle was strictly used to go to town (Morrill, Mitchell or even Torrington, Wyoming) to quickly get supplies. Otherwise, horses served as the main mode of transportation in the day. *Courtesy of the Jim Duncan family, Morrill, Nebraska.*

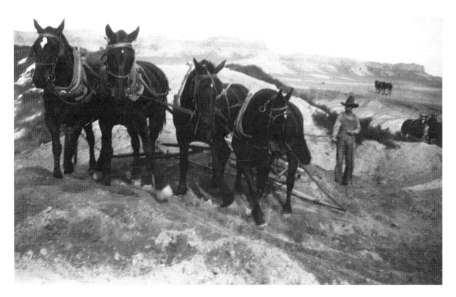

An unidentified man wearing his "work hat" of the day served as part of the Broadbent/ Carpenter crew, subcontracted to help build the road from Angora to Alliance, circa 1930s. *Courtesy of the Jim Duncan family, Morrill, Nebraska.*

of 1888, they had their ditch constructed some six or eight miles in length. This feat entitled the Minatare Ditch Company to the honor of having the first ditch in the North Platte Valley in Nebraska, making it a practicable and profitable use of water for the production of crops. By this time, the people were being rapidly converted to the belief that irrigation was necessary, and other enterprises were started.[94]

On the floor of U.S. Congress and in the Nebraska state legislature, the battle for irrigation development was center stage but moving slowly. Who would pay for it? Develop the systems? Do the work? And how would they get the farmers to adopt the new methods? Towns began hosting irrigation conventions. Frustrations mounted when the Nebraska lawmakers took no action on the so-called Irrigation Bill in the 1891 and 1893 sessions. Farmers who owned land in five Panhandle counties—Box Butte, Sheridan, Sioux, Cheyenne and Scotts Bluff—announced that they were ready to secede from Nebraska and join Wyoming because that state already had acceptable irrigation laws on the books.[95]

Irrigators were frustrated with the lack of support, and farmers were losing interest in irrigating. During this critical time, the Business Men's Association of North Platte put out a call for a convention to meet in that city in 1893.[96] From that meeting, the delegates created the Nebraska State Irrigation Association to provide leadership. By the next convention, the following year, there was "water preaching, water teaching and water reaching."[97] The state's new Irrigation Association continued to hold conventions and meet to provide representation on the issues before the state legislature and Congress. It aided in getting irrigation education for the farmers through other organizations and the University of Nebraska. On top of the list was securing funding and support for developments that affected irrigation. New methods and ways to bring water to the surface were advocated. Artesian wells were being used, and as many as two thousand windmills were used to aid irrigation in the state by 1898.[98]

Soon, as farmers understood that irrigation was practical and essential, it wasn't long before many were seeking skills for using water. Information and education was becoming available. An Irrigation College and publications like *The Irrigation Age* were helpful tools. Aware of what leading geologists, scientists and engineers knew to be possible in securing and supplying water to the West, it gave them hope for a future. They were all too aware of what "arid lands" meant and looked like without water.

Water. Nebraska and its citizens had finally come to realize the value of that five-letter word. They began to understand what irrigation with water would

mean to the world of agriculture, to "home making" and to "farm building." When Senator Francis G. Newlands of Nevada introduced his National Reclamation Bill in Congress to provide federal help for irrigation projects, and when President Theodore Roosevelt endorsed the bill in December 1901 and the resulting act passed on June 17, 1902, it meant one thing for certain: with water on the way, Nebraska would become a leader in agriculture.

Early Developments

It was important for the Nebraska State Irrigation Association to provide leadership, structure and a collective voice in the early years when new projects and irrigation districts were being formed. Change was a constant, with new inventions, systems and information introduced by individuals, businesses and educational organizations. During the state convention in 1896, W.R. Akers, secretary of the organization, spoke to the delegates and encouraged them to look to the future: "The time will come when there will be thousands and thousands of apparatuses for raising the water out of the bowels of the earth and lifting and pouring it out over the surface of the land and all the irrigator will have to do will be to go to the central station and touch the button and the water will begin to flow and Nebraska will prove herself to be the grandest country on the face of the earth."[99]

Akers led by example and rolled up his sleeves next to his neighbors to demonstrate what irrigation could accomplish and how to do it. He helped empower his statesmen and showed them the vision of a hopeful and bright future with the promise of water for thirsty crops and successful harvests.

For more than 120 years, the Nebraska State Irrigation Association has continued to represent irrigation districts and projects, as well as its water user constituents. The association represents about 75 percent of the surface water project irrigated acreage in the state. It works with individuals, organizations and groups with interests in surface water irrigation and has monitored and contributed to countless irrigation developments for the benefit of all Nebraska.[100] In the early years, it advocated for irrigation and helped introduce new inventions—or apparatuses, as Akers called them. Each was a welcome change, and irrigators were eager to learn if it assisted in the efficiency of delivering the water and decreasing the hard manual labor.

By the 1870s, windmills had become the first workhorses for water on farms and ranches from Omaha to the Panhandle. The windmill brought water to the surface by harnessing the wind of Nebraska's prairie. The concept was effective. Metal blades mounted in a circle were attached to the

top of a stand, normally ten to twenty-five feet high, and built above a well. The wind would cause the blades to rotate. The rotation created motion that could be attached to a rod that would go up and down, naturally pumping the well it was connected to and then pouring water out of an attached pipe.

Charles Dempster founded Dempster Industries in 1878 in Beatrice, becoming the first windmill manufacturer in the country. His product line included water pumps, cisterns and other tools for pioneer life.[101] Not far away in Nebraska City, Charles Kregel patented and invented the "ELI" water-pumping windmill and sold this windmill to a relatively small market in Nebraska City and the surrounding area.[102] Operating for 112 years, the Kregel Windmill Company believed in making a product of quality that filled a need and was sold at a fair price. Recently, it was turned into a museum, and visitors can experience the factory just as it was back then and see what it was like to build a windmill. Little has changed since its original working days. The Kregel Windmill Factory Museum provides a tangible way for visitors to understand how Americans used "innovation, resourcefulness, hard work and thrift to live successfully through changing times."[103]

Axtell, Nebraska, claims to be the "Windmill City" of the state. The small agricultural community southeast of Kearney was founded in 1885. Early pictures of the community show a spectacular view on this treeless plain, with a windmill at nearly every location.[104] Up to 130 windmills could be seen from 1885 to the early 1900s. Like other industrial advancements, windmills in the area began to go by the wayside as public utilities were introduced to the communities.

The U.S. Rural Electrification Administration (U.S. REA) was created in 1935 to facilitate the extension of electric service to rural America. The Nebraska Rural Electric Association was established at the same time to help bring electric service to rural Nebraska.[105] Electricity brought more advanced technology for irrigation and manufacturing. Both allowed for more surface acres to be irrigated.

From the 1900s through the 1930s, gravity irrigation ditches were opened by hand with a spade or shovel. It was back-breaking work, and there was no guarantee of the water being distributed evenly. Once the water would run down the main ditch, a "V" would be cut at the top of the ditch for each row. Flooding and erosion would wash dirt down the field and sometimes seep through the ditch. Lathe boxes were introduced and became a great solution at the time. Lathe was an inexpensive housing construction material. To build the boxes, irrigators would strip the lathe into two- to three-foot sections and make a narrow square box. Next, they

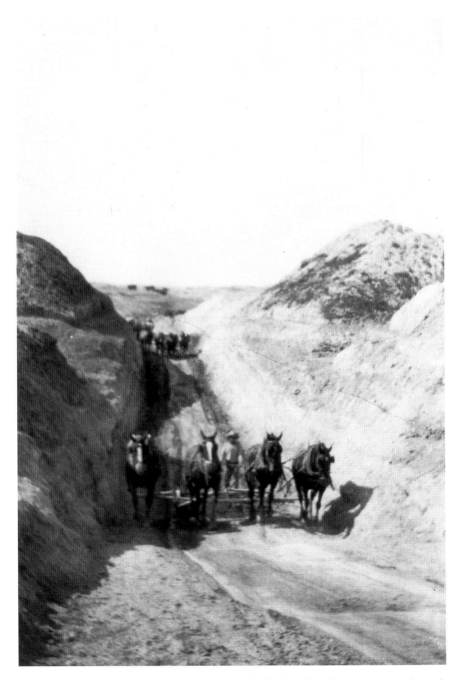

The Broadbent/Carpenter crew and draft horses hooked to a four-horse evener cut through the hills in Box Butte County to build the road from Angora to Alliance, circa 1930s. *Courtesy of the Jim Duncan family, Morrill, Nebraska.*

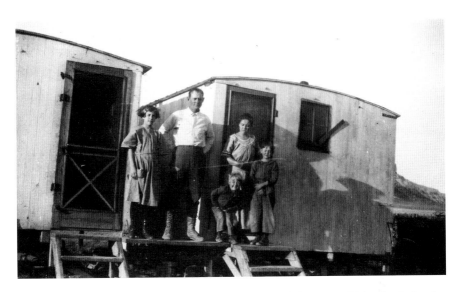

The W.C. Broadbent family lived in a bunkhouse on wheels in western Nebraska during the construction of the Pathfinder Canal System from 1915 to 1924. The bunkhouse and cook shack to the left were pulled from camp to camp as construction progressed. *Left to right*: Thelma Andrews (half sister to Doris Broadbent), W.C. and Lizzie Broadbent and Harold (half brother to Doris). Doris Broadbent, Jim Duncan's mother, is in front. *Courtesy of the Jim Duncan family, Morrill, Nebraska.*

Young Doris Broadbent, circa 1925, sits with her doll on the western Nebraska prairie south of Gering at her father's work campsite. *Courtesy of the Jim Duncan family, Morrill, Nebraska.*

would be embedded in the ditch, one for each row. When the main ditch filled, the water would run down the rows. Lathe boxes meant that the volume of water flowing down each row was far more uniform than by the bank-cut method.[106]

On the South Platte River near Cozad, Milo German was a hardworking farmer determined to achieve uniform distribution of water for his fields. He knew that there had to be a better way and recalled the metal siphon tubes used by the military at Fort Sidney. In 1932, he began using discarded boiler flume pipes, but they proved too heavy. Later, aluminum seemed like a favorable alternative, but with the onset of World War II, aluminum became a key strategic metal for the war effort. Plastic had just been invented, so German ordered a railcar full of tubing to experiment with, although his neighboring farmers thought he was crazy. He was successful in bending the tubes to fit the laterals coming out of the main ditch and was able to water each row the same. As a businessman, German began building siphon tubes out of plastic and, in 1945, started Nebraska Plastics Inc., one of the oldest family-owned plastic extrusion companies in the world.[107] In 1957, as the company was beginning to grow, Milo died in a plane crash in a pasture south of Ashby along with two others. His son, Rex, at the age of twenty-two, left his teaching job to run the family business, which celebrated its seventieth anniversary in 2015. Milo German's commitment to solving a problem he had in his own field helped irrigation take a giant leap. Up to that point, there had not been an invention that offered a solution for water control and ease of implementing. For the first time, farmers could set their siphon tubes in the fields and manage other practices or simply take a break for a few hours.

From the 1940s through the 1950s, gated-irrigation pipe was used and greatly reduced labor. The first pipes were made of steel. Nebraska Plastics in Cozad transformed agriculture in the Platte Valley by inventing aboveground PVC, gated-irrigation pipe. Working together with Dow Chemical, the two companies also developed the first aboveground weatherable PVC compound.[108]

Paul Hohnstein, a machinist, got the idea for a gate inside a pipe to better deliver water. While serving in World War II at the Hastings Naval Ammunition Depot, Hohnstein worked with aluminum and knew that he could replace the heavier galvanized steel. In his garage shop, Hohnstein perfected a system of aluminum pipes with evenly spaced gates to control the flow of water.[109] He filed a patent for his invention, and work began in the early 1950s at the company he founded, Hastings Irrigation Pipe Company. It produced eight-, nine- and ten-inch aluminum gated-irrigation pipe

from six to eight thousand feet per week.[110] In 1982, he was inducted into the Nebraska Hall of Agricultural Achievement. In 1991, he received the Hastings Chamber "Aggie Award"; in 1992, the Nebraska Water Conference Council "Pioneer Irrigation Award"; in 1995, Nebraska "Entrepreneur of the Year"; and in 1997, the Nebraska Diplomats "Outstanding Nebraska Industry Award."[111] The company continues to manufacture in Hastings and also operates a manufacturing plant in California.

With aluminum-gated pipe, an efficient, rust-proof, lighter-weight system to deliver water had arrived. An expansion in irrigation occurred, as most irrigators began buying gated pipe for gravity irrigation systems and converting their labor-intensive siphon-tube and lathe systems.[112] The new pipes could accommodate the new wells from the Ogallala Aquifer. Nebraska was on its way to being an irrigation leader.

Changing the World

With the availability of water from the Ogallala Aquifer, farmers were able to irrigate more acres with wells, pumps and gated pipe. The work was still labor intensive and required hands-on dedication and supervision. Producers, researchers, inventors and innovators continued to imagine more efficient ways to get more water to develop land. Frank Zybach was one of those farmers and dedicated inventors and believed that there was a better irrigation system. As a youth growing up near Columbus, he created his first invention at thirteen years old and continued to experiment and explore ideas. Tired of walking in the dust behind their horse-drawn harrow, he built a small cart with swivel wheels and a seat that mounted on the front end of the harrow. Detachable pins held the swivel wheels straight and allowed him to remove them when he needed to turn. His invention was helpful on the farm, but that's where it stayed.[113]

Zybach worked on the Nebraska family farm and raised his own family during the 1920s, while still dedicating time and efforts to create inventions to make farming easier. After his children were grown, he and his wife moved near Strasburg, Colorado. He continued to work the land as a tenant wheat farmer and, whenever time allowed, develop his inventions. In 1947, Zybach attended an irrigation demonstration of "hand moved sprinkler irrigation pipe" and was intrigued by the potential of the new irrigation method, as it simulated rainfall.[114] After watching men continually move the pipe with the sprinklers attached each time a section of field had been watered, he knew there was a better way.

Sprinkler irrigation was not new. Early systems were created but primarily focused on municipalities, lawns and gardens, city parks and golf courses. The first lawn sprinkler U.S. patent (no. 121949) was registered to Joseph Lessler of Buffalo, New York, in 1871—it activated with the help of gardening hose.[115] Sprinkler irrigation meant not having to depend on using the ground to distribute the water, which instead was delivered to an opening by a hose or tube that had a sprinkler head attached to it that sprayed the water equally and uniformly over an entire area.

Charles Skinner of Troy, Ohio, adopted the principle for agriculture in 1894 with his sprinkling system, known as the "Skinner System," which carried water through a pipe above the vegetation and sprayed it out at an opening. Historian Robert Morgan credits Skinner with developing field irrigation to the center-pivot systems that dot today's farm and pasture land.[116] After World War II, the potential of portable sprinkler irrigation in crop production catapulted when lightweight aluminum metal replaced the heavy steel tubing and fittings made of cast iron or steel.[117] Advocates and proponents of sprinkler irrigation knew that times were changing fast and demand for raw materials would be on the rise. The urgent need for a trade association to represent the irrigation industry was answered in 1949 when a group of eight industry leaders formed the Sprinkler Irrigation Association. Among the first board members was Ross B. Whidden with Aluminum Company of America (ALCOA).[118]

Meanwhile, Zybach, unbeknownst to him, was well on his way to revolutionizing the irrigation industry. Zybach's theory was realized when he built a prototype of an automatic, self-propelled sprinkler irrigation system. He applied for a patent in 1949 and finally received one on July 22, 1952, for the "Zybach Self Propelled Sprinkling Irrigation Apparatus."[119] He built his first model, and a farmer, Ernest Englebrecht, north of Strasburg, agreed to test the invention on his forty-acre sheep pasture. The sprinkler system included five towers and sprinkler pipe that passed about three feet above the ground. As water pressure moved the system in a circle, pistons moved up and down in a cylinder and were connected to rods and levers, which were attached to a bar. Concurrently, the bar turned the cogs on the metal wheels and moved the entire system forward. Zybach knew that the speed of the tower closest to the pivot point needed to be less than those on the outer section, but he couldn't find a two-way water valve that would work for the job. So, just as he had done many times before, he designed and built his own.[120]

Zybach's new invention wasn't as acceptable to other farmers, who saw it as cumbersome and not easily adaptable—especially since it moved in a

circle and left five acres in the corner of each section without any water. Additionally, there were mechanical problems at times, and it needed to be developed to irrigate taller crops. Zybach's biggest challenge was proving to the public and agriculture industry that he had a good idea.[121]

Knowing that he needed help with marketing and manufacturing, he contacted friend and businessman Albert Edward Trowbridge from his hometown of Columbus. With Trowbridge's financial backing, Zybach moved back to his hometown to produce his invention in a rented machine shop. He sold 49 percent of the patent rights to Trowbridge for $50,000.[122]

Originally, Zybach intended his system to water shorter-growing crops, but he knew that his modification was needed for the taller crops like corn. Although he adapted and made accommodations, farmers were still reluctant to invest financially, and those who wanted to were often turned down at the bank. In 1954, Zybach and Trowbridge sold the manufacturing rights to the owner of Valley Manufacturing Company, Robert B. Daugherty, who had started the business with his own life savings of $5,000.[123] Daugherty was a struggling businessman searching for new products to advance irrigation and was familiar with Zybach's new concept of center-pivot system. He decided to take a chance on the relatively unknown and untested "center-pivot" irrigation system in 1954.[124] In exchange, Zybach and Trowbridge received 5 percent royalty rights for every unit sold until the patent expired in 1969.[125]

The next few years, Daugherty's team designed and manufactured a sturdier and stronger system made especially for taller crops. By 1960, Valley Manufacturing, now known as Valmont Industries Inc., was producing fifty systems annually and had become a world leader in manufacturing agricultural irrigation systems.[126] Lands that couldn't be irrigated with gravity systems were now in full production, helping farmers dramatically reduce the intense hours of labor once needed to irrigate. Nebraska's own inventors, innovators and investors were leading their state, the nation and the world in agriculture through center-pivot irrigation.

Frank Zybach received the first pioneer Irrigation Award ever presented by the Nebraska Water Conference Committee and the University of Nebraska–Lincoln. He also won the Sprinkler Irrigation Association's Industry Achievement Award and the Nebraska chapter of the Alpha Zeta fraternity's award for outstanding achievement.

Leslie Sheffield, coordinator of outreach programs for the Water Center and formerly Extension Irrigation economics specialist and farm management specialist for UNL, said of Zybach, "He was one of the few single inventors who had a great impact on the field of agriculture and

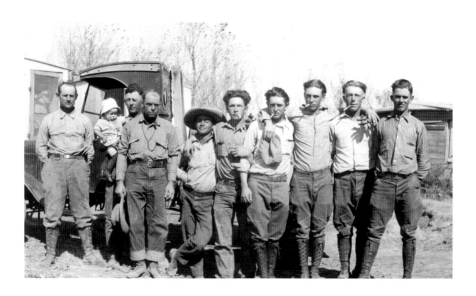

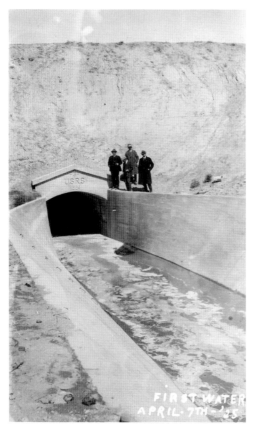

Above: The W.C. Broadbent crew poses long enough for a picture near the Sheep Creek camp north of Morrill. Jim Duncan described his grandfather W.C. (*far left*) as a hardworking man who instructed that all the farm chores, like feeding and milking cows, had to be done before going to work. *Courtesy of the Jim Duncan family, Morrill, Nebraska.*

Left: First water to arrive in what is believed to be the Fort Laramie Canal system south of Gering on April 7, 1925. As part of the Pathfinder Canal System, the 129 miles of the Fort Laramie Canal was built from 1915 to 1924. *Image digitized by the Legacy of the Plains Museum from the Joseph Fairfield Collection.*

irrigation."[127] Sheffield also said, "It would be appropriate to give thanks to the genius of Frank Zybach and his contributions which have revolutionized agriculture."[128]

Writing for the *Lincoln Journal Star*, historian Jim McKee noted, "It has been said that from outer space three manmade technologies are visible: The Great Wall of China, electric illuminations of the world's cities and the green crop circles made by center pivot irrigation."[129]

Once Zybach's patent expired in 1969, other companies began manufacturing center-pivot systems. By then, Zybach and Trowbridge had received more than $1 million from the 5 percent royalty payment they had negotiated with Daugherty. Today, Daugherty's company and the Valley® brand of center pivots remain the number one leader in the world for center-pivot irrigation development. At one time, there were as many as seventy-five companies manufacturing and selling the systems. After a few years, only seven manufacturers survived, and by 1993, five of those remaining were from Nebraska, including Valmont, Reinke Manufacturing Company of Deshler, Lindsay Manufacturing Company of Lindsay, T-L Irrigation Company of Hastings and the Lockwood Corporation of Gering.[130]

As other companies expanded and manufactured center pivots, the industry continued to improve and supported agriculture's growing needs. New designs allowed for better efficiency. Richard Reinke started a manufacturing company in Deshler on the family farm in the early 1950s. During his career, Reinke invented and patented more than thirty innovations for the center-pivot systems. He is best known for the "Electrogator," the first electric-drive center-pivot system that was reversible. Reinke also was a pioneer of the irrigation industry. His company, Reinke Irrigation Systems, continues to operate, and many of the innovations he conceived have become standards for the industry throughout the world.[131]

Management and Conservation

As the state's number one natural resource, water takes top priority and requires a strong management program. Located above the largest aquifer in the nation, Nebraska grew into one of the leading agricultural producers for corn and beef. With the most irrigated acres in the United States, it has been necessary to commit to the education of new technologies, future planning and implementing effective policies for water usage. Since the 1950s, irrigation's heavy pumping and withdrawals from the rivers,

streams and aquifer have made an impact on the arid West's water levels. Understanding the balance of supply and demand without depleting this natural resource is necessary to ensure the quality of life and ability to continue the production quotas in the state's future.

Early pioneers traveling through Nebraska were unaware of the groundwater resource below their rutted trails leading west to the Pacific Ocean. In 1887, H.C. "Hank" Smith, a U.S. Department of Agriculture geologist, documented the aquifer's existence and functionality.[132] The aquifer, he reported, works like a sponge made up of layers of sand and gravel full of water residing below eight states of the Great Plains, including South Dakota, Wyoming, Nebraska, Colorado, Kansas, Oklahoma, New Mexico and Texas. As water from the Rocky Mountains' snow melts, rivers and annual rainfall have fed the Ogallala Aquifer for thousands of years.

Nelson Horatio Darton, a hydrogeologist working for the U.S. Geological Survey, named the water resource the Ogallala Aquifer in 1898 for being close to the cowtown of Ogallala, where his team was working. The aquifer stretches for 174,000 square miles underneath the surface and holds enough water to fill Lake Huron. It supports nearly one-fifth of the wheat, corn, cotton and cattle produced in the United States.[133] Sustained in part by the Ogallala Aquifer, farmers and ranchers were not able to tap into this underground reservoir until center-pivot irrigation systems were manufactured in the 1950s and 1960s. Windmills were the first to use the natural water source, but those wells could only be dug so deep. Hydraulic well-drilling equipment allowed for deeper wells, and centrifugal pumps were able to supply enough water for the new center-pivot systems. Land that was once a part of the "Great American Desert" began transforming into lush, high-yield producing fields. This production has come with a cost, as constant monitoring has indicated that the aquifer's levels are declining faster than it can recharge itself.

However, among the Ogallala Aquifer's states, Nebraska is an exception—two-thirds of the aquifer's water lies beneath the Cornhusker State.[134] Ogallala water creates wetlands and small lakes and seeps up into the pastures, especially in the Sandhills, eventually flowing into the rivers. The Sandhill region is really a great dune sea, the largest in North America where rainfall and snowmelt percolate through the sand, giving Nebraska the most substantial recharge on the aquifer's 174,000-square-mile span.[135] Other states above the aquifer have not been as fortunate, with no ability to recharge. Those portions of the aquifer have been completely drained, and it will take thousands of years to refill.

The health of the Ogallala Aquifer is vitally important to Nebraska and the Great Plains. Jay Famiglietti, senior water scientist at NASA and lead researcher on a study using satellites to record changes in the world's largest aquifers, cautioned that "the consequences will be huge" if we overdrain the supply,[136] especially as food production in the world will need to increase 60 percent to feed 9 billion people by 2050.

Agriculture research, engineering and technology advances constantly to create better ways to be more efficient. Companies like T-L Irrigation in Hastings have dedicated themselves to manufacturing systems and supplying products for the irrigation industry as it has evolved. In 2015, the company celebrated its sixtieth anniversary. T-L Irrigation founder LeRoy Thom has become a world leader in improving center-pivot designs to help the equipment reach maximum potential for the producer, while keeping in mind water waste management. In 1994, T-L Irrigation helped introduce computerized pivot control, allowing the farmer to program precise water application rates for varying locations within the field. In 2001, it introduced "Point and Precision Point Controls," allowing systems to be operated from the pivot point or any other location by the farmer. At the same time, communication for remote wireless pivot systems was introduced. This allowed the irrigation systems to be operated from the pivot point or from other locations the farmer would choose.[137]

Nebraska irrigators have recently started working with subsurface drip irrigation (SDI). Instead of irrigating on the surface, SDI is buried beneath the ground and provides water to the root area of the plants. These systems help eliminate water loss from evaporation and runoff and require less water. The Natural Resources Conservation Service has been helping implement the SDI systems.[138] It has also assisted landowners with converting acres of irrigated lands into dryland production. In 2012, through irrigation water conservation practices, Nebraska saw the amount of irrigation water applied to cropland decrease by nearly thirty-seven thousand acre feet annually.

Owen Palm, CEO of 21st Century Equipment LLC, has long been an industry leader in precision farming, understanding the importance of managing water resources through advanced technology and implementation. The company owns seventeen John Deere agricultural dealerships and operates in five states. In June 2010, 21st Century purchased the assets of Irrigation Specialties, a Valley Center pivot dealership in Gering. The name was changed to 21st Century Water Technologies LLC. Later that year, in November, the newly organized business became the first agricultural dealership in North America to be appointed an official

John Deere Water Dealer, extending its offerings to include subsurface drip irrigation and soil moisture management tools. In January 2014, 21st Century Water Technologies LLC entered into a partnership with ECO-Drip, a pioneer in the subsurface drip irrigation industry.

At the April 2016 Water for Food Global Conference, at Nebraska's Innovation Campus in Lincoln, Palm shared as one of three panelists for a *View from the Field* discussion, "There is tremendous opportunity to both conserve water and to improve water quality." Technology is playing a big part in water management too. Palm continued, "We are at an intersection today from a technology standpoint. We've got the ability to collect data in unbelievable proportions…and the ability to manage that data [better] than we ever have before. We've got that intersecting with GPS technology that allows us to know that data down to the square meter, or smaller, [where it] came from, whether its yield, soil type or even moisture in that soil. That technology intersecting with telematics is allowing us to transmit that data back to some repository somewhere for analysis. All these technologies are coming together today."

In a September 2016 interview with the 21st Century innovative leader, co-author Jody Lamp learned the value of monitoring and measuring agriculture water consumption and the impact it has on water conservation, as well as how new technology provides accountability and tremendous economic savings. Palm described how field soil probes are helping make

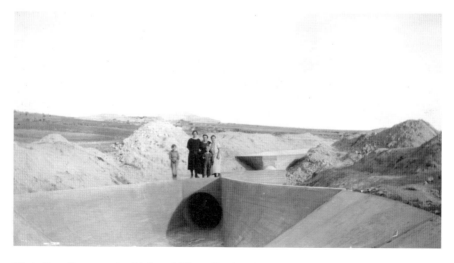

Lizzie Broadbent stands with her children, Doris and Harold, along with two other women, on top of the culvert of a drainage ditch from the Pathfinder Canal System, circa 1925. *Courtesy of the Jim Duncan family, Morrill, Nebraska.*

a difference and serving the role of moisture manager. The challenge is helping growers measure their moisture levels and understanding the information available to them to make management decisions and turn them into direct cost savings. Palm explained that it takes $3,000 in electricity to send a center-pivot irrigation system in the field one rotation and $20,000 per year for each pivot. By keeping close tabs on the level of moisture through soil probes, the economics prove themselves. As much as $77,000 in savings has been seen by some in their overall farming operation. That's real money being saved and money going back in the producers' pockets all while saving water. "Eventually technology will lead to the operation of center pivots through automation, involving science technology through one weather station," Palm said. "More and more, the management of water is going to be important."

Water management today will continue to require a solid understanding of the following issues: the allocation of water, instream flows, groundwater management, conjunctive use of surface and groundwater, water quality, trans-basin diversion, financing water development, recreation and the Sandhills development.[139] The state relies on the Natural Resource Districts to assist in administering, protecting and managing its water for agricultural purposes, industry, municipalities and recreational needs. Nebraska's system of local natural resources management is unique in the United States, where, unlike the countywide districts found in most states, Nebraska's Natural Resource Districts (NRDs) are based on river basin boundaries, enabling them to approach natural resources management on a watershed basis.[140]

Past governing programs from the early 1900s and midcentury were not effective for meeting the challenging and emerging needs. As larger water projects developed, it was difficult to determine where the responsibility of proper sponsorship or ownership belonged. Water projects were getting bigger and crossing county lines and earlier established boundaries. Defining the governing authority became a "multiplicity" issue. There was confusion in overlapping authorities. It was hard for the local people to rely on the state and federal government to carry on the affairs, and it was clear that proper geographical organization of local governmental subdivisions was important and needed.[141]

Protecting Lives, Protecting Property, Protecting the Future

State officials realized the problem and passed LB1357 in 1969 during the 80th Unicameral. The new bill allowed Nebraska to create its current NRDs. The boundaries of these new subdivisions were in accordance with the state's naturally delineated river basins on the premise that natural boundaries would provide a better opportunity for dealing with resource-related problems.[142] With the adoption of LB1357, twenty-four Natural Resource Districts were created; later in 1972, 154 special purpose districts that had been established earlier to handle problems were merged into their respective district areas. By 1989, a merger had reduced the number to twenty-three districts currently serving the state. Through the new NRDs, the state had a more effective way to introduce, implement, coordinate and monitor programs.[143] Many felt that creating the NRDs could never be accomplished. However, it is just another example of and testimony to Nebraska's ability to understand and cooperatively manage its number one natural resource for generations to come.

Most western Nebraska crops require irrigation because annual average precipitation is between fourteen and seventeen inches. With more irrigated acres of land than any other state in the nation, Nebraska is the only state that manages its water through NRDs. Other states are managed through Conservation Districts. The North Platte NRD includes Banner, Garden, Morrill, Scotts Bluff and southern Sioux Counties, with a land area of more than 3 million acres. The largest source of irrigation water is the North Platte River.

"NRDs demonstrate true responsible stewardship of our water and sustainable management by governing ourselves," said John Berge, North Platte NRD general manager. "It's unique and it's responsible for our needs today and for future generations that will continue to live, recreate and be involved in the agriculture industry in this area and the great state of Nebraska."

Berge, a Morrill County native, had held various positions at the U.S. Department of Agriculture for Nebraska, including deputy administrator for field operations and state executive director at the Farm Service Agency. Taking the helm at the North Platte NRD in July 2013, Berge works to build partnerships with Nebraska's other NRD administrators and organizations. Nebraska Natural Resource Districts today celebrate more than forty-five years of protecting lives, protecting property and protecting the future. NRDs were created to solve flood-control, soil erosion, irrigation runoff, groundwater quantity and quality issues.

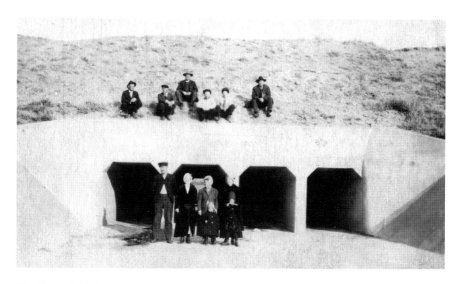

Members of the Broadbent work crew, women and children gather at a "dedication" of a finished gate system of the Pathfinder Canal System before water would make its way to western Nebraska via irrigation, circa 1925. *Courtesy of the Jim Duncan family, Morrill, Nebraska.*

Speaking this spring as a panelist at the 2016 Water for Food Global Conference break-out discussion titled *View from the Field*, Berge shared how the North Platte NRD works to implement programs, improve technology and increase efficiency through accountability. In a brief overview, he explained how they strive to achieve their goals that make an impact in managing the area's water for all groups:

> *Our goal here is to do basically three things....One is to serve as a regulator in order to protect the resource. Second, is we have a fiduciary responsibility to the taxpayers that fund our operation. Third, is to insure that we are as good of partners to our land owners as possible to live within the confines of our regulations.*

The North Platte NRD works progressively to seek funding, provide incentives and incorporate better technology into the fields. A peer-to-peer relationship with research centers, extension services, the university campuses and the producers has had a major impact. Berge continued to reflect at the conference, "Thirty years ago when my Dad was farming, I'll guarantee you he was applying 30 inches in Garden County to grow corn. Today, they're doing that with 12 inches."

Most recently, NRDs pursued funding to implement "telemetric" technology. Now producers can monitor water output from their pivots located several miles away. "We know that if you know how much you are using, you are apt to reduce it—this is an industry standard. You are apt to reduce it by 15 percent." Berge explained, "If a guy knows that that pivot 50 miles away with one of Owen's moisture probes is running in a field that is wet, he's going to turn it off."

Tapping into the North Platte River's water supply required engineering ingenuity. Only by irrigation could the area of Nebraska's North Platte River Valley be transformed from the "Great American Desert" to "America's Valley of the Nile."[144]

Since the water western Nebraska needs is transported from and through Wyoming, it makes sense that there have been some "interstate struggles" on the way concerning the amount of water distribution. Water disputes between the Cowboy and Cornhusker States reportedly began in 1933 and weren't settled until 1945, when the United States Supreme Court issued a decision on the Kendrick Project.[145] The Wyoming state engineer issued a permit for the Kendrick Project, which was a filing for water right applications for all the unappropriated waters of the North Platte River to be used for development and irrigation. When the filing covered about two-thirds of Wyoming and only one-third of Nebraska, a suit followed until Nebraska water rights advocates were satisfied. The Supreme Court decision allowed the water to be used for 168,000 acres in Wyoming, 145,000 acres in Colorado and 1,580,455 acres in Nebraska.[146]

The Natural Resource Districts will continue to forge partnerships between stakeholders, integrate management plans and monitor for programs to allocate and protect Nebraska's vital water resource. A group also focusing on the future in water management for more than fifty years is the Nebraska Water Center (NWC). The NWC was established by Congressional mandate as one of the fifty-four Water Resources Research Institutes in 1964, and its research and programs support and promote the University of Nebraska as an international leader in water research, teaching, extension and outreach.[147]

The future of Nebraska's water is not merely a local and state concern. As Nebraska invests into research and determines best practices, what better place than at the University of Nebraska–Lincoln's Innovation Campus and the Robert Daugherty Water for Food Institute. The university has been a national leader in water resources research and management. Since the state's agricultural research and irrigation

manufacturing companies have aided countries around the globe, it is important that the institute lead the discussion for innovative ways to feed the world with less water as global population increases.

To learn more about water, irrigation and western Nebraska, visit the Legacy of the Plains, Nebraska's newest museum that celebrates the lives and tells the stories of High Plains agriculture, communities and people. On your way to the Scotts Bluff National Monument, start off at the museum's new twenty-nine-thousand-square-foot main exhibit hall, featuring seven different zones filled with state-of-the-art interactive displays and collections covering more than two thousand years of human life in the North Platte Valley.

See many valuable, one-of-a-kind resources on westward migration, regional settlement, cultivation patterns, technological evolution, climate trends and more. Learn how the migration stories of western Nebraska hold universal appeal and how the food produced in the Panhandle helps feed the whole country. Historians, agronomists, scientists and other scholars will learn how western Nebraska inventions and innovation are mirrored throughout America. Individual and family memberships are available and help support the museum. For more information, call the Legacy of the Plains Museum at (308) 436-1989 or visit www.legacyoftheplains.org.

The Barn. Courtesy of Gene Roncka, Willow Point Gallery, Ashland, Nebraska.

MAKING A GO OF IT

The Family Farm: A Century of Change

Hopefully our children will carry on our legacy and appreciation of faith, family and farm in their own ways.
—*Valarie Geisert, co-founder of Prairie Preservations and the Prairie Haus*

From the 1870s through the 1970s, America saw agriculture through its most expansive and innovative years due in part to inventions and investments made by citizens from Nebraska. This innovative period laid the foundation for engineering and educational advancements to enhance equipment and production. Improvements abounded in communication, distribution and management techniques. The family farm as it was known was changing with the times. Generations learned to adapt and adopt new methods to stay competitive with the expanding marketplace. Always known for their hard work ethic, traditions and strong value system, Nebraskan farm families remain connected to the land their immigrant ancestors settled more than a century ago—dreaming of a better life.

For the Geisert family, their farm roots share similarities with nearly every other founding family in the St. John's community, southeast of Ogallala. Families immigrated across an ocean and trekked through this new country in search of a place of their own. Nathan (Nate) Geisert's great-grandfather August Geisert came to homestead in Keith County, near Ogallala, known for being the end of the Texas Cattle Trail.

August's older brother, Reinhard, was only eighteen years old in November 1879, living in the village of Eichstetten, South Baden, Germany, when he applied for permission to leave his native homeland and immigrate to North America. Traversing the distance between the eastern edge of a range of hills known as the Kaiserstuhl on the Upper Rhine Plain of Germany to the southwestern edge of the Nebraska Sandhills on the Great Plains of America, this young man began a legacy of faith, family and farming that now spans five generations.

A bevy of reasons most likely drove Reinhard to America, a land reportedly full of promise but a place that was certainly unknown to him. His father, Matthias, passed away, leaving him, as the oldest son, with the full responsibility for his widowed mother and younger siblings. His mother had already suffered through the deaths of several infant children. While men his age were being drafted into the German military, Reinhard hoped to improve their meager existence. Drawing his attention toward America, publications advertised that some midwestern areas were anxious to increase their populations. The words enticed and encouraged immigrants from Europe about "the wonderland on the American prairies."[148]

The Homestead Act of 1862 offered any person of twenty-one years of age who was the head of the family 160 acres of free land if willing to build a home on the property and farm the land for five years. Reinhard seized the opportunity. On February 10, 1880, he boarded an America-bound ship in Havre, France, to New York City. While he left challenges behind, he knew little of the trials ahead. Reinhard would soon discover that the first available land was in the heart of what was deemed the "Great American Desert, unfit for civilization with its expansive, mostly treeless, windswept prairie."[149]

Reinhard spent the next several years searching for available land before making it to the rural America's heartland. In 1884, the twenty-three-year-old settled on a homestead in Keith County. Surely it was a source of frustration to have passed the fertile land that had already been claimed in Illinois, Iowa and eastern Nebraska and gradually see the vegetation and moisture levels taper off the farther west he traveled. But never mind that. Survival and shelter were his immediate concerns, so he built a sod house and began learning to live off the land he had traveled all the way from Germany to homestead.

Two years later, Reinhard returned to his homeland to encourage his mother, Luise; his brothers, Wilhelm August "August," Johann Jakob "J.J." and Albert; his sister, Luisa; and his sweetheart, Miss Katie Mueller, to venture back to America with him. The group made its way to Henry County,

Illinois, where the women stayed with relatives and the men journeyed west to Reinhard's Nebraska homestead, with their stock and machinery loaded on an emigrant train car. Upon their arrival, the Geisert men worked to build a wood-frame house, as the original sod house was not big enough for the entire family. The women eventually joined the group, and thus began the Geisert family's history of forging their way together in a new country.

Water Runs Deep

The first settlement congregated in what became the St. John's Lutheran Church community, built around the one-room rural school and church by two families of brothers: William, Henry and Fred Holscher and August and Reinhard Geisert.[150] Along with the Holscher and Geisert families, the Keith County community also became the new "home country" for the Hansmeiers, Elmshausers, Mosts and Nelsons. As stated on January 22, 1898, in the *Republican Argus*, "Mr. and Mrs. Conrad Elmshauser deeded to the St. John's First German Lutheran Church ten acres of land for church purposes. This church is located about ten miles southeast of the city in a settlement of prosperous German farmers and is in very flourishing condition."[151]

The Geisert family, their neighbors and countless other families of the Great Plains, through good stewardship, agricultural technological innovations and mechanization, as well as conservation practices, turned desert ground into a viable dryland and irrigated farmland and ranch land. Although their life had been hard back in Germany, their new life on the prairie presented an altogether different set of challenges. J.J. Geisert put it best in his own words in an article published by the *Keith County News* in 1935:

> As soon as the house was completed, my mother, sister and Rinehard's [sic] sweetheart (to whom he was married after their arrival) came from Illinois to join the family. They must have taken the change more to heart than we and many times during the hardships which followed they longed for old familiar scenes and faces in place of rolling plains which stretched of the nearest neighbors. Everything in this new land was strange and the silence of the night, with an occasional mournful howl of the coyotes added to their loneliness. The rattlesnakes which were legion in number kept them in constant terror, and prairie dogs though harmless, added to their discomfort. In fact the only things in this new country which we enjoyed in our home in Germany were the sky, the sun and the moon and stars.

In 1910, August Geisert built a wooden windmill that still stands on the Geisert family farm today southeast of Ogallala. *Courtesy of the Geisert family, Ogallala, Nebraska.*

August Geisert soon struck out on his own and purchased a homestead several miles to the west where he began his own farm and cattle herd. To date, five generations of August Geisert's family have lived and worked on this farm, including August and his wife, Nettie Geisert; his son, Edward, and wife, Louise Geisert; his grandson, Gerald, and wife, Rosemary Geisert; and his great-grandson, Nate, and wife, Valarie, as well as their three children, Jakeb, Jordan and Jensen.

Crucial to the survival of all living things, water was the center of existence on the prairie. Land near the river was quickly claimed. Water was essential for living, farming and raising livestock. For those who had to "prove up" on homesteads farther from a surface water source, the challenge seemed overwhelming. The Geiserts and their neighbors soon discovered a groundwater supply that they and pioneers who had passed through the land before them had never seen—it was lying beneath their feet.

Keith County, Nebraska, sits on one of the world's largest underground water sources: the Ogallala Aquifer. After windmills were invented, farmers were then able to drill a well, utilize the windmill by channeling the prairie wind into energy and pump water from the ground. This new water source made life seem possible on the prairie. It now supported their lives and their livelihood: the crops and livestock. The Geiserts have heard many comments about the "deliciousness" of Nebraska Sandhills' groundwater, as it is filtered straight through the sand. Geisert family folklore passed down through the generations tells of one relative who would often hold up a glass of "Sandhills water" and admiringly say in German dialect, *"Dies ist gutes wasser!"* (This is good water!")

By the early 1900s, August Geisert and his son, Edward, were searching for ways to use the groundwater and improve their farm yields. In 1910, August constructed a wooden windmill that still stands on the farm more than a century and several generations later. Edward and his son, Gerald, filed for a permit in 1947 to drill a well that would make flood irrigation possible for the first time on their bottom hay ground south of the South Platte River. Soon, flood irrigation became the instrumental factor for increasing yields on the Geiserts' corn and dry-edible bean crops. In 1973, Gerald Geisert applied for a permit to put a center-pivot irrigation system on 130 acres of corn. Edward remarked often how over the years he was sickened to see crop after crop die due to the lack of water, as well as how amazing it was to see the innovation of a sprinkler system that would ensure that a crop could grow to maturity without rainfall.

Traditions to Transitions

Gerald's son, Nate, has utilized his agricultural economics and marketing education from the University of Nebraska–Lincoln by incorporating treasured traditions with progressive marketing practices, diversifying crops, utilizing technology and innovation in his farm practices. Surely to the amazement of his forefathers, technology advances now allow Nate to manage center-pivot irrigation systems on nearly all of his fields remotely and online by using his cellphone or computer. Although the presence of irrigation remains the cost of doing business as a producer, it also serves at times as the only salvation for area farmers to glean a crop, especially during droughts, like the eight-year period at the start of the new millennium.

Along with the discovery of how to utilize groundwater, the Geisert family implemented soil conservation practices to create and preserve farm ground. Soil conservation has always been a big part of this farm operation. Even though primitive efforts were made in the early years, improvements began in 1958 with some of the first terraces in Keith County under the newly formed Soil Conservation District.[152] These terraces, which Gerald built with a John Deere A and a two-bottom plow, were seeded to grass. Miles of terraces have been installed and rebuilt at various times, along with three flood-control dams and two miles of grassed waterways.

Since 1995, the Geiserts have installed underground outlets serving more than twenty-two thousand feet of terraces under center-pivot irrigation. All pivot irrigation land is under a conservation tillage system and irrigation

Above: Agriculture technology advancements allow Ogallala farmer Nate Geisert to manage center-pivot irrigation systems remotely and online by using his cellphone or a computer. *Photo by Valarie Geisert, Prairie Preservations, Ogallala, Nebraska.*

Below: The Geisert family farm of Keith County has earned several conservation awards over the past century for tree planting. Currently, there are 1,200 mature trees protecting the farmstead. *Courtesy of the Geisert family, Ogallala, Nebraska.*

water management program. Proper grazing use is always practiced on all grazing land supporting the cattle operation. Over time, trees were planted as windbreak protection, with more than 1,200 mature trees surrounding the farmstead. "You won't find any better general farmers than those in the St. John community," said Keith County extension agent Russ Hughes in a January 3, 1948 *Nebraska Farmer* article. "They believe in and prove the wisdom of a program of diversified farming built on livestock and wheat....You won't find any community where there are more beautiful farm homes. Trees help greatly to make these farms attractive and fine places on which to live."[153]

Over the last century, the Geisert family farm has earned several conservation awards for tree planting and extensive terracing and was honored and recognized by the Knights of AKSARBEN and ConAgra in 1996 for maintaining family ownership of the farm for more than one hundred years. Continuing the good stewardship of the land, Nate implements no-till farming practices, contour terracing and crop rotation to preserve the land's precious topsoil.

Maximizing Mechanization

Along with water innovation techniques and topsoil conservation, the Geisert family also implemented various mechanization methods. August Geisert certainly used horses on the homestead to put up hay, farm and herd cattle. But by the early 1900s, his sons had started experimenting with early types of tractors and mechanized machinery. A progression of tractors and equipment followed. Imagine the difference in efficiency and productivity the machinery made in contrast to the physical limitations that a team of horses could produce.

In 1929, Ed Geisert purchased a new twelve-horsepower John Deere GP tractor, followed by the purchase the next year of a Model D John Deere. The Model D tackled most of the heavy farm work, such as disking and listing, while the GP was used for the lighter farm work, including mowing and putting up the hay. The Geisert family used a Model A tractor with a John Deere binder and a John Deere Model D running a threshing machine to bind and thresh the wheat. The threshing machine was used in later years for local demonstrations on the farm and at the county fair to show onlookers how wheat was harvested with these early machines.

Gerald Geisert's first John Deere tractor was a new 1942 Model A. The family soon bought a new John Deere binder, which came equipped with

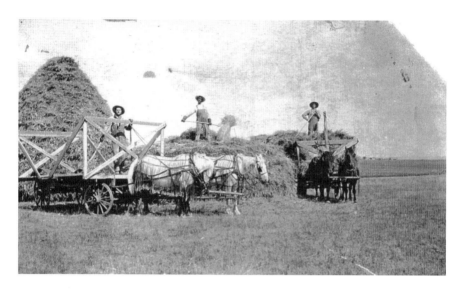

The Geiserts used teams of horses and hay racks to load straw piles for the threshing machine to feed livestock. August Geisert (*middle*) is with sons Albert (*left*) and Bill, circa 1920. *Courtesy of the Geisert family, Ogallala, Nebraska.*

a hydraulic remote cylinder, to bind grains. The men were stumped as to what it was. Upon further investigation, the local John Deere dealer deduced that it was an innovation by which you could remotely raise and lower the implement instead of using levers. Soon, Gerald ordered the hydraulic system to retrofit his Model A tractor to have one of the first hydraulic pairings in the area.

In the 1940s, the Geiserts purchased a No. 5 power mower for the Model A to mow hay. The Model A took over the work of the steel wheel GP tractor, doing the mowing and binding. At that time, the Model D was still on disking and listing duty. Soon, a 1947 John Deere G was in use on the farm that replaced the workload of the D. The G tractor was larger framed with more horsepower and pull for the heavier work. Later, the G tractor was traded off for a new 720 Diesel, which became the workhorse for the farm. Its innovations featured power steering and a three-point hitch, which they used with a three-bottom roll over plow. Pairing this tractor and plow greatly improved overall work efficiency. A 70 Diesel was purchased from a neighbor as the Geisert farm grew, and that is the tractor Nate used to cultivate the corn crop during his youth.

When the 1969 New Generation of John Deere tractors debuted, Gerald Geisert bought a new six-cylinder 4020 Diesel and traded in the 720 Model.

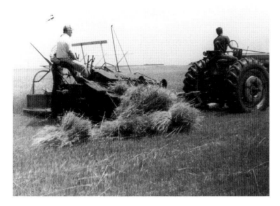

Wheat binding demonstration at the Geisert farm in 1984 with a John Deere 70 Diesel Row Crop tractor and John Deere ten-foot power binder. The tractor is driven by Nate Geisert, and the binder is operated by Gerald Geisert, with a neighbor looking on. *Courtesy of the Geisert family, Ogallala, Nebraska.*

He also purchased a twenty-four-foot John Deere chisel to pull behind. The New Generation series marked the first time John Deere transitioned from the two-cylinder designs to building tractors that had four and six cylinders, which revolutionized the industry. The 4020 was one of John Deere's most popular tractors, due to horsepower and efficiency for the farmer. The increase in horsepower and greater farming efficiency for the Geiserts continued with the purchase of a used 4430 in 1978, which allowed them to go from pulling an eighteen-foot disk to a new John Deere twenty-five-foot disk. This was aided by the purchase of another 4430 and eventually a used 8430 in the late 1980s. The 8430 was the first four-wheel-drive John Deere tractor used on the farm; an even wider disk could then be used.

The first John Deere tractor Nate Geisert bought in the 1990s, other than a growing collection of antiques, was a used 8630 four-wheel-drive tractor that he used for disking and planting with his eighteen-row corn planter. That was quite the sight for the times, pulling such a wide planter. During these years, Nate and his dad also ran a 7720 Titan II John Deere combine. Along with his father, Nate was instrumental in implementing an antique tractor pull at the Keith County Fair, using the University of Nebraska Tractor Test Laboratory (NTTL) test results for classification of horsepower. NTTL is the officially designated tractor testing station for the United States and tests tractors according to the Organization for Economic Co-operation and Development (OECD) codes.[154]

Contrasting the efficiency and productivity of August's horses that would take days to farm forty acres, Nate now runs a 310-horsepower John Deere 8310 RT equipped with GPS guidance and onboard computer system that only takes hours to work the same amount of ground. This tractor features

tracks instead of tires, is steered by GPS and has a computer on board that regulates the infinite variable transmission, motor, hydraulics, fertilizer rates, fuel consumption, lights and more. Onboard ergonomically friendly fertilizer tanks tucked between the tracks and the chassis eliminate obstructive tanks being attached to the front of the tractor, and a fertilizer metering system controlled by computer eliminates the need for guesswork.

A Curator's Collection

All the aforementioned tractors are still used on the Geisert family farm in 2016, with the exception of the G Model and the 720. When Nate was about twelve years old, Gerald encouraged him to try restoring the 1930 John Deere D that was originally purchased new by Nate's Grandpa Ed. The learning experience fostered Nate's interest and skills in the preservation, restoration and classification of old John Deere tractors and other collectible tractors and vehicles. To date, Nate has restored many

Fourth-generation farmer Nate Geisert stands with his wife, Valarie, in front of their Prairie Haus, an agritourism destination that showcases the legacy and handiwork of the Geisert family farm. Behind them is a Waterloo Boy, the first tractor manufactured by the John Deere Company, and a John Deere 8310 RT, equipped with GPS guidance and onboard computer system. *Photo by Valarie Geisert, Prairie Preservations, Ogallala, Nebraska.*

early model John Deere tractors and an assortment of other models in his vast collection. The Geisert brothers owned several different tractors together in the early 1900s, but since 1929, the family have used mostly John Deere tractors on the farm.

"My great-grandpa August would be astonished how farming has revolutionized in just a little over one hundred years since he settled in Keith County," Nate reflected. "I enjoy bringing the life back to the pieces of equipment that were the forerunners in the revolution of mechanization on the farm. My JD track tractor has made farming the same number of acres much easier. I couldn't accomplish what I do today without the modern technology, but I appreciate the antiques and how innovative they were in their own time."

As the new millennium approached, Gerald and Nate were well on their way to being avid collectors of the early-style John Deere tractors and equipment. Their 2010 acquisition of a fully restored 1919 JD Waterloo Boy was the pinnacle of their years in collecting. In 1918, the John Deere Company purchased the makers of the Waterloo Boy tractor so that it would have a tractor to offer its customers. The Waterloo Boy was the first tractor manufactured by the John Deere Company. This unique tractor is now on display at the Prairie Haus, an agritourism destination at Nate and Valarie Geisert's farmstead.

Prairie Preservations

The Geisert family agriculture heritage, interests and skills are common threads in Nate and Valarie Geisert's marriage, providing inspiration and a platform for the family, as well as her business venture, Prairie Preservations. The business and farm history museum is located in the Prairie Haus, a three-story structure that was built by Nate, Valarie and all three of their children—Jake, Jordan and Jensen. Each had a hand in its completion, starting the new build in the spring of 2012 and finishing in the winter of 2016.

The couple's son Jake was an architect student at the University of Nebraska when he began designing the building. By the time it was completed, Jake had graduated with his Master of Architecture degree and was employed as an architect with a Lincoln firm, specializing in historic preservation of landmark buildings and structures. It was important for the family to incorporate history into the new structure. Nate and Jake used

Remarque. Courtesy of Gene Roncka, Willow Point Gallery, Ashland, Nebraska.

reclaimed barn wood, and the iron wagon wheel rim light fixtures that hang from the vaulted ceiling were built by the father-and-son team.

As a tribute to their homesteading German ancestors, the Prairie Haus showcases the legacy and handiwork of the Geisert family farm within and nearby the structure: Nate's collection of restored antique tractors and farm equipment; Valarie's love for arranging flowers, antiques, photography, entertaining and teaching; Jake's craftsmanship and wood design; and daughters Jordan and Jensen as artists and avid photographers. Visitors to the Prairie Haus enjoy perusing quality history displays of the generational Geisert and Johnson (Valarie's family from Gordon, Nebraska) family farms, the Prairie Market and the lovely event space upstairs. To preserve the story of the Geisert family history, Nate and Valarie also partnered as agrarian ambassadors with the American Doorstop Project, preserving stories that shaped American agriculture.

Valarie Geisert's favorite agriculture historical place in Nebraska is "right here at home! I love having the family around! And lots of friends and guests! It's wonderful to be able to share our rich heritage with them, taking the best values and skills of the past that we've been given, sharing, showcasing and teaching about them right now and, in essence, preserving them for the future."

Other points of interest that make Keith County an agriculture tourist attraction include the rich history of Ogallala's former cattle drive days.

Left: The Geisert brothers (*left to right*) Reinhard, Jake and August all homesteaded south of Roscoe in Keith County, Nebraska. Reinhard left Germany first and came to Nebraska in 1884. *Courtesy of the Geisert family, Ogallala, Nebraska.*

Below: The August and Nettie Geisert family in 1910. After arriving in the late 1880s from the village of Eichstetten, South Baden, Germany, their children were the first generation to be born in America. *Courtesy of the Geisert family, Ogallala, Nebraska.*

For a ten-year period between 1875 and 1885, Ogallala became known as the "End of the Texas Trail." Longhorn cattle were being driven up to meet the Union Pacific Railroad at the same time the Geisert family and their St. John's community neighbors were homesteading the area. With the

development of irrigation and water management practices of the Ogallala Aquifer, the "Great American Desert" is now an area of productive farm and ranch operations. The Mansion on the Hill, Boothill, Ash Hollow and the historic Front Street show combine to tell visitors the western history of this area. The unique history of the area combined with the Geisert family's tale of innovation, conservation, mechanization and preservation make it a place "Where Legacy Comes to Life."

Gone: The Grand Island Horse and Mule Market

At one time, the world's horse buyers, traders and sellers came to Grand Island, Nebraska. But now it's Sunday, December 12, 2004, at 610 East Fourth Street, and the end of an era is unfolding. The last yard gate swings closed, the auctioneer's rhythmic cadence no longer resonates through the Bradstreet Livestock Commission sale ring and now the last horse sale consignor-to-buyer transaction is in the books. The descendants of Thomas E. Bradstreet say goodbye to not only a business but also a lifestyle and history that their great-grandfather created in central Nebraska more than a century earlier. It's Sunday and it's horse sale day at the Bradstreet Livestock Commission. But it's the last one, now and forever. Siblings Steve Arrasmith of Longmont, Colorado, and Carole Miller of Phoenix, who reopened the livestock market on December 5, 2002, believe that their great-grandfather, who started the first horse and mule markets on June 23, 1903, would have been proud.[155] Their cousin Stacia Larsen, who has a picture of her great-grandfather Thomas

A photo of Thomas Bradstreet holding his "great" great-granddaughter, Stacia (Tully) Larsen of Grand Island, who was only seven months old in 1943, while her father was serving in the U.S. Army in the South Pacific. *Photo taken by co-author Jody L. Lamp.*

PLUM STREET STATION

Stacia (Tully) Larsen holds a picture of her great-grandfather Thomas Bradstreet, who started the first horse and mule market in Grand Island on June 23, 1903, at the once named "Plum Creek Station," now called the Burlington Railroad Depot. Built in 1911 on Sixth and Plum Streets to be near the markets of Fourth Street, the building was purchased in 1999 by the Hall County Historical Society, which saved it from demolition. By January 2015, the depot was listed in the National Register of Historic Places. *Photo taken by co-author Jody L. Lamp.*

holding her at seven months old, said that saying goodbye to the last sale barn on Grand Island's East Fourth Street was like losing a family member.

Grand Island Independent reporters Carol Bryant and Robert Pore covered all the events leading up to and during when the brother-and-sister team purchased the 5.5 acres of land and the buildings along both sides of East Fourth Street from their mother, Marian Arrasmith, of Phoenix, and her sister, Hazel Tully, of Grand Island, whose father was Archie Bradstreet, Thomas's son. As Carole Miller noted in the January 22, 2005 *Grand Island Independent*, "The business actually grew for a while. Then it started to decline. There's a lot of reason for that decline, but I just don't think the market can support the business here. It breaks my heart to see it happen. It was a hard decision. We put our heart and souls into trying to make it work. We wanted it to work, but our biggest problem is it is too far away from where we live. You can't run a business unless you're hands on. That was probably part of the problem, that we were not here. If we lived here, maybe we would keep it open and have some other type of auction or hold other events."[156]

Less than two weeks from Christmas Day 2004, the business and area that once was the home of the World's Largest Horse and Mule Markets closed. The economic impact generated by Grand Island's horse and mules markets on Fourth Street captured the early days of Nebraska's role in the worldwide horse industry. And now, the only semblance of the era—the iconic Black Stallion horse that graced the top of the markets—was coming down. The owners, Miller and Arrasmith, respected the wishes

of their mother and aunt by donating Grand Island's Black Stallion to the nearby Stuhr Museum.

Gone now are the horse and mule markets that once dotted Grand Island's cityscape and crowded Fourth Street north of the Union Pacific Railroad tracks and east of the Chicago, Burlington & Quincy Railroad line near North Plum Street. But through the stories, memories and even careers of some of the founder's descendants, the legacy continues.

Grand Island: Nebraska's Agriculture West

Nebraska historians date the first horses to Nebraska about 375 years ago. Brought by Spanish explorers, horses mobilized the Plains Indians, as they used them to hunt, gain economic dominance and prominence and wage war and defend themselves.[157] Although horses were few among Nebraska's early settlers, the revolution in agriculture technology between 1820 and 1870 created a demand for larger, stronger horses to power new farm equipment.[158]

As Grand Island found itself on the edge of the agricultural West, its first settlers came from Davenport, Iowa, consisting of German immigrants. They arrived nearly a decade before Nebraska's statehood in 1867. William Stolley, the leader of the Holstein Colonization Company, was offered an opportunity to participate in a "speculative enterprise" of founding a town in the Platte Valley of the Nebraska Territory.[159] By 1868, Union Pacific surveyors had laid out and platted a town called Grand Island. That same year, the nation's first veterinary college opened at Cornell University in New York, and farmers became more educated about the care, feeding and breeding of horses.[160]

In 1884, the Burlington line opened up from Aurora to Grand Island and later extended to Billings, Montana. In 1867, H.A. Koenig established the State Central Flour Mills, which were powered by steam and produced large quantities of flour.[161] And by 1890, the sugar beet crop had been introduced in Nebraska. The first sugar beet factory built and operating in the United States started in Grand Island and was later moved to Scottsbluff.

Before the passing of the Homestead Act, the average American farm was about one hundred acres. While oxen and light horses had been adequate for tilling the eastern farmland, where there was adequate rainfall, a stronger power source was needed to work the virgin soil of Nebraska's prairie.

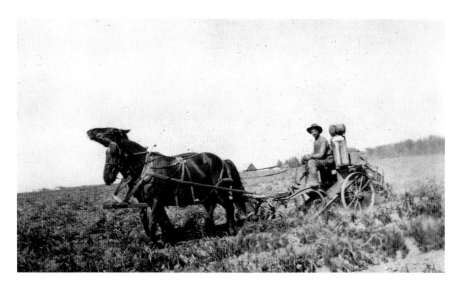

The revolution in agriculture equipment between 1820 and 1870 created a demand for larger, stronger horses to power new farm equipment. A two-horse team pulls a potato digger through the field with an old Model T engine, which mechanizes the digger. *Courtesy of the Jim Duncan family, Morrill, Nebraska.*

Early businessmen at the turn of the century also recognized central Nebraska's plentiful grain, hay and pasture supply. As farm equipment advanced, so did the demand for draft horses to power them. Chauncey North and William Clarence Robinson acquired a livery stable from Scudder Brothers and opened a sales barn in Cairo, about fifteen miles northwest of Grand Island on the main line of B&M. The North & Robinson Company eventually gained a statewide and national reputation for traveling to France and Belgium to import and breed quality Belgian, Percheron and French draft horses at its 340-acre ranch. The duo later expanded the program to include a new partner, H.T. Dean of Bridgeport, which increased the operation by another 5,000 acres. By 1900, there were more than twenty-seven thousand purebred Belgians, Clydesdales, Percherons, Shires and Suffolk Punches in the United States. The infusion of these new bloodlines helped increase the average horse size from about 1,200 to 1,500 pounds.[162]

Business and livestock opportunities did not go unnoticed by thirty-seven-year-old Thomas E. Bradstreet. Before moving to Grand Island in 1902 from Sioux City, Iowa, Bradstreet's life began on February 14, 1865, in Independence, Iowa. Born to William and Mary (Redman), who homesteaded to Iowa from New York, Thomas was the tenth of twelve children and the only member of his family to have been known to move

to Nebraska. He farmed with his father and later finished primary school. Expanding his education, Thomas attended a business college at Dubuque and Waterloo. He became a teacher, rented a farm and married Luella Biddinger in 1886. Finding opportunity in the dairy farming and cattle feeding industries, the Bradstreets moved to Sioux City.

Bradstreet's livestock business success in Iowa began with his brother, Mr. A.J. Bradstreet. His first shipment of livestock consisted of eight carloads and later a full train load of twenty-one cars. Stopping in Grand Island for feeding, Bradstreet quickly became impressed with the area. Looking over the map, he did not see any reason why Grand Island couldn't be one of the principal horse markets of the West. Many, like the North & Robinson Company, already had been drawn to the prosperous agricultural confluence of the Wood and Platte Rivers, a relatively new settlement on an area the French traders called La Grande Isle.

In early 1903, with wife Luella and young sons Archie and Deo, Bradstreet moved his family to Hall County and quickly established his presence in Grand Island. With some assistance of the Union Stock Yards—which was under the management of H.O. Woodward as president, F.G. Cockrell as general manager and J.L. Johnson as secretary-treasurer—Bradstreet started in the commission horse market business. It was June 23, 1903, the timing was right and Bradstreet knew it. He held his first sale at the Union Pacific Stockyards, which was the site of the Cow Palace and the first livestock auction ever held in Grand Island.

Joe Christie, born on January 13, 1893, in Rushville, Sheridan County, recalled earning his first money at nine years old running errands around the sale barns for Bradstreet. After leaving the Nebraska Sandhills and his parents' brief attempt to homestead to Oklahoma, the Christie family traveled back to Nebraska in their covered wagon and settled in Grand Island. In Christie's book, *Seventy-Five Years in the Saddle*, about his life working at the Grand Island horse and mule markets, he credited Bradstreet for pioneering the livestock auctions and laying the foundation for others to follow.

Bradstreet, being the central figure at that first sale horse sale, commanded the crowd and knew how to market his products. Christie recalled that Bradstreet orchestrated every last detail to promote the sales and even hired a band to play as soon as the auctioneer called out, "SOLD!"[163] Knowing the band would draw the crowd's attention from the occasional unruly steed, Bradstreet instructed the music to continue playing until the sale ring had been emptied and filled with the next horses up for sale. "This was true,"

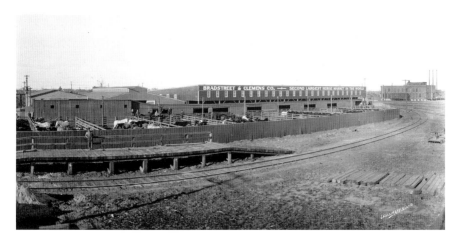

A Julius Leschinsky Studio photo of the Bradstreet & Clemens Company sale barn and stables near the Union Stock Yards on East Fourth Street, Grand Island. In the foreground, a man stands on the ramp, which would have been used to load horses and mules into railcars on the Burlington Railroad tracks. The sign on the building indicates that the business had already coined itself the "Second Largest Horse Market in the World." Image circa 1905. *Courtesy of the Thomas Bradstreet family, via great-grandchildren and siblings Steve Arrasmith and Carole Miller.*

Christie wrote. "When the band was playing, the people sat and listened to the music and watched the players instead of milling around discussing the good and bad qualities of the horses."

Bradstreet's horse sale tactics worked—create an environment to attract buyers and they will come. And continue to attend, they did! Within six months of having his first sale, at the end of 1903, Bradstreet sold 4,000 head. The numbers continued to increase the following years too. In 1904, 7,184 head were sold and, in 1905, 8,112. Bradstreet took on a partner, Jess Clemens, and the newly formed and growing business, Bradstreet & Clemens Company, moved its operation from near the Union Stock Yards to East Fourth Street. Bradstreet began to buy property to make room for more pens. Like the French settlers before them, Bradstreet recognized the area as the "crosshairs" of western business. The scope of Grand Island's magnetism became undeniable when studying the distance the horses were being shipped from the Grand Island markets. The Burlington Railroad shipped horses in from Oregon, Washington, Idaho, Montana, western South Dakota and Nebraska; in addition, the Union Pacific Railroad system brought horses from Oregon, Nevada, Idaho, Utah, Colorado, Wyoming, Arizona and New Mexico.

Seventy-five Years in the Saddle

Seventy-Five Years in the Saddle, a book written by Joe Christie, who recounts the years he worked in the yards of the Grand Island Horse and Mule Markets with various owners like Thomas Bradstreet, John Torpey Sr., William I. Blain and Jack Webb. The authors found an out-of-print, autographed copy, dated May 27, 1976, on a shelf in a Grand Island bookstore for one dollar. Christie's book was the only personal recollection the authors could find that described how it must have been to work on Fourth Street during the peak time of the horse and mule markets. *Photo image digitized by co-author Jody L. Lamp.*

As business gained momentum, so did the news coverage of the sales. On Friday, September 21, 1906, the *Grand Island Independent* reported that in Bradstreet's estimation "there was not another point on the map where the prospects for a horse market were better, and now horsemen, in business in the river markets, look to Grand Island as the coming horse market of the west....Particularly is this the case for western horses. Many of the local men are not aware of the fact that more range horses will be sold in this city this year than at any of the river markets, which heretofore have been the principal horse markets, namely Sioux City, St. Joseph, Kansas City and Omaha."[164]

Editors August F. Buechler and Robert J. Barr of the *History of Hall County, Nebraska* wrote of Bradstreet that "when he went into a line of business with which he was familiar and for which he was well equipped, since 1903 no resident of Hall County having prospered more substantially in the horse business....[T]he horse and mule market was the industry that has probably done more than any other one industry ever represented in Grand Island to spread the name of this city over the entire world."

Bradstreet & Clemens Company sale barns continued to grow. In 1910, the company built two barns, one to accommodate twenty-five carloads of horses and one to hold fifty carloads, with outside pens opposite the barns to carry another fifty carloads.[165] As the business grew, Bradstreet required the talents of a young bookkeeper, Arthur Henry Langman.

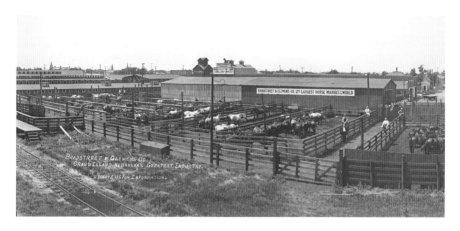

By 1910, the Bradstreet & Clemens Company had grown to accommodate and ship more than one hundred railcar loads of horses at a time. The inscription on the picture indicates that Thomas Bradstreet is standing in the alley in the white shirt. *Courtesy of the Thomas Bradstreet family, via great-grandchildren and siblings Steve Arrasmith and Carole Miller.*

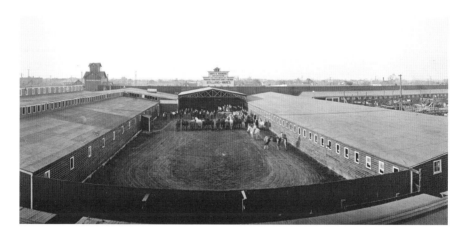

Panoramic view of the Bradstreet & Clemens Company sales plant, taken on November 1, 1913, for a print advertisement. Across Fourth Street is North & Robinson, importers and breeders of Percheron, French Draft, Shire and Belgian stallions and mares. *Courtesy of the Thomas Bradstreet family, via great-grandchildren and siblings Steve Arrasmith and Carole Miller.*

Born on March 20, 1882, in Grand Island, Arthur was the youngest son and child of Fred (Fritz) and Magreta (Rief) Langman. He was named after Chester Alan Arthur, an American attorney and politician who served as the twenty-first president of the United States from 1881 to 1885. Soon

after Arthur's first birthday, a "shuddering mishap"[166] claimed the life of his mother on May 25, 1883. In the early days, before waters from the winter melt of the Rocky Mountains were dammed, or bottled up, for irrigation purposes, the spring pilgrimages of the Platte River became a continual source of worry for Nebraska homesteaders and others who had settled near its banks.[167] After most winters of snow, sleet and ice in the far west, the spring thaw would race through the Platte River and slowly subside into smaller outlets.

But then came the spring of 1883. Rains swelled the swift-moving water over the banks and into the Langman homestead. Fred was away at the family's Prairie Creek farm, which was northwest of Grand Island. Meanwhile, pools of water entered Magreta's kitchen and engulfed the out barns, damaging large quantities of hay and separating mother cows from their calves. Seeing the Langmans' hired man, Hans, across the opposite bank, Magreta quickly gathered her young children and placed them on the highest spot away from the river she could find. Turning her attention back to Hans, she trudged back toward the river and to a small boat and ferry, grabbing the attached rope to maneuver herself to the other side. Then, something broke![168] The boat bounced and capsized, tossing Magreta into the plunging waters and sweeping her helpless body downstream. It wasn't until four months later in June that someone found the skeleton of a human body on a sandbank near Columbus. On the third finger of the hand was a ring bearing the inscription, "Fritz to Magreta."[169]

Bringing her remains back to Grand Island, Fred was able to inter her there and begin facing the reality of caring for his three motherless children. Margaret (Magreta) Catherine Rief Langman, twenty-eight years old at the time of her death, left behind her husband, who was born in Parchin, Mecklinberg, Germany, on May 2, 1850, and three children: oldest son, Frederick, eight; daughter, Caroline, four; and Arthur, the youngest at one. Fred came to America in 1866.[170] At sixteen years old, he worked for two years in the coal mines of Scranton, Pennsylvania, with his brother, John, before striking out on his own and moving to Davenport, Iowa. In 1869, Fred became one of the first homesteaders to Hall County and started farming south of Grand Island near the Platte River. He had married Margaret on April 12, 1874. After her passing, he married Miss Ida Krueger in 1885. Fred continued to live and work on his homestead until 1908, when he retired to Grand Island and lived at 407 West Koenig Street until his death on December 27, 1924.

Photo of the Fred "Fritz" Langman (*seated second from right*) family, circa 1905. Arthur Henry Langman, Fred's youngest son with his first wife, Margaret (Magreta), is pictured standing behind him. Arthur's full siblings, Caroline and Frederick C., are pictured seated on opposite sides of their father. Fred married his second wife, Miss Ida Krueger, in 1885, after Magreta died in a tragic drowning accident in 1883. *Courtesy of the Scott Langman (grandson of Arthur H. Langman) family, Billings, Montana.*

Arthur spent the rest of his childhood working on the eighty-acre Platte River farm with his father and siblings. His brother, Fred C., served as the clerk for the Hall County Court for ten years before moving west to Potter, Nebraska, and opening a garage. Sister Caroline married J.L. Converse, a traveling salesman. The two lived in St. Louis before he died, and she moved to South Pasadena, California. Caroline became a writer and founded the Pasadena Branch of the National League of American Pen-Women, among numerous other clubs. In her 1949 book, *I Remember Papa*, she assembled and recounted the early trials and hardships that early Nebraska pioneers like her father endured when they came to America and built up the communities in which they lived. She grew up with an unforgettable love for the prairies.[171] She described her younger brother, Arthur, as growing up "to become a good looking chap" who earned money by helping neighbors with chores so he could acquire a horse and buggy.

About Nebraska, Converse included the words of Gilbert L. Cole from his book, *In the Early Days Along the Overland Trail in Nebraska Territory, in 1852*: "It has been said that once upon a time Heaven placed a kiss upon the lips of Earth and therefrom sprang the fair State of Nebraska."

In her own words and from the 1963 book *Island in the Prairies*, Caroline dedicated her pages to Grand Island, Hall County, Nebraska, and to her "Papa," as well as to the glorious era of work and hardship in which he lived:

> *My pioneer father, I see him now,*
> *Following the furrows of the plow.*
> *The rich black earth, the virgin sod,*
> *Acres in escrow held by God,*
> *Shaping a land's posterity,*
> *Filling his role in destiny.*

The Founders of the Grand Island Horse and Mule Market

After leaving the Platte River family farm, Arthur H. Langman delivered groceries for Frank Olson's store. He met folks who were engaged in selling horses and found himself entering the business. The November 9, 1906 *Grand Island Independent* included this announcement: "Arthur Langman will resign his post at Olsen's [*sic*] store and will take a position with Bradstreet & Clemens at their large sales stable now being erected. He will attend to the bookkeeping, etc., of the firm."

Within a month, Langman was making trips to Cairo to buy horses from the North & Robinson sales and bringing his purchases to the Bradstreet & Clemens market in Grand Island.[172] By 1907, North & Robinson had moved its sale barn from Cairo to Grand Island, across from the Bradstreet & Clemens Company barns. With its business partner and bookkeeper in place, the firm of Bradstreet & Clemens continued to increase its sale numbers and barns. Bradstreet capitalized on its horse-dealing potential by establishing six independent commercial sales operations on East Fourth Street. From 1906 to 1912, it sold 82,236 head of horse and mules, making its average nearly 12,000 head per year. The barns were built between East Fourth Street and the Union Pacific Railroad tracks, with loading chutes accessible for ease of shipments. Some barns could hold twenty-five carloads of horses or more.[173] With the rapid growth, one can only imagine the amount of bookkeeping required

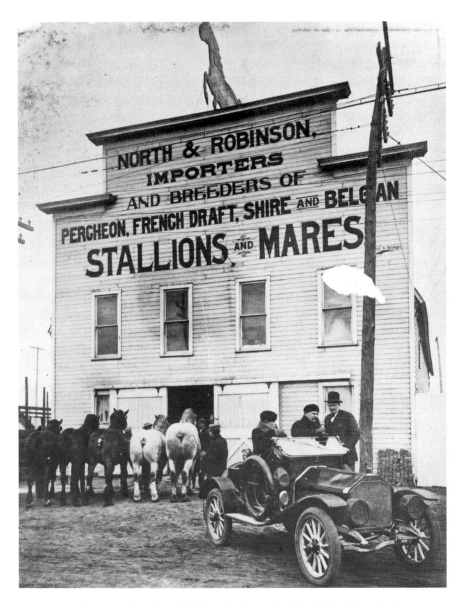

Operated by Chauncey North and William Robinson, the North & Robinson business gained a national reputation for breeding and importing quality workhorses. In 1907, the men built their business on Fourth Street in Grand Island opposite the equally successful horse and mule dealers of Bradstreet & Clemens Company. To set themselves apart, they hired local craftsman Henry Faldorf to construct a big, black stallion advertising icon that stayed on top of the building, serving various markets, until December 2004. *Julius Leschinsky Studio Collection, courtesy of Stuhr Museum of the Prairie Pioneer.*

for twenty-five-year-old Langman to manage—and the opportunity he saw to manage a horse sale barn of his own.

History of Hall County, Nebraska authors August F. Buechler and Robert J. Barr wrote that Langman's contribution to his business interest and success could be credited back to his native Grand Island for his upbringing, schooling and residence:[174] "The business success that has made his name so widely known, has been secured by persistently following an industrious path in a common sense way, making use of the practical talents that nature bestowed and with good judgment never assuming responsibilities too heavy to carry."[175]

With good horse sale managers, marketers, bookkeepers and rail transportation to and from Grand Island, the questions remained, "Where did all these horses come from? Who were all the people buying these horses? Where did all these people come from?"

For starters, U.S. Army cavalry officers were detached periodically to purchase horses for their respective regiments. At the beginning of the twentieth century, the army recognized that securing suitable cavalry and artillery mounts proved difficult, as the market for riding horses was in a slump and ranchers had stopped breeding their mares.[176] Both the army and the U.S. Department of Agriculture (USDA) feared that the American riding horse was in danger of disappearing. In 1907, Major General James B.

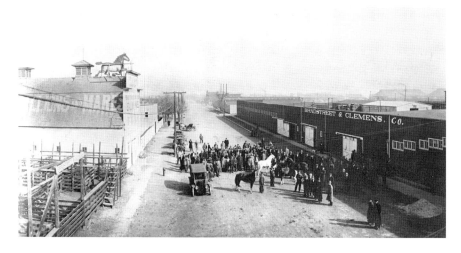

Front view of the Bradstreet & Clemens Company sales plant, taken on November 1, 1913, for a print advertisement. On the left side of Fourth Street is North & Robinson. *Courtesy of the Thomas Bradstreet family, via great-grandchildren and siblings Steve Arrasmith and Carole Miller.*

Aleshire, the quartermaster general, established the Army Remount Service to create an efficient breeding program and train personnel in handling the animals for future mobilization. Before World War I, the first remount depot station was established at Fort Reno in central Oklahoma. Others that followed included Fort Keogh in Montana and Front Royal in Virginia. By 1919, the War Department had established a quartermaster remount depot at Fort Robinson near Crawford.

Norman Bruce Critchfield, secretary of agriculture for the Commonwealth of Pennsylvania, with the help of Carl W. Gay, director of horse breeding, issued Bulletin No. 181, *Timely Hints to Horse Breeders*, across his state in the hopes of helping farmers and stock breeders of stallions and brood mares with their profit margins, programs and marketability. "It is a fact known to all persons giving the matter any attention, that Pennsylvania falls short of producing the number of horses needed for service in the State," Critchfield led in the preface of the 1909 bulletin. "This condition exists in regard to both draft and driving horses."[177]

Additionally, there was little to no economical mechanized transportation for Nebraska's travelers, town residents or farmers for plowing. Horses were still the most reliable and demanded source of power. The *Grand Island Daily Independent* reported on Tuesday, February 7, 1911, that horses and people were coming to the city from everywhere. Every railroad centering in Grand Island leading up to "Tuesday—Horse Sale Day in Grand Island," had been bringing horses in by the carload. An air of unusual activity surrounded the unloading chutes, with shipments destined for New York, Mississippi, Alabama, Tennessee and Pennsylvania:[178] "There is a fascination about one of these big stock sales that is irresistible. The enthusiasm is infectious and whether a man is a buyer or not he becomes submerged in the swim and is carried away with the general excitement inspired by the oratory of the auctioneers, the parenthetical remarks of the owner who is posted on the qualities of the animal offered."[179]

While states like Virginia and Kentucky remained known for their Thoroughbred racers, horsemen east of the Mississippi River, like the army's procurement purchasers, looked west for the sturdy, stout and stocky draft horse breeds to bring power to the farm equipment. Buyers and purchasing agents, like John Washington Torpey, traveled to all the major markets in East St. Louis, Illinois; St. Paul, Minnesota; Chicago; Kansas City; Omaha; and Grand Island. From 1902 to 1908, Torpey worked for the Ivins C. Walker's Sales Stables on Valley Forge Road near Norristown, Pennsylvania, searching for well-bred working horses and cattle. Torpey had

Before transitioning to the horse and cattle buying business, John Washington Torpey of Radnor, Pennsylvania, enjoyed a favorable career as a steeplechase jockey. *Courtesy of the John Torpey family.*

transitioned into the horse and cattle buying business after a favorable career as a steeplechase jockey.

Both Torpey and the sport of horse jumping can trace their lineages back to mid-eighteenth-century Ireland. Born in Delaware County, Pennsylvania, near Philadelphia on February 22, 1870, Torpey was the third of five sons to William and Ellen (Lee) Torpey. His parents were natives of Ireland but were brought to the United States as children.[180] Torpey attended and completed public school in nearby Radnor, Pennsylvania, before becoming an expert horseman and jumper.

Torpey's travels west eventually led him to Columbus, Nebraska, where he met and entered into a partnership with A.C. Scott and opened the Green Front sales and feed yard in 1910. With the horse market numbers continuing to increase, Torpey and Scott made their move to Grand Island, where other livery stables, feed stores, horse dealers, blacksmiths and harness shops opened close to the Union Pacific Stockyards and along East Third, Fourth and Fifth Streets. Early businessmen, like John Fonner, opened the American Feed, Livery and Sale Stable.

By March 18, 1912, Arthur Langman had already left his bookkeeping position at the Bradstreet & Clemens Company, where he was in a partnership

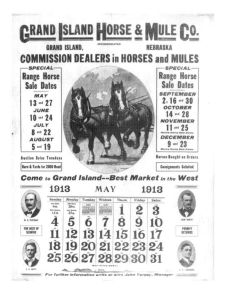

A Grand Island Horse and Mule Company calendar poster advertisement from May 1913, which included photos of founders John W. Torpey (*top left* portrait) and Arthur H. Langman (*bottom right* portrait). The two businessmen remained friends even after Langman moved to Billings, Montana, and founded Billings Livestock Commission in 1934. The poster was owned by Joe Christie and given to Raymond Beckler, foreman of the Grand Island Livestock Commission. *Courtesy of the Ed Beckler family, Cairo, Nebraska.*

with the I.C. Gallup Horse and Mule Company.[181] But by November 1912, a newly formed team comprising W.S. Fletcher of Loup City, Arthur H. Langman as president, John W. Torpey as secretary-treasurer and A.C. Scott as vice-president had founded and opened the Grand Island Horse and Mule Market at 607 East Fourth Street. William I. Blain served as auctioneer. However, Fletcher only appears to be included on early advertisements in 1913, and a Grand Island Horse and Mule Company letterhead only lists Langman, Scott and Torpey as proprietors.

In 1910, Langman married Miss Daisy Heffeifinger. By February 1914, Langman appeared to have left his position at the Grand Island Horse and Mule Market Company to operate individually back at Bradstreet & Clemens and to pursue other business opportunities in Grand Island leading up to the start of World War I. They had one son, Arthur Jerome (Jerry), who was born on August 24, 1918. Jerry was baptized on January 25, 1919, at Grand Island's St. Stephen's Episcopal Church at 422 West Second Street. Sometime in the 1920s, the Arthur H. Langman family moved to the Denver, Colorado area, where Arthur became president of the Walker-Langman Land & Live Stock Company of Elbert County. They eventually moved to Billings, Montana, in 1934 to open Billings Livestock Commission, which remains open today and has gained the national reputation of hosting America's largest monthly horse sale.

Meanwhile, at the onset of 1914 and leading up to the start of World War I, on July 28, Torpey and partners made strong, steady progress. While the Bradstreet & Clemens Company held its horse sales every Monday, the Grand Island Horse and Mule Market held its sales on Tuesdays. Both owners advertised in the *Grand Island Independent* with similar to nearly

A front and back view of a 1913 watch fob from the Bradstreet & Clemens Company. The back side denotes all the horse and mule market sale dates for the year. Watch fobs often were given to buyers as trinkets from the sales. This one belonged to Frank Hummel, a partner of the Horse Shoe Livery, Feed & Sale Barn in Gordon, Nebraska. Hummel's granddaughter Cher Maybee of Scottsbluff found it in a trunk of her grandfather's possessions. *Photos taken by co-author Jody L. Lamp.*

identical advertisements, appealing to buyers and consignors to come to Grand Island. It was the perfect location for farmers, ranchmen and horsemen to sell their horses at satisfactory prices to eager buyers. In the note to potential customers, Torpey stated:

> *When you want to buy or sell Horses or Mules, come to the BEST MARKET in the world, The Grand Island Market, and trade with a Commission Company that is second to none. The Grand Island Horse & Mule Company, an incorporated company who devote their entire time to the interest of the horse and mule business, and are now selling more horses and mules at public auction than any other commission firm in the United States.*
>
> *When you ship your Horses and Mules to us, you are shipping them where you get the best possible service and highest market price for your goods.*
>
> *When you come to our sales to buy, you come where you get good value for your money and go away satisfied that you have been treated right and got what you wanted at fair prices.*

We have Auction every MONDAY AND TUESDAY and always have from One Thousand (1000) to Sixteen Hundred (1600) head for our weekly sales.

Write or wire us at any time or telephone 903.
JOHN TORPEY, General Manager.

The World War I Years

For the next six years, the Grand Island Horse and Mule Market saw tremendous growth. Just as Omaha had been an attractive location to build cattle stockyards for Wyoming cattlemen in 1884, Grand Island had become Nebraska's "Third Largest City" and was rapidly on pace to becoming home of the "World's Largest Horse & Mule Market." The *Grand Island Independent* continually reported on the number of horses being brought in and shipped out by the train carloads to various locations east of the Mississippi. On January 7, 1914, the front-page newspaper headline read, "WEEKLY HORSE TRAINS STARTED. Special Will Leave Every Tuesday Night for Chicago. BIG THING FOR HORSE SALES."[182]

For the first time in the history of the horse and mule marketing business in Grand Island and anywhere west of that point, weekly trains would be designated to leave every Tuesday night after the sales of the Bradstreet & Clemens and the Grand Island Horse and Mule Company for Chicago. The last horse was sold at 7:30 p.m., and by 9:15 p.m., the first special shipment on January 6, 1914, was loaded to include 475 horses, equaling twenty train carloads, representing $75,000 worth of cargo. In addition, another ten carloads of horses were being shipped out and were destined for locations including Montgomery, Alabama; Buffalo, New York; Memphis, Tennessee; Merry Oaks and High Point, North Carolina; Fort Worth, Texas; and Oklahoma City, Oklahoma. "At no sales center in the country can horses be bought and shipped out in such short order as they do here. For the year 1913, 23,922 head of horse were actually sold here."[183]

The easy railroad access helped fulfill orders for the large demand of horses and mules necessary to supply the French and British armies during World War I. War horse buyers flocked to Grand Island. Nine months into the war, British colonel George Holdworth and his representatives attended the Monday sales to "buy up all the horses" and have them shipped to Canada. However, captains and majors from the Italian army were registered at the

nearby Koehler Hotel with horse buyer agents from Oklahoma with the same intentions.[184]

By October 1915, the "big news" on Grand Island's East Fourth Street markets was that Thomas Bradstreet had acquired the total interest of the Bradstreet & Clemens Company and now shared ownership with his two sons, Archie L. and Deo Bradstreet. William I. Blain had served as the auctioneer for the Grand Island Horse and Mule Market since its opening in 1912. In November 1915, Blain, Bradstreet and Will R. King filed articles of incorporation to form the Blain Horse and Mule Commission Company, which held auctions every Tuesday and Wednesday.

Cattle were now beginning to enter some of the Grand Island market sales as more of Nebraska's prairie was being turned into farmland. The practice of "feeding out" cattle for the eastern markets became more profitable, and the demand for feeder cattle grew.[185] Cattle had been part of Nebraska's landscape since after the Civil War when Texas cattlemen brought their herds north to the railheads of the Great Plains and "cow towns" like Ogallala. But in Grand Island, the cattle were still sold by the head instead of the pound, which usually was a good deal for the buyer but not the consignor. Horses remained the most profitable transaction for the sale barn owners.

Advertising sign of the Blain Horse, Mule & Cattle Commission Company, in Railroad Town at the Stuhr Museum of the Prairie Pioneer, Grand Island. *Photo taken by co-author Jody L. Lamp.*

The biggest contract to purchase horses and mules from the Grand Island markets came from the French government and army agents, the same day that U.S. President Woodrow Wilson opened a "Preparedness Movement" program, a campaign to strengthen the U.S. military after the outbreak of World War I.[186] On January 27, 1916, John Torpey, president of the Grand Island Horse and Mule Company, closed a contract with the Hilliker-Simpson & Smith Company for fifteen to eighteen thousand horses to be shipped directly from Galveston and then sent across the Mediterranean Sea to southern France:[187] "The papers for this contract are at hand and ready to sign and the deal is one of the largest ever to be signed of the kind."[188]

The Union Pacific train leaving Grand Island, Nebraska, that winter day in 1916 bound for the Texas seaboard consisted of thirty-two cars filled with the shipment of horses and eight hundred head of mules. This transaction was the beginning of increased demands of horses and mules from the French and British governments—the United States' allies soon erected temporary yards in Grand Island to handle the purchase and shipments from there.

By this time, Bradstreet and Torpey had sent twenty-three-year-old Joe Christie to scour the United States to round up, buy and often sell horses on behalf of their commissions before even returning to Grand Island. His travels took him as far as Montana to New York and in between to the unpopulated South Dakota Badlands, which proved to be a mecca for hundreds of wild horses. With little to no human contact, the horses were rank at best. Christie noted that it was not uncommon for him and the other yard hands to handle four thousand head a day.

The horses were classified as to size or "hands"—one hand equals about four inches. A uniform price per head was established for three categories: an artillery horse was fifteen to sixteen hands high and weighed between 1,500 and 1,600 pounds; a cavalry horse was fourteen to fifteen hands high and weighed about 1,100 pounds; and a Cobb, which was used for a riding horse, was between fourteen and fifteen hands but weighed less than 1,100 pounds.[189] Every cavalry horse was ridden for inspection by the British government but ran the risk of rejection if it appeared too much of a "bronc." "These horses weren't being bought for their bucking ability," Christie wrote. "The British weren't interested in how well we could ride a bucking horse; they wanted horses that didn't buck."[190]

Christie's horse riding and handling ability impressed the British officers, and he was eventually offered a job at the same wages Torpey had been paying him. To keep good relations, Torpey advised Christie to take their offer. The horses were kept at the old Union Pacific Stockyards on the

far east end of Fourth Street until they could be sorted and loaded into stock cars and railed to the coastal harbors for shipment to England.[191] Christie noted that other authorized British buyers were purchasing horses and mules from markets farther west, but any livestock traveling east came through Grand Island. His new job was to feed, sort and prepare all the horses for shipment.

The Taylor Ranch

For we ourselves, and the life that we lead, will shortly pass away from the plains as completely as the red and white hunters who have vanished from before our herds. The free, open-air life of the ranchman, the pleasantest and heartiest life in America, is from its very nature, ephemeral.[192]
—*Robert Taylor, April 12, 1905*

Wet summer weather in 1915 in central Nebraska forced the British army agents to move 2,700 horses and their operations from the ten pastures to nearly four sections of the Robert Taylor Ranch, about six miles northwest of the existing Veterans Hospital in Grand Island, along the Burlington Railroad tracks, marked the "Taylor Spur."[193] The Burlington Railroad built the switch to the ranch in 1897, making it a regular stop on its line. Christie and the men who helped him care for the British army horses lived in the bunkhouse three and a half miles north of the main Taylor Ranch headquarters.

A native of Scotland who immigrated to the United States at eighteen in 1865 on a cattle boat,[194] Robert "Bob" Taylor settled in Hall County in early 1890, purchasing 160 acres one mile east of the small Hall County village of Abbott. He was already known as one of the most successful wool growers in Wyoming and served in the state senate twice. Located in Section 32 of Prairie Creek Township, the new headquarters for the Taylor Ranch had once belonged to Eli Barnes, a Union army veteran, and later D.R. Castiday of Medicine Bow, Wyoming. Taylor's purchase of the Castiday ranch was the first of many Nebraska land acquisitions.[195] As Taylor established his sheep breeding stock in Hall County, he also purchased up to 18,000 acres of farmland in southwest Nebraska's Perkins County. By 1895, Taylor's Hall County Abbott ranch had grown to 1,600 acres. He continued improvements by building a thirty-thousand-bushel elevator for loading, unloading and storing grain.[196]

Housing and raising productive stock required an ample food supply. Sheep ranches and wool growing had been the center of California agriculture in 1860s, when Taylor served as a shepherd at one of the largest operations in the Sacramento Valley. It was there that he learned the cultivating skill of producing alfalfa in sandy, well-drained soils, into a high-quality protein and calcium-dense livestock feedstuff. Northern Hall County, south of the Loup River, contains upland, sandy hills called "the bluffs" that many homesteaders settled but later abandoned. Taylor purchased many of the abandoned farms after the drought of 1894 and started growing alfalfa there. He had purchased the Hall County land not from the homesteaders but from Grand Island merchants, who had acquired the title to the land from men who bought it from the original settlers.[197] By 1902, Taylor was planting 1,500 acres of alfalfa on his Hall County ranch. Harvesting the hay required thirty full-time men and forty teams of horses.[198]

The Taylor Ranch had long attracted statewide and national attention. A month before President Theodore Roosevelt broke ground on the new Carnegie Library in Grand Island on April 27, 1903, the president had requested that Grand Island's city fathers organize a twenty-five-mile horseback tour of the county so he could travel the countryside. They chose Taylor, an expert horseman, to be accorded the place of honor next to President Roosevelt on his ride.[199] Roosevelt, Taylor and accompanying dignitaries traveled by horseback to several Hall County pioneer homes before stopping for a "dainty luncheon" prepared by Mrs. Agnes Taylor in the parlor at the Taylor Ranch. Mrs. Taylor had given birth to the couple's fourth child—a daughter, Grace—just eighteen days before the president's visit.

It was reported the next day in the *Grand Island Independent* that during the lunch, President Roosevelt was advised that a "crowd of nearly three hundred citizens from various distances" had ascended to the Taylor Ranch to catch a glimpse of him.[200] Lunch being concluded, the president paid his compliments to Mrs. Taylor and her help and greeted the assembled crowd from the Taylor porch. With that kind of western hospitality, it's no wonder that Taylor's prominence grew as a leading livestock producer in Nebraska and America. By 1913, Taylor owned seventy-five thousand acres, 65,000 range sheep, 3,000 steers, 700 cows, 400 horses, 340 Aberdeen Angus cows and 250 Shires and Clydesdale horses.[201]

As Joe Christie's time at the Taylor Ranch came to a close, his horse handling and work experience with the British officers led to another job offer as their time in the Grand Island area expired. The next assignment would have taken Christie to Egypt, but he politely declined to work as the foreman

This page: At the intersection of NE Highway 2, 6000 West and 60 Road 3200 North, these two barns still stand today in Hall County as reminders of the Robert Taylor Ranch. *Photos taken by co-author Jody L. Lamp.*

for William Blain at the newly changed business name of the Blain Horse, Mule & Cattle Company. Also in business with Blain, Thomas Bradstreet had acquired and was tearing down the old North & Robinson building to erect a new sales barn that would feature a heated auction ring. This was welcome news for the regular cattle and horse buyers and consignors in the winter of 1917, although central Nebraska's humid, cold weather never seemed to curtail the sale numbers.

Becoming the World's Largest

One of the most notable horse sale consigners for the Grand Island Horse and Mule Market was Albert McMindes, owner of the Livestock Auction Sale Barn in Ord. McMindes would travel more than sixty miles southeast to bring train carloads of horses and mules to Grand Island for purchase and shipment. When the remarkably heavy "war sale" period of 1916–17 had passed and by the time World War I ended on November 11, 1918, the Grand Island Horse and Mule Market business began its next cycle. It was just a matter of time before the Fourth Street market's wooden sale barn structures and the proximity of the livestock's feeding supply destructively mixed. On Sunday morning, June 9, 1918, sometime between 1:30 a.m. and 5:00 a.m., a fire was discovered on the north side of Fourth Street in horse barns leased to the Grand Island Horse and Mule Market. Listed owners of Torpey, Langman, Scott and the company endured an estimated $27,000 in damage, with twenty-seven animals perishing. Luckily for the other nearby barns, the wind had been from the west, which blew the flames and heat away from other businesses.

The livestock scene continued to change when Bradstreet in October 1919 expanded and diversified his leadership and business influence by being elected a Nebraska state senator and taking an active role in improving the facilities at the Soldiers Home in Grand Island.[202] As sole owner of the Bradstreet Clemens Company, he sold the name to the Blain Horse, Mule & Cattle Company for a reported $173,000 and decided to retire from the horse business for the time to pursue other interests. He pushed to save the Nebraska taxpayers about $1 million when he advocated that while the new state capitol building was under construction, the old building should remain intact.[203]

Meanwhile, the effects after the armistice began to leave cattle ranchers and speculators throughout the Midwest a supply surplus and no markets. During World War I, the U.S. government had guaranteed farmers high prices for their crops and livestock. More acres had been put into cultivation and herd sizes increased. The federal government ended its guarantees, and signs of the Great Depression began. When a shipment of 1,200 three-year-old longhorn steers arrived in Grand Island from Chugwater, Wyoming, they were met with no buyers.[204] Bradstreet's former business partners and friends—including Blain, Torpey and Christie—were forced to winter the steers until the spring of 1920.

Hard times continued, although it wasn't long before Bradstreet returned to Grand Island from Lincoln. On Monday, October 15, 1923, the *Grand Island Independent* reported in "The City in Brief" that the entire sale barn property on East Fourth Street—leased by the Blain Horse, Mule & Cattle Commission Company and the Grand Island Horse and Mule Company—was resold to Bradstreet and his two sons, Deo and Archie. However, Bradstreet made certain that Blain's business continued as usual, on a lease basis. Christie recalled that even during the years when cattle prices were low, the majority of the area's farmers still used horses for transportation and breaking farm ground. There was always a market for a good, broke mule, especially with British forces still occupying the area of Egypt. The horse and mule market, particularly in Grand Island, remained strong in the United States.

A consistent workforce of about fifteen men handled all the stock and the sixty acres along East Fourth Street necessary for the feed yards and grazing grounds. Always running a close second behind the livestock companies in St. Louis, it was reported that Grand Island finally surpassed the sales of its Missouri neighbor on Tuesday, November 24, 1924. The headlines declared that the Grand Island Horse and Mule Market was the "World's Largest Horse and Mule Market."[205] Each year since 1912, an average of fifteen

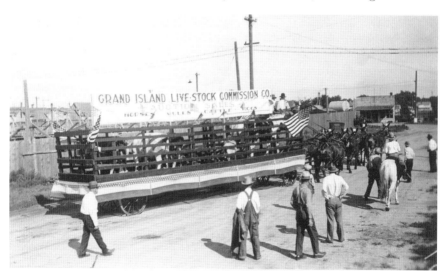

Participants gather to enter the Grand Island Livestock Commission float into a local parade. The signage advertises the sale of "Horses, Mules, Cattle and Hogs." The inscription on the picture indicates that John (Jack) W. Torpey is walking near the back of the float. *Courtesy of the John Torpey family.*

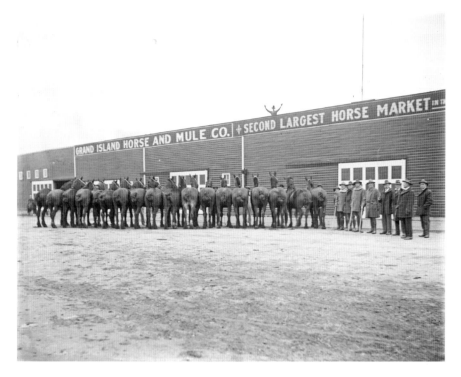

Always running a close second behind the livestock companies in St. Louis, it was reported on Tuesday, November 24, 1924, that the Grand Island Horse and Mule Company had finally surpassed the sales of its Missouri neighbor to declare that it was the "World's Largest Horse and Mule Market!" *Courtesy of Stuhr Museum of the Prairie Pioneer.*

thousand head of horses and mules had been distributed through Grand Island by the company. Livestock came from all over the United States and were shipped to markets all over the country and the world. During World War I, horse and mule traders and buyers wanted animals in large numbers, so they naturally came to Grand Island. Representatives from the United States, French, British, Italian and Belgian governments were buying stock in large quantities. Train carloads of horses and mules were shipped to South America and the West Indies.

Sales were held each Monday from January to June and each second Monday from June to January. At least five to six times a year, purebred horses, mules and cattle sales were held, which drew more locals and buyers from Nebraska. F.F. Simpson, a prominent mule dealer from Omaha, secured a contract to furnish about seven hundred head of mules for the British government from the Grand Island area. Colonel Gordon and Dr.

Gilbert of the British army arrived in Grand Island on Thursday, October 1, 1925, from East India to inspect the selection of about three hundred mules. It was noted that A.C. Scott of the Grand Island Horse and Mule Company had taken "particular pains in the purchase of these mules and nearly every one of the animals was accepted and would be loaded for shipment."[206] The officers reportedly returned the following week for the remaining shipment of mules. "The British government has been buying mules in this territory for the past three years, but this bunch is the best that the government has ever obtained," noted Colonel Gordon.

From Diversification to Consolidation

From yard help to aspiring auctioneer, thirty-three-year-old Joe Christie married Marion Webb on June 2, 1926, and enrolled in the Auction College at Kansas City. Returning to Grand Island, he partnered with Herman Henry to auction farm sales near Chapman. The Harry family brothers—Henry Jr., Bill and Herman, whose parents immigrated to the United States from Germany in 1884 and settled on a farm near Chapman—had long been involved with the Grand Island Horse and Mule Market both as auctioneers and business owners. The eldest, Henry Jr., became one of the leading auctioneers in central Nebraska. His reputation as an auctioneer far transcended mere local limitations, as he was called on to conduct livestock sales in other markets in Nebraska, Wyoming, Montana, Colorado and St. Joseph, Missouri.[207] Up until his death in 1923, Henry Jr. was retained continuously at the Grand Island Horse and Mule Company.

In 1931, Jack Torpey bought out the Blain Livestock Commission Company and organized the Grand Island Livestock Commission Company, consolidating the horse and mule, cattle and hog business under one institution.[208] At this time, Walter Carpenter joined the newly organized firm as vice-president. Others joining Torpey included R.L. (Bob) Lester as secretary and office manager, an experienced railroad traffic coordinator, and William J. (Bill) Harry, the firm's genial auctioneer and member of the Nebraska Livestock Auction Association.

Two years into the Great Depression, Colonel Jim Webb recognized an opportunity to start dabbling in the Grand Island livestock business. From 1921 up until 1931, he had only been a furniture auctioneer.[209] But on July 11, 1931, he put his investment into starting the Webb Livestock Commission Company on the west end of Second Street, near Highway

30 and the Union Pacific, Burlington, St. Joseph and Grand Island railroad lines. Cattle from all over Nebraska, Colorado and Texas were received at Webb's sales.[210] Within the first nine months of business, Webb Livestock boasted sales of 48,526 head of cattle, 30,996 head of hogs and 7,437 head of sheep, for a gross value of nearly $5 million. At the time, Webb served as the president of the Nebraska Auctioneer Association and Nebraska Livestock Auction Association.[211] In 1938, Wilbur Bachman, whose father had kept books for Jack Torpey and Bob Lester both, joined Webb. Always putting Grand Island first, Colonel Webb served as president of the local chamber of commerce in 1946, the same year he retired from auction work at the commission company due to poor health; he sold the interest of the firm to Bachman and Lester.[212]

A Torpey Tribute

Since arriving in Grand Island via Columbus, John "Jack" Torpey's leadership and influence in the horse and livestock industries continued to make a national and worldwide impact. Early on, his persona resonated with local buyers and sellers, and he befriended and mentored many of his clients, including an Aurora farmer and his son, Elwin and Marion Van Berg. With Grand Island being the nearest sale barn of significance to Aurora, the Van Bergs often took their horses and mules along a twenty-mile fence line procession to market either by riding or walking them.[213] Marion Van Berg spent his childhood to early adulthood on the Hamilton County family farm, keeping close business ties with Torpey. By the early 1930s, when the effects of the Great Depression reached central Nebraska culminating with a record drought, now thirty-seven-year-old Marion Van Berg looked for any opportunity to move his wife, Viola, and young family to nearby Columbus. "A seed of hope was planted in the mind of Marion"[214] when John Washington Torpey[215] discussed a venture of opening a sales barn there.

The mere suggestion of opening a competing sale barn only sixty miles away in Columbus could have come from none other than Torpey, who was twenty-six years Van Berg's senior. Torpey valued hard work and surrounded himself with those he trusted. He had operated a feed and sales yard in Columbus more than twenty years earlier with A.C. Scott after coming to Nebraska from Pennsylvania and sensed the potential for the town of seven thousand to have a well-run sales barn there. And he believed

Marion Van Berg was the man for the job.[216] Torpey introduced Van Berg to a local Columbus banker, and he soon found a building to lease in downtown Columbus on Twenty-Seventh Avenue between Tenth and Eleventh Streets.[217] At a time when most Platte County farmers and ranchers sold their livestock to the Union Stockyards at the Omaha Livestock Exchange, Van Berg's first year in business yielded few to no buyers and no profit. Defeated and near the end of his means and dreams, Van Berg drove to Grand Island to visit his good friend, "Jack" Torpey.

As the story goes, after hearing Van Berg's frustration and distressful story, Torpey leaned back in his chair, reached into his suit coat, taking out his checkbook, and said, "You're not broke," tossing the checkbook across the desk. "Go back to Columbus and try it again, Marion. And use my checkbook to buy anything you need to get that sale barn up and running."[218]

The intangible belief and confidence Torpey had in Van Berg proved bigger than the financial backing that was promised to him that day in the checkbook. Within a year and without the use of Torpey's checkbook, Van Berg's downtown sales barn and business expanded. On March 6, 1936, the operation was moved to Eleventh Street, and Van Berg Sales Pavilion was opened; it still remains today as the Columbus Sales Pavilion Inc. On June 7, 1936, Marion and Viola welcomed their ninth child, a boy, whom they named John Charles Van Berg and affectionately called "Jack" to honor John Torpey.[219] (*Authors' Note*: Marion Van Berg went on to operate one of the nation's most successful Thoroughbred horse racing stables from 1937 to 1970. He trained 1,500 winning horses, competing primarily at midwestern tracks and earning nearly $14 million in winnings. He was the first inductee of the Nebraska Racing Hall of Fame.[220] In the early 1950s, his son, Jack, joined him to break more national racing records. Jack's best horse was Hall of Famer Alysheba, the 1987 Kentucky Derby, Preakness Stakes and Breeders' Cup Winner and Horse of the Year in 1988. Jack was the first trainer to win five thousand races, and he won the Eclipse Award for Outstanding Trainer in 1984. Jack Van Berg was inducted into the National Museum of Racing's Hall of Fame in 1985.[221] Located in the Fonner Park Concourse in Grand Island, the Nebraska Racing Hall of Fame features the Jack Van Berg Collection, including trophies, photographs, stories and paraphernalia, such as saddles used by winning jockeys. Sculptures and figurines also are in the collection.)

The Grand Island Livestock Commission Company continued to hold its cattle, hogs and sheep sales every Monday and horse and mules sales every Wednesday. Starting on May 18, 1938, sixty-eight-year-old Torpey and his

GRAND ISLAND LIVE STOCK COMMISSION COMPANY

JOHN TORPEY
President

WALTER CARPENTER
Vice President

GRAND ISLAND, NEBRASKA

Auction Sales of Cattle, Hogs and Sheep Every Monday
Auction Sales of Horses and Mules Wednesdays

**HORSE & MULE
SALE DATES
1938**

•

WEDNESDAY

MAY
18

JUNE
1·15·29

JULY
13·27

AUGUST
10·24

SEPT.
7·21

OCT.
5·19

NOV.
2·16·30

DEC.
14·28

Oct. 7, 1938

Mr. Frank Slattery,
Caldwell, Idaho

Hello Frank:

 Your letter got here this morning.

 I was here last Monday and helped with your sheep sale. Your sheep sold very good. Ewes like yours at Omaha $3.65 per hundred. Don't let that sheep man kid you about what those old mammas bring on the market for $4.50 per hundred you can really buy a good one. About half those ewes would go for slaughter around $3.00 to $3.25.

 Well Frank I have not been getting along very good. I am around but not very useful. Have to stay in bed most o f the time. I can just walk around very slow and that is all, really should be in bed and have some one carrying me hot drinks, but seems good to be able to be around at all.

 The cattle trade is not so bad, good quality sells very good. A lot of cattle are being sold in the country for more than they would bring on any market. I am going to try and be here at each sale and do what I can so long as there is no work attached to it.

 Glad to hear from you at any time.

 Yours truly

JT:N

AUCTION SALES CATTLE AND HOGS EVERY MONDAY
HORSE AND MULE SALES EVERY OTHER WEDNESDAY

In a letter to his friend Frank Slattery dated October 7, 1938, John (Jack) W. Torpey shares with his friend the current state of the livestock markets in Grand Island, as well as his health. Less than two years later, Torpey would succumb to coronary thrombosis, a heart affliction, at the age of seventy. *Courtesy of the John Torpey family.*

livestock company held seventeen horse and mule sales through December 28 that year. Two days after the October 5 horse sale, Torpey wrote a letter to his fellow horseman and friend Frank Slattery of Caldwell, Idaho, who had recently moved from Grand Island, about the recent sheep market, cattle trade and his health: "Well Frank I have not been getting along very good. I am around but not very useful. Have to stay in bed most of the time. I can just walk around very slow and that is all, really should be in bed and have some one carrying me hot drinks, but seems good to be able to be around at all."[222]

Over the next year, Torpey reportedly suffered and survived a series of heart attacks. But on Monday, April 22, 1940, John (Jack) Washington Torpey Sr. died from coronary thrombosis, a heart affliction, at the St. Francis hospital in Grand Island. He was seventy years old. Relatives, friends and mourners from about forty states attended Torpey's funeral services at St. Mary's Cathedral in Grand Island.[223] One of Nebraska's best-known men in the horse and cattle business, Jack was active in the chamber of commerce and served various state livestock and marketing organizations as president. In his later years, he was active in legislation and regulation affecting truck transportation and had a financial interest in the operation and management of a market near Janesville, Wisconsin.[224] He also was one of the principals in a group that was planning the establishment of a packing plant at the old Grand Island Canning Factory.[225]

The following tribute about Jack Torpey appeared as is in the Tuesday, April 23, 1940 edition of the *Grand Island Independent*:

Jack Torpey

Boundless energy typified Jack Torpey, whose unexpected death yesterday came as a grievous shock to thousands of Nebraskan, who knew him through his 27 years in the livestock business in Grand Island. Mr. Torpey came to Grand Island in 1910 and went into the business of buying and selling horses and mules. During the World War, largely through his company, this became the second largest horse and mule market in the world. After the war he branched out and took in other livestock, but he continued to make Grand Island a notable point for trading in horses and mules. What made Jack Torpey a success in his chosen business was the thoroughness with which he knew it. It was impossible to delude him on livestock values. He was a judge also of human values, and surrounded himself with buyers in whom he had implicit trust. If a man ever betrayed that trust, Jack Torpey

Left: Portrait of John (Jack) Washington Torpey Sr., used in early advertisements when he served as the secretary-treasurer of the Grand Island Horse and Mule Company. In a tribute upon his death on April 23, 1940, Torpey was described as one of Nebraska's best-known men in the horse and cattle business. *Courtesy of the John Torpey family.*

Below: Even during the era when the Grand Island Horse and Mule Company earned the "World's Largest" title, Torpey continued to hold horse sales in his home state area of Philadelphia. This sale catalogue features the cover and inside cover details of the sale and is dated May 23, 1924. *Courtesy of the John Torpey family.*

was through with him. He could forgive mistakes, but not dishonesty. Mr. Torpey was a tireless worker. The vigor with which he attacked the many problems of the livestock business may have been a responsible agent in shortening his life, but he would have been unhappy and restless without plenty to do. His civic spirit was strong, and he had intense pride in and love for Grand Island. His death is a severe loss to the community in which he had lived so long.

"The Tails and Tales They Told on Tuesdays"

After John "Jack" Torpey's passing, his wife, Lillian, sold his interest in the firm. Torpey's sons, John W. "Jack" and Charles L. "Chick," were only twenty and nineteen years old, respectively, at the time of their father's death. They both served in the military before returning to Grand Island to enter the only business they had ever known. In 1945, when the Grand Island Livestock Commission Company firm moved to the western part of the city and took over the name of Webb Livestock, Jack Torpey Jr. joined Bachman as a cattle buyer before moving to California and starting his own business, Torpey Cattle Corporation. Brother Charles would later become vice-president and part owner of the Grand Island Livestock Commission.

Back at Fourth Street, a new business took over the former Grand Island Horse and Mule Company: the Harry Livestock Commission Company, owned by Bill Harry. Staying true to his father's legacy, Archie Bradstreet continued to own the barns and yards there, while Bill Harry owned the commission business. Bill Harry operated the business with his brother Herman up until his death on May 29, 1953, at age fifty-five. Herman took over as manager and auctioneer, and the business changed names to the Third City Livestock Company in 1957.

Being sick from school on Tuesdays seemed to be a commonality among some Grand Island youngsters whose parents attended the weekly sales. The unsuspecting parents soon realized that their children's ailments coincided with the days of the horse sales at Third City Livestock. Carol Harry Quandt remembered spending her childhood playing in the pens at the sale barn and working with her dad, Herman, brother and cousins. "It's just what we did," she recollected while sharing pictures of Third City Livestock and stories of learning how to write the checks out to the consignors after they sold their animals. "It's how we grew up."

Inside the sale barn at Third City Livestock, circa 1957. Pictured on the auction block (*left to right*): Bill Kirby, Clyde Karnes and auctioneer Herman Harry. *Courtesy of the Carol Harry Quandt and Allen Quandt, Clinton Harry, Jim Harrie, Don and Judy Harrie and Glenn Schwarz families.*

By 1954, tractors and cars were beginning to outnumber horses on Nebraska's farmlands and highways, and the steeds no longer served their purpose of pulling a plow or providing means for transportation. On Tuesday, December 1, 1959, a swift-spreading fire turned the block on East Fourth Street into a raging inferno. The fire destroyed three large barns, the historic sale ring, the Stockman's Café and thirty-five animal pens.[226] Up in smoke were the historic wooden barns, forever changing the cityscape and the street where the world once came to Grand Island.

What was left after the fire blew down in 1960, and by 1977, the Nebraska Livestock Auction Board had requested that the old Third City Livestock barn be replaced with a metal building.[227] Helen Bradstreet, daughter of Archie and granddaughter of Tom, instructed all but the cattle auction building on the north side be torn down. And what about the horse—the big black horse that had been "prancing on the roof of the Third City

Artist's rendition of the Harry Livestock Commission Company, formerly the Grand Island Horse and Mule Company. Bill Harry owned the commission business with his brother Herman Harry. *Courtesy of the Carol Harry Quandt and Allen Quandt, Clinton Harry, Jim Harrie, Don and Judy Harrie and Glenn Schwarz families.*

Livestock Commission Co." since the original structure had been built and had been part of the city's historic panorama for more than a century? He would come down, too. To honor the markets that he stood watch over until 2004, Grand Island's Black Stallion was donated to the Stuhr Museum and stands restored today in Railroad Town. Siblings Carole Miller and Steve Arrasmith offered it to honor their mother, Marian Arrasmith, and aunt, Hazel Tully, the granddaughters of Thomas Bradstreet.

Visit Grand Island's Fourth Street today and most locals would never know the many lives the markets touched daily a century ago when ten to fifteen thousand heads were being sold and shipped out on rails from the weekly sales. Imagine the French and British armies building stables there to accommodate their purchases. Think about the economic impact the markets made, not only in the city where they were located but also throughout the markets in the United States and in countries around the world. From the owners and their families to the office managers and auctioneers, the yard help (who were often family members) and the brand inspectors, consignors and buyers, Grand Island's horse and mule markets

now rest in the history books. The dedication that so many gave created a thriving economy for a city growing up.

This narrative is a tribute to their stories and the lives of the founders and family members who kept the markets alive. While we may never see another livestock market in Grand Island again, we can be sure that all the horse and mule, hog, sheep and cattle sales of the day provided a social fiber in the fabric of the community that will never go away. The markets brought multiple business opportunities and supported the livelihoods of hardworking, stockyard-savvy individuals who affected generations that continue to reminisce and share their experiences.

Go to the 1890s Railroad Town at the Stuhr Museum and visit Grand Island's Black Stallion. Visualize how this large wooden and tin iconic figure, built by local craftsmen Henry Falldorf and Louis Detlefsen, towered over the Fourth Street markets to become one of the city's most identifiable advertising symbols. Next, follow the signs northeast to downtown toward the Burlington Station. The renovated train depot at Seventh and Plum Streets, formerly the Plum Street Station and now owned and maintained by the Hall County Historical Society, is listed in the National Register of Historic Places. Picture yourself as a horse and mule buyer coming to Grand Island in 1911 from Chicago, Kansas City or East St. Louis on the Burlington & Missouri River Railroad on the city's east side to see the newly built red-

To honor the markets that he stood watch over until 2004, Grand Island's Black Stallion stands restored today in Railroad Town at the Stuhr Museum. *Photo taken by co-author Jody L. Lamp.*

stone brick structure that replaced the wood-frame depot. Now make your way over to Fourth Street, where the world once came to Grand Island. The buildings that hosted the sales have vanished, but listen closely and you'll begin to relive those days to the point of hearing the auctioneer's cry and the marching band play, just like it was back in the days of Bradstreet, Clemens, Torpey, Scott and Langman.

As historians, we have spent years reading, researching, traveling and listening to the stories and know that it was time well spent. Meeting so many of the individuals who had a direct connection to the markets reaffirms that the legacy of the World's Largest Horse and Mule Market needs to be preserved for generations to come. We are indebted to all those who shared their stories, memorabilia and time to give us insight into a piece of Nebraska's agriculture history that is etched in our memories but forever gone. As Joe Christie noted in his *Seventy-Five Years in the Saddle*, "Over the years I have seen a great many changes take place in the growth of the livestock industry in Grand Island, and I have seen a great many good men come and go. To me, the names of Bradstreet, Torpy [*sic*], Blain, Webb, Wilbur, and Lester are synonymous with livestock. These men have long ago passed out of the picture, but their memories linger on."

The Lockwood Grader Company

Directed by Fred and Carol Lockwood of Scottsbluff, the Lockwood Foundation supports western Nebraska projects and continues the legacy of Fred's father, Thorval John (T.J.) Lockwood, who founded the Lockwood Grader Company in 1939 and spearheaded the drive to mechanize the U.S. potato industry.

Known for his mechanical genius and numerous patented potato inventions, T.J. Lockwood started and expanded his western Nebraska business from its humble beginnings in Gering to regional facilities across the United States, Canada, Holland and England. In 1950, Lockwood was the first company to introduce a successful pull-type PTO harvester. A life cut short, T.J. Lockwood passed away on August 7, 1957, his forty-fourth birthday, just six months after being diagnosed with a brain tumor.

Noted in his memorial tribute, T.J.'s one firm conviction was that the following rule would apply to any home or business and make it prosper: "On my honor I will do my best to do my duty to God and my Country

16 Good Rules FOR MAKING A SUCCESS IN BUSINESS

1. THE FIRST JOB is to develop the character and talents and Christian thinking of your employees, and they will make your business prosper.

2. EVERY PERSON can be a teacher to his fellow man by setting an example of Christian living that is above reproach.

3. PLACE SERVICE to your associates above personal gain, and their responsiveness will, in turn, bring a great success to you.

4. ANY DECISION that must be made, can almost always be right if one disregards his personal gain, and does what he honestly feels is right.

5. DEAL FAIRLY with men and they will be fair to you. Only thus can justice prevail, and helpful cooperation becomes a fact.

6. THINK OF OBLIGATIONS as of primary importance, and your rights as secondary, and you will win the faith and confidence of your associates which are the first essentials of success in business.

7. HAVE THE RIGHT KNOWLEDGE of your liberties, the right to do with your possessions only those things which will help your fellow man as well as yourself. Only thus can you be sure of continued freedom.

8. YOUR PERSONAL POSSESSIONS and what you control are only as a trust and yourself as an administrator, only for the good of men and glory of God thus only shall your wealth bless and not curse you.

9. CULTIVATE THE RIGHT ATTITUDES in your living. Dominate things, but be kind and considerate, helpful, in human relations. Worship God in His teachings and thus you avoid friction and worry.

10. GREATER ACHIEVEMENTS are obtained in spiritual thinking, in faith, confidence, intelligence, ambition, character, creative capacity, joy in service, which are far more valuable than lands, machines, and material possessions.

11. ASSUME YOUR RESPONSIBILITY to your schools, community and church, youth fellowship. It is your small way of repaying what others have already done for you.

12. IF SOMEONE RECOMMENDS a person or material thing for some certain use, then it is your responsibility to report to them results at a future date that is beneficial for all. Difference of opinion must be honored for each person, as time alone will give the correct answer.

13. ACCEPT THE PHILOSOPHY of Christ in thinking, your true belief, and without thought of gain for your personal self. "Seek ye the glory of God and his righteous way of life, and all these things shall be added unto you."

14. BE A TRUE BROTHER to your employee and fellow workers, and there will be wonderful teamwork under your leadership.

15. NO ONE HAS AUTHORITY or position in business. The only basis for consideration is ability to cooperate with your fellowman.

16. DO NOT HARBOR IN YOUR MIND that if you fail you have a good excuse. The answers to any question are available to all who have the courage to follow them.

— T. J. LOCKWOOD

— 2 —

T.J. Lockwood's 16 Good Rules for Making a Success in Business.

and to obey the Scout law; to help other people at all times; to keep myself physically strong, mentally awake and morally straight."

Fred, T.J. and Margaret Lockwood's oldest child and only son, reminisced about the seventeen years he had with his dad. "He never drank, he never smoked, he never cussed and you definitely never did those kinds of things around him. My father was the biggest influence in my life. I spent my entire

Thorval John (T.J.) Lockwood founded the Lockwood Grader Company in 1939 in Gering and spearheaded the drive to mechanize the U.S. potato industry. In the background is the Scotts Bluff National Monument. *Courtesy of the Legacy of the Plains Museum, the Lockwood Collection.*

childhood traveling this country and the world wherever potatoes were grown. That's just what we did with Dad."

"I always dreamed of going back into the family business," Fred said from his FALCO accounting office in Scottsbluff. "But I guess fate had other plans."

Fate had many plans for T.J. Lockwood and his ancestors, whose history has been traced back to the mid-1600s. However, for the purposes of Nebraska's agriculture history, we will only recall some accounts from more than two hundred years ago to introduce T.J. Lockwood's great-great-grandfather John Caleb Lockwood, who was born on August 25, 1811, in Kent County, Delaware. Since before the Civil War years, the Lockwood family and their relatives the Dodge brothers, Nathan Phillips and Grenville Mellen, made significant contributions to the development of Nebraska's agriculture and transportation, respectively.

T.J. was born on August 7, 1913, to Alfred John Dodge Lockwood and Harriett Elizabeth (Lawrence) in Albion, Nebraska. His grandparents Alfred Oliver Lockwood and Mary Vesta Lockwood were known among some of the earliest settlers of Boone County, which was named in honor of Kentucky pioneer and hunter Daniel Boone.[228] T.J.'s great-grandfather Alfred Oliver, the father of Alfred John Dodge, was the fourth child of John Caleb and Susanna Wilson (Mitchell) Lockwood. He was born on December 17, 1841, in Middletown, Delaware, but was reared and educated in Odessa, Iowa. John Caleb Lockwood married his wife, Susanna Wilson Mitchell of Philadelphia, on June 1, 1835. Their niece, Susanna, was born on October 23, 1838, in St. Louis. Although no Lockwood family history records indicate it, the authors suspect that Susanna was named after her father's brother John Caleb Lockwood's wife. Young Susanna was only ten years old when her father, Isaac Lockwood, John's second oldest brother, died of cholera at forty-seven. The epidemic spread, and her mother, Ellen, died sixteen days later. Her two youngest siblings died the following two months.

The authors believe that John Caleb, feeling obligation to help care for the orphan children of his brother Isaac, moved west to Iowa from Middletown, Delaware, in 1842, the year after their fourth child, Alfred Oliver Lockwood, was born. John Caleb received a common school education in Delaware and pursued a mercantile business. After moving to Iowa, he continued the business, and by 1854, he had been elected by Louisa County as a representative in the legislature of Iowa on the "Anti-Nebraska" ticket, as opposed to the ticket favoring extension of slavery in the territories. Although Nebraska's statehood didn't come until 1867, areas west of the Missouri River were often referred to as "Nebraska," with its territory extending as far west as what is now Montana and north to the Canadian border.

In 1855, John Caleb was elected by the state of Iowa to the Office of Register of the Desmoines [*sic*] River Improvement, while his eldest sons, Edwin Jaynes and Alfred Oliver, farmed and raised stock. In Grant Lee Shumway's book, *The History of Western Nebraska*, the connection is made between the Lockwood family and their distant relatives Nathan Phillips (N.P.) and General Grenville Mellen (G.M.) Dodge by the early 1860s, when both families were noted as living in Iowa and then later Nebraska. Known as one of the greatest brother acts ever to settle the Omaha area, the Dodge brothers homesteaded to Douglas County, Nebraska, in 1853 from Massachusetts.[229] After founding a land office in 1855, the brothers surveyed land in Nebraska and Iowa and represented eastern investors as new territories opened up. By 1859, G.M., a young engineer, had already

made surveys of the Platte River Valley in the Nebraska Territory for the Chicago & Rock Island Railway when he met, by chance, a railroad attorney named Abraham Lincoln in Council Bluffs, Iowa.[230] Dodge assured Lincoln, who was not then vying for the U.S. presidency, that Nebraska's Platte Valley would one day be the route of the Pacific Railroad.

On November 6, 1860, Abraham Lincoln became the sixteenth president of the United States. Iowa had already been the twenty-ninth state of the Union for nearly fifteen years by the time the Civil War broke out in April 1861. Soon after, President Lincoln called for volunteers from each state to enlist for ninety days to help put down the Southern rebellion. Iowan farmers and merchants helped provide food and supplies to the eastern cities and troops to the Union army.[231] In 1862, John Caleb Lockwood enlisted in the Union army as a quartermaster sergeant of the Thirtieth Regiment, Iowa Volunteer Infantry; son Edwin Jaynes served with the Eleventh Regiment. Alfred Oliver also enlisted in the Union army as a member of the Iowa Volunteers and served until peace was established.

Grenville Mellen Dodge joined the Union army in 1861 and was asked by Iowa governor Samuel Kirkwood to join his staff.[232] He was assigned the task of securing weapons for the Iowa regiments and later was appointed as major general to lead the Left Wing in Major General William T. Sherman's famous "March to the Sea." The Lockwoods served in the regiments led by Dodge, and although not known to the authors, we speculate that a personal alliance was made between G.M. Dodge and John Caleb Lockwood and his sons, Edwin and Alfred, during the Civil War.

Even at the height of the Civil War years, President Lincoln kept Dodge and his knowledge of Nebraska in his memory until he needed the supervision for laying railroad tracks for the Union Pacific lines.[233] In 1863, Lincoln summoned Dodge from his post as major general in the Union army to take over the construction of the transcontinental railroad. In May 1866, nearly a year after President Lincoln's assassination, Dodge resigned from the military and became the Union Pacific's chief engineer with the endorsement of Generals Grant and Sherman. Becoming the leading figure in the construction of the transcontinental railroad, Dodge and crews reached the 100th meridian at present-day Cozad, Nebraska, on October 6, 1866:

See the 100th Meridian Sign across U.S. Highway 30 in Cozad where it intersects with the routes of the Oregon Trail, Pony Express, Transcontinental Railroad and the Lincoln Highway. In 1873, town founder, John J. Cozad

was traveling west on the Union Pacific Railroad when he saw the "100th Meridian" sign. According to city history, Cozad was impressed with the location as a favorable site for a town. He returned to Ohio to organize a company of people, who he brought back to Nebraska and founded the town named after him. At the center of Dawson County with deep roots in agriculture and livestock production Cozad and the 100th Meridian line is where "the humid East meets the arid West."[234]

Back in Nebraska and Iowa, Grenville Mellen's brother, Nathan Phillip Dodge, had stayed in the land sale business to build the foundation of what is now one of America's oldest real estate firms and one of Omaha's most well-known businesses, the NP Dodge Company. The Lockwood/Dodge family connection extended when N.P. married twenty-six-year-old Susanna C. Lockwood, the daughter of Isaac and niece of John Caleb.[235] Alfred Oliver had returned to the Iowa farm after the Civil War when he married Mary Vesta on October 27, 1864. Five children were born by 1878, when the Alfred Oliver Lockwood family left Iowa to secure some of the "good, cheap land" in Nebraska that was being advertised under the Homestead Act of 1862.[236]

The family's sixth child, a son, Alfred John Dodge, was born on September 16, 1879, in Boone County, Nebraska. After surviving the Civil War and only seven years of cultivating the family's large tract of land near Beaver Creek, Alfred Oliver passed away and was followed a year later in death by his wife, Mary Vesta, who was only forty-one years old. Leaving the family of eight children alone, the responsibility of continuing the family farm fell to the oldest son, Charles Elmer, who was a young man of nineteen years. Charles had learned the farming industry and continued to assume the family business to take care of his younger siblings. He bought the ranch when it sold to settle his father's estate. He continued to buy more land in the Beaver Creek Valley until he owned 5,400 acres of grazing and farming property and up to 1,500 head of sheep, 600 head of cattle, 500 head of hogs and additional pasture for horses. After seeing the determination and success of his wife's first cousin once removed, Charles Lockwood, Nathan Phillip Dodge helped the now twenty-one-year-old obtain credit in Council Bluffs, Iowa. With his determination and marketing ingenuity, Charles served an important role in the development of Boone County.

Moving West

When the Union Pacific began selling its land in 1884, the doors to settle southwestern Nebraska opened. Kimball County was established in 1890 and became a sizable trading area, with the settlers arriving daily by rail with their livestock. As families came, so did farming and the necessity to produce food. Both population and crop production experienced cycles of boom and bust. With farming as the major source of income, the arid climate accompanied by low prices for farm commodities contributed to the hard times and declining population of Kimball at various times.

However, with the passing of the Reclamation Act (also known as the Lowlands Reclamation Act or National Reclamation Act) of 1902, the U.S. federal law allowed the funding of irrigation projects for the arid lands of twenty states in the American West, including Nebraska. By 1909, Charles Elmer Lockwood had sold the eastern Nebraska ranch. Nearly the entire Lockwood family, including Alfred John Dodge, followed the westward movement of the Union Pacific Railroad and transitioned to Kimball County, where Charles formed the C.E. Lockwood Land Company.[237]

Pat Maginnis, a blacksmith in Kimball's earliest days, patented an irrigation flume, a trough designed to carry irrigation water across ravines. The Maginnis Irrigation Aqueduct factory was built in 1912. The trough consisted of a "woodend trestle" supporting a galvanized steel flume about 180 feet long and about 15 feet in height. Flumes were manufactured in his factory in Kimball for export to many locations in the United States and abroad. In 1994, the Maginnis Irrigation Aqueduct was listed in the National Register of Historic Places for its significant association with irrigation and agriculture in Nebraska and "as an excellent example of a structure designed to overcome a topographical obstruction."[238]

At the onset of World War I, Nebraska farmers expanded both their planted acres and production to unprecedented heights. The greatest increase in cultivated acres of wheat occurred when the southwest counties of Nebraska (Cheyenne, Deuel, Kimball, Perkins and parts of Banner, Garden and Keith Counties) were developed into specialized wheat-producing areas.[239] Frank Cunningham, one of the largest wheat growers in the state, made Kimball a well-known stop along the Union Pacific Railroad when he opened the Wheat Growers Hotel in 1918. He had used the profits from his bumper wheat crop to celebrate his success. To further give homage to the crop, Cunningham decorated the two-story brick hotel lobby with a shock of wheat inlaid on the tile floor, along with a mural of a threshing scene.[240]

Other decorative features included polychromatic brickwork in the hotel's window and door surrounds and leaded stained-glass windows with wheat shocks alongside the words "Wheat Growers."

The hotel featured eighty-six guest rooms, with most of its clientele coming from the nearby passenger train, which had expanded its line one block north of the hotel in 1913. Also bringing travelers to the area and putting Kimball on the map was the establishment of the Lincoln Highway, providing a much-needed stop between Ogallala and Cheyenne for salesmen, developers, investors and tourists.[241]

Although America experienced a period of high wheat prices during and shortly after World War I, the boom only lasted about five years afterward. By 1923, Cunningham's spoils and real estate achievement were short-lived, as the effects of "black rust" spores spread throughout the northern region, draining wheat's vitality. With wheat flour running low, Americans were forced to give up their bread, crackers and other pastries. America mobilized for the struggle ahead, as commodities like wheat, sugar and meat were rationed by government decree.[242] The federal government even banned the sale of bread on Wednesdays and Mondays, and hotels and restaurants could serve no more than two ounces of bread.[243] Cunningham's Wheat Growers Hotel closed, and all the hotel's original interior furnishings were repossessed. Different owners over the next sixty years renovated and refurnished the hotel until it permanently closed in 1983. The hotel still stands today.

Agriculture's Adaptability and Advances

In 1917, Charles Lockwood's younger brother, Alfred John Dodge Lockwood, and his wife, Hattie, along with their six children, moved west to Kimball, which was declared the leading potato-producing county of Nebraska.[244] With the scarcity of wheat and its byproducts, the area's potato producers began to label every Thursday as "Potato Day" and urged the local Kimball merchants to reduce prices of potatoes so consumers could substitute wheat with potatoes to make flour. Newspapers and magazines encouraged adaptability to the wheat shortfall by featuring recipes using potatoes instead of wheat.[245]

Certified seed potatoes became the new cash crop in the 1930s and 1940s for western Nebraska's Panhandle, with nearly 50 percent of the state's crop raised and sold from the area. "Potato caves" were built along or near the

railroad tracks and used for storage until entire crops sold to growers as far south as Texas, Louisiana and Bermuda could be shipped. Nearly 90 percent of the certified seed potatoes planted in Louisiana were produced in northwest Nebraska's ideal climate of low summer temperatures and cool nights.[246] "Today, Nebraska ranks near the top 10 in potato producing states. The state's climate, water resources, and soils make it a desirable location for both table and seed potatoes."[247]

Sorting the potatoes in the winter months became a source of employment, and Alfred's son T.J. knew that there must be a better way to help his family's farm become more profitable. After graduating from Kimball High School at sixteen years old, T.J. attended Colorado A&M College in Fort Collins. His major was pre-engineering, but lack of funds prevented him from returning to school the next year.[248]

Raising dryland potatoes in Kimball County presented its own challenges. In the 1930s, potatoes in many areas were sold unsized, ungraded, unwashed and often not weighed for volume of price. Back at the Lockwood family farm shop eight miles north of Kimball, T.J. sought to find a solution, and his natural, God-given aptitude for mechanical engineering took flight. From 1936 to 1939, young T.J. tinkered in the 526-square-foot Lockwood family farm shop to make harvesting potatoes less labor intensive, and he came up with a workable grader for sorting potatoes.[249] The grader was used by the Lockwoods and other area farmers to grade table stock and seed potatoes. While the table stock was sent to local dealers for distribution, the undersized seed potatoes were used for planting the next year's crop.

The grader was a small machine designed to fit the needs of the times.[250] It sized, graded and sacked the potatoes right on the farm, which made it possible for area growers to command a premium for their crop. After successfully using the potato grader machine that he invented, T.J. began traveling western Nebraska looking for potential customers. Along his travels, T.J. met and married twenty-year-old Margaret K. Schanou on July 11, 1939, in Kearney. Four years earlier, Margaret had graduated from Odessa High School in Buffalo County and attended what was known as the Nebraska State Normal School at Kearney for two years. She had moved west to help her married sister cook for hired men during the summer of 1937 and later found a teaching job for two years in a one-room schoolhouse in Banner County.

To introduce the potato grader equipment to prospective buyers, T.J. listed the products in a catalogue from his Kimball workshop to display each one's capabilities and price. On March 1, 1938, T.J. wrote, "It has

Above: The 526-square-foot shop on the Lockwood family farm nine miles north of Kimball, where T.J. worked from 1936 to 1939 to invent solutions for making harvesting potatoes less labor intensive. *Courtesy of the Legacy of the Plains Museum, the Lockwood Collection.*

Right: One of T.J Lockwood's first inventions: a potato washer/ dryer/grader manufactured by T.J. Lockwood in Kimball at the Lockwood family farm. Image circa 1936. *Courtesy of the Legacy of the Plains Museum, the Lockwood Collection.*

been our aim to build potato handling equipment to fill the demands of the customer, who in turn, is trying to put out his product on the market in No. 1 condition. It is my personal desire in my continuous travel over these United States that I will be able to meet personally all with whom we do business."

The positive response for the "Lockwood Grader" continued and prompted T.J. to move the business north, with intentions to move to North Dakota. However, a stop in Scotts Bluff County led him to a back room in a suitable old building on Seventh Street in Gering and a more promising territory along the Burlington Northern Railroad line. T.J.

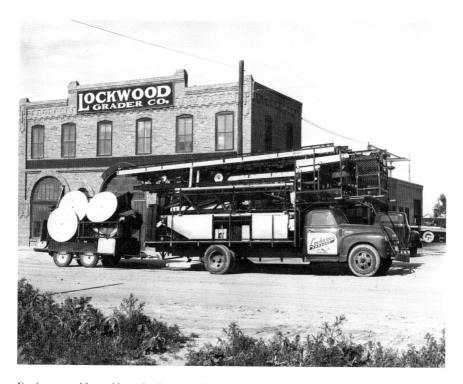

Equipment with stacking wheeler ready for shipment from the Lockwood Grader Company in Gering. T.J. told his salesmen not to return until everything was sold. *Courtesy of the Legacy of the Plains Museum, the Lockwood Collection.*

moved his new potato grader business from Kimball in 1939 and paid five dollars per month in rent for the building. (*Authors' Note*: Jody Lamp, a native western Nebraskan whose agriculture story begins with her great-grandfather homesteading to Sheridan County, explained how the western Nebraska potato growers in 1936 provided her grandfather with a potato harvesting job during a time when many rural Nebraskans and Americans struggled to recover from the Depression and Dust Bowl years. "When I think how my own grandfather had to travel more than one hundred miles to Scotts Bluff County just to find work, promoting commodities like potatoes, agriculture careers and businesses becomes real personal to me," Lamp said. "What an honor to write about inventors like T.J. Lockwood, who worked hard and desired to help producers increase efficiency and profitability and provide jobs for others.)

Three years after the move to Gering, T.J. continued to meet with each of his customers personally and began to standardize what had been considered

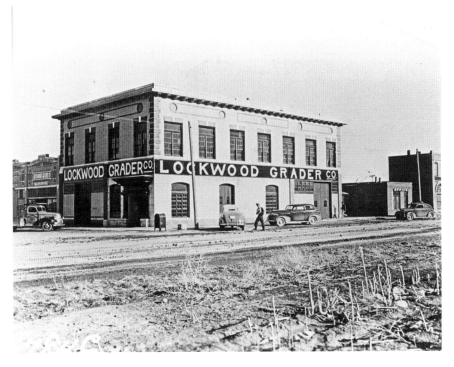

The original location of the Lockwood Grader Company's 17,300-square-foot factory and warehouse on the 1800 block of Seventh Street in Gering. The photo was taken on February 1942. Noted on the back of it was, "[P]aving was being put in." The inscription also indicated from Lockwood or an employee that "all buildings built by us and all paid for." *Courtesy of the Legacy of the Plains Museum, the Lockwood Collection.*

During World War II, men like co-author Jody Lamp's grandfather Earl King, who was born in 1898 and could not serve in the military due to a farming accident injury, stayed on the homeland and played a crucial role in plowing, planting, cultivating and harvesting much of the nation's crops from 1942 through 1945. On August 16, 1943, Earl King was awarded this certificate for his patriotic service and contribution to agriculture production. *Courtesy of the Eva (King) Johnston family.*

Mrs. America Demands
Washed Potatoes

"TOP THE MARKET"
. . . USE A LOCKWOOD WASHER ! ! !

Will Fit Grading
Equipment You
May Now Be
Using

A
PROVEN
WASHER
Available in
24" - 36" - 48"
widths

Model 1330

For Those Who Want the Finest Washer Available . . .
"BE CONSISTENT — SHIP THE BEST"
Lockwood Washers Will Help You Market
Top Quality

— 7 —

"special order" equipment. In an updated catalogue, he issued another statement to his customers on March 1, 1941: "We believe there has been a great change in the potato business the past three years, and we believe that with the help of good equipment potatoes have been put on the market in a condition as good or better than many other farm commodities. We believe that in this catalogue as in the old one you will find new type of equipment, better built, and we have worked with the users, in all parts of the nation to build the type to fill their needs."

The Lockwood Grader Company in Gering became one of the fastest-growing industries in Scotts Bluff County and the entire potato-producing industry. T.J. began buying the buildings on Seventh Street until he owned the whole block. The floor space, which was dedicated to manufacturing and storing the products, tripled to about 17,500 square feet in 1942. Products were shipped to nearly every state in the potato-growing nation. In addition to inventing potato equipment, T.J. also earned a pilot's license. He purchased a company airplane to fly himself to directly meet with customers and help them set up their Lockwood equipment.

As potato marketing increased, the demand for washed potatoes to merchandise and attract consumer buyers began to outpace the current potato graders. North Dakota potato producers needed a machine to handle dry soils, while southern potato producers needed equipment to remove mud from the potatoes. It soon became necessary for the Lockwood Grader Company to extend its product line by designing and manufacturing washers and brushers to help "dress up" the fresh potatoes, in addition to creating elevators and air conditioner appliances to help expedite the handling and ensure proper care of potatoes while in storage.

As Mrs. Lockwood explained in recounting T.J.'s history in *Kimball County, Nebraska: 100 Years*, "Mr. Lockwood was quick to see the need for new methods and new machines to do the job. He feverishly developed

Above: Margaret and T.J. Lockwood depart a plane from one of their many adventures of traveling the United States and Europe promoting and selling potato production equipment where potatoes were raised. T.J. later became a licensed pilot and purchased a company airplane to fly himself to meet with his customers.

Opposite: Lockwood Grader Company advertisement started marketing to "Mrs. America," who demanded washed potatoes. *Courtesy of the Legacy of the Plains Museum, the Lockwood Collection.*

Home Office	Gering, Nebraska	DEALERS

Lockwood Affiliated Factory Outlets

Town	Manager
Quincy, Washington	Austin Overcast
Tulelake, California	Willard Morris
Rupert, Idaho	George Knoblauch
Monte Vista, Colorado	Wayne Talley
Hereford, Texas	Alva Neal
Grand Forks, N. Dak.	Robert Sweeney
Antigo, Wisconsin	Robert Auner
Six Lakes, Michigan	Donald Lundy
Presque Isle, Maine	Glen Hitchcock
Hastings, Florida	Cecil Wilson
Gilcrest, Colorado	Keith Vaughn
Nieuw Amsterdam, Holland	Koert ter Veld

Resident Salesmen Serving At These Places

Bath, New York
Donald Rasmussen

Bakersfield, California
Lewie Ringsby Ed Snell

Phoenix, Arizona
R. G. Knoblauch (Seasonal)

Hightstown, New Jersey
Donald Skinner

Idaho Falls, Idaho Fruitland, Idaho
Bob Mieners O'Dell Warr

— Serving Canada —
Northern Seed Potato Co., Ltd.
Vancouver, B. C.
Saxon Sales & Service
Hillaton, Nova Scotia

— Serving Alaska —
Yukon Equipment Company
Seattle, Washington

— Serving The U. S. —
Jefferson Potato Company
Metolius, Oregon
Heinen Implement Company
Osseo, Minnesota
Rolle Brothers
Riverhead, Long Island, N. Y.
J. W. Parsons & Sons
Northampton, Massachusetts
Tallman Bros.
Tower City, Penn.
Capital Chemical Co.
Summerdale, Alabama

Print advertisement showing an aerial view of the home headquarters of the Lockwood Grader Company on Seventh Street in Gering. *Courtesy of the Legacy of the Plains Museum, the Lockwood Collection.*

all types of machines to handle the potato—from the time that it left the storage bins until it was ready to be put in a neat package." "To the market with Lockwood Graders" became a slogan known throughout the potato-producing areas during the twentieth century.[251]

T.J.'s most vital inventions in industrializing the potato harvest included the bearing designed to make machines run smoothly, molded rubber rollers that minimalized bruising of the potatoes and a link chain that rolled the potatoes along in elevators.[252] All these small inventions played a larger role in the overall development of producing the larger Lockwood machines, and this created jobs in the North Platte Valley and central Nebraska to earn T.J. and the Lockwood Grader Company an international reputation.

It was reported that the first Lockwood Grader plant installation of any size was in the potato-growing area of Gibbon, Nebraska. The grader

The potato "grading line" of equipment stacked outside the Lockwood Grader Company on Seventh Street in Gering. *Courtesy of the Legacy of the Plains Museum, the Lockwood Collection.*

made at that plant cost $300. To keep expenses to a minimum, Lockwood only paid himself about thirty cents an hour in wages and slept in his car.[253] "Thorval was constantly improving each machine for the area to which it was sold," Margaret noted in *Gering, Nebraska: The First 100 Years.* "He believed each machine should be built to suit the special needs to his individual customers."

T.J. was known to be personally involved in his products and would take his family to wherever was necessary to service and work on the machines and conveyors. After World War II in 1947, the company opened regional manufacturing facilities in Grand Forks, North Dakota. The plant was designed to carry spare parts and service the machinery and equipment in the Northern Territory.[254] Three years later, a plant was built in Monte Vista, Colorado. From there, Lockwood Graders experienced rapid growth, with additional plants built in Rupert, Idaho; Antigo, Wisconsin; Robertsdale, Alabama; Presque Isle, Maine; Tulelake, California; Hastings, Florida; New Amsterdam, Holland; Quincy, Washington, and Six Lakes, Michigan. "We have built our business on large volume over the entire United States making it possible to furnish equipment at low price and give good service," T.J. stated on March 1, 1943. "And under present conditions we will do our best to furnish repairs and service."

Above: The Lockwood Grader Company became an international business when it opened a factory in New Amsterdam, Holland, in the early 1950s. *Courtesy of the Legacy of the Plains Museum, the Lockwood Collection.*

Opposite, top: T.J. Lockwood (*far left*) stands next to one of the Lockwood Grader Company's "Top the Market" pieces of equipment, which features brushes to clean potatoes and cucumbers, at a tradeshow in Atlanta. Image circa March 1950. *Courtesy of the Legacy of the Plains Museum, the Lockwood Collection.*

Opposite, bottom: T.J. Lockwood (*second from left*) gives U.S. Republican senator Roman Hruska (*second from right*) of Nebraska and his staff member a tour of the Lockwood Grader Company on Thursday, November 17, 1955. Also pictured is Tom Spence (*far left*) of Scottsbluff. *Courtesy of the Legacy of the Plains Museum, the Lockwood Collection.*

Leonard Eisenach, a longtime Lockwood employee, recalled in the fiftieth-anniversary Lockwood Grader Company newsletter that T.J. consistently traveled for five to six winters with Margaret and the children to Alabama to the shipping docks where parts arrived—welder, torch, bearings and sprockets in hand. The Lockwoods also traveled to South America, England, Holland and Germany, wherever potatoes were raised. "The four [younger] kids used to say we never went anywhere unless it had to do with potatoes," Margaret Lockwood recalled. "That was life."[255]

"My Most Unforgettable Character"

In January 1957, forty-three-year-old T.J. traveled to a Denver hospital for tests and learned that he had a brain tumor. He only lived until August 7, when he died on his forty-fourth birthday. In a memorial feature published a year after T.J.'s passing, the *Star-Herald* included a literary contribution describing the "Fascinating Career" of a businessman whom the newspaper staff must have interviewed on numerous occasions:

> *Interviewing him was a refreshing experience for newsmen. Usually plainly dressed, lean, swift and deft in movement, he wasted neither words nor motions. He spoke quietly and precisely. Spare, unadorned sentences etched his points with no need for emphasis or repetition…*
>
> *He worded ideas as he would sketch a new machine. Each segment of information, his interpretation of it and his conclusions were presented with the clarity of a cutaway drawing…*
>
> *The one-time Nebraska farm boy produced more than machinery. His determination and vigor made him a successful manufacturer there by creating jobs for many skilled workers. He also made time for civic and church activities, for the YMCA and Scouting, giving largely of time, money and the driving energy characteristic of him.*
>
> *His untimely death is a blow to a community he served well in many capacities.*

On the one-year anniversary of T.J. Lockwood's death, Lyle L. Fry, executive vice-president of Lockwood Grader Company, sent this note to employees, customers and friends to accompany a memorial booklet honoring T.J. Lockwood's life. *Courtesy of the Legacy of the Plains Museum, the Lockwood Collection.*

Two months after T.J. Lockwood's death, a faulty air compressor exploded at the Lockwood Grader Company factory. At a time when T.J. would have normally still been in the building had he been alive, ironically, all the plant workers had gone home. Several interior walls were bowed, buckled or demolished, and the roof caved in, causing $20,000 worth of damage. Image circa October 1957. *Courtesy of the Legacy of the Plains Museum, the Lockwood Collection.*

At the time of T.J.'s death, Lockwood Grader Company had about three hundred employees. One of the many condolence letters Margaret received came from J.D. Swan Jr., representing the Wisconsin Potato Growers Association. It was featured in the Lockwood Grader Company "In Memoriam" tribute, which was sent out to employees in an accompanying booklet on July 31, 1958, to honor the one-year anniversary of the passing of T.J. In it, Mr. Swan expressed the sorrowful wish of the entire Wisconsin Potato Growers Association. "A pall of sorrow hangs over the many potato fields belonging to many friends who came to know, respect and honor T.J., at the very time of the commencement of another harvest made lighter and pleasanter by the use of the machinery that was unselfishly developed and distributed by our friend," Swan articulated. "T.J. stood out as a Christian man devoted to his work, his friends and his ideals with a willingness to enter the dust and dirt of the toils of those of us whom he sought to serve and thus to learn better and ameliorate upon the problems of our particular work."

What was described as a "rare phenomenon" two months after T.J.'s death in the company's *News and Views* monthly newsletter was the appearance of "THE CROSS" after an explosion at the Lockwood Grader Company. It was a Monday evening, about 5:10 p.m. All the plant workers had already left when a large air compressor exploded. Steel walls buckled. Doors blew from their hinges, ripping through lumber and breaking cement block walls. Huge shafts and pieces of steel shot through the air. The explosion caused an estimated $20,000 worth of damage to the plant.[256] After the firemen left and the confusion of the explosion subsided, workers clearing the debris noticed that the defective compressor smashed through a concrete partition near a steel-encased window.

The steel bowed and glass disintegrated, but the workers looked up in shock to discover that seven panes from the window remained and formed a pattern of a cross.[257] The remaining panes bowed and curved in such a way that even the most resilient glass under the tamest circumstances should not have survived the explosion. The workers and company officials believed that the incident defied the laws of physics. "That cross has significance for us," explained Ernest Barcell, a Lockwood Grader Company executive. "Fortunately, there were no lives lost. No one even seriously injured, since the explosion occurred after closing time."

In a sermon following the explosion, T.J. Lockwood's minister, Dr. Henry C. Beatty of the First Methodist Church of Gering, who had presided over his funeral, wrote, "For me it was a reminder of a man who planned well

Lockwood Grader Company workers discovered the formation of what look like a cross after a devastating structural explosion caused $20,000 damage in other parts of the building. The workers and company officials believed that the creation defied the laws of physics and accepted it as a reminder of their founder's strong Christian faith. *Courtesy of the Legacy of the Plains Museum, the Lockwood Collection.*

the operation; a man who believed deeply in God. As I looked at the cross, I thought of a man, my friend, who under great shadow and heavy problems knew Jesus was the Author and Finisher of his faith. Here was a reminder that in the cross there is a place where God's power most adequately meets our weaknesses, our sin, our hopes."

The Lockwood Legacy

"It's Not a Meal without Potatoes"
—Lockwood Grader Company slogan

The June 1960 cover photo of the Lockwood Grader Company *Potato Horizons* newsletter. "Over high passes, past scenic mountains, and through the Scott Bluff National Monument, Lockwood trucks traverse the nation's highways to deliver potato equipment to growers from Maine to California." *Courtesy of the Legacy of the Plains Museum, the Lockwood Collection.*

As stated in company literature, the *Potato Horizons* monthly newsletter, which first went to press in March 1958, Mrs. T.J. Lockwood was soon serving as president of Lockwood Grader. Vice-President E.A. Barcell introduced the concept of a newsletter to fill a communicative niche and serve as a tool for the potato industry to carry interesting news to "potato people." Editor N.L. Morton enforced the company's intent and objectives to exchange ideas among potato growers and shippers throughout the industry; to report new methods of raising, handling and processing; to publish news of interest; to assist in developing better potato machinery; and to keep the potato industry vigorously independent.[258]

By the end of 1958, the Lockwood Grader Company was reporting that more than 1,000 potato grader units helped bring in the nation's harvest that year. With the home office remaining in Gering, the company had factory stocks at fourteen strategic locations throughout America. Company reports indicated that there were 350 Lockwood Harvesters in the Red River Valley; more than 115 in Long Island, New York; more than 100 in

Idaho; and hundreds more in the top potato-producing states of Oregon, Washington, California, Maine, Utah, Texas and Nebraska. Plus, there were many more in various locations across North America and Canada.

Technology and efficiency of getting the product from the farm to table became the focal point for Lockwood Grader. One of the main attractions at the 1958 Western Growers Association Thirty-Third Annual Convention at the Biltmore Hotel in Los Angeles was the new sewing machine displayed by Lockwood Grader representatives of Tulelake, California, and Gering, Nebraska. The sewing machine was designed to sew more potato and onion bags per hour. The company also had recently added a line of carrot-processing machinery to its already versatile line of machines, thereby expanding its footprint into the produce industry.[259]

Agriculture education and advocacy, which this book is intended to inspire, was promoted to the 1958 convention attendees by W.J. Thornburg Jr., president of the Western Growers Association, which was founded in 1926 in California's Imperial Valley. The association's mission was to fight for fair transportation rates for the agricultural industry and bring those in the agriculture industry together to support a common goal with the philosophy that there is strength in numbers.[260]

In his annual report to the group, Thornburg stated:

> *With 15 percent of the nation's population producing all its food and fiber, and with a good many of the 85 percent remaining looking upon the farmers as a "subsidized leech," it's high time that agriculture entered the field of public relations with both feet. Today, a lot of our youngsters growing up don't know what a farm looks like, much less understand the basic importance of agriculture….We live in a nation where the majority rules, and where the majority neither understand or know very much about our problems, there is always the dire possibility of being legislated out of business…It's high time that we both understand and competently use the tool of public relations.*

(*Authors' Note*: We praise W.J. Thornburg Jr. for having the foresight to encourage members of the Western Growers Association and its supporters like Lockwood Grader to adopt public relations as a tool to educate and advocate agriculture nearly sixty years ago, long before social media, chatrooms and smartphones existed. Today, the number of our nation's population producing the food has decreased to less than 2 percent. As the

authors of a series of agriculture history books, including this one about Nebraska, we encourage you to take time to educate and advocate for our state and nation's farmers and ranchers to help others gain a better understanding of where their food, fiber, fuel and feed come from before generations removed from the family farm forget their ancestral roots.)

In 1959, from the home office headquarters in Gering, the Lockwood Grader Company continued to market its dealers as respectable members of their communities who actively contributed to running the city or lending a hand to their neighbors. Much like T.J. was described by his employees and peers, President Margaret Lockwood continued the "unpretentious" reputation of her founder husband. The November 1960 *Potato Horizons* featured a profile of "Lockwood people you should know," starting with the Lockwood family of Margaret, son Fred and daughters Linda, Genene and Andrea.

T.J. Lockwood served the Boy Scouting program of Troop 15 in Gering and was a representative on the Boy Scouts of America National Council. The T.J. Lockwood Memorial Boy Scout Building was dedicated on December 7, 1958. *Courtesy of the Legacy of the Plains Museum, the Lockwood Collection.*

The family continued to live in the simple brick home a block away from the Lockwood factory in Gering. After her husband's death, Margaret, forty-one, continued to serve as the company president until 1964, when the family sold their interest in the company. Fred was a junior attending the University of Colorado in Denver. Linda was a senior attending Gering High School, while twelve-year-old Andrea attended the seventh grade at Gering Junior High School across the street from the family home. Oldest daughter Genene married Stuart Morrison of Mitchell.

While T.J. had been instrumentally involved and served the Boy Scout program of Troop 15 in Gering and as a representative on the Boy Scouts of America National Council, Margaret was equally active in the Campfire Girls organization. Mrs. Lockwood is living proof of the old adage, "If you want something done, find the busiest woman in town."[261]

Lockwood Company Expands

Lockwood Grader had not entered the potato harvesting field until 1950. But in the 1960s, Lockwood harvesters dominated the market in every potato-growing region of the United States. Other firsts in the potato equipment industry included the star roller table, steerable axles, use of coulters, reduced potato drop distance, feather-edge chain and many other features to reduce potato bruising and increase a producer's productivity and profitability.

Although Lockwood had been the largest manufacturer of specialized potato planting, harvesting and warehouse equipment in North America, the company began to diversify its line of products to other crops. Silage made from the tops of sugar beets, a part of the plant that was usually discarded once the beet was dug, showed promise as a viable and alternative to corn silage as livestock feed when a University of Nebraska researcher conducted a twelve-year study of feeding the tops to fatten lambs. From 1951 to 1963, Lionel Harris, superintendent of the Scotts Bluff Experiment Station at Mitchell, conducted experiments to determine the feasibility of using beet top silage as the only "roughage in lamb and cattle finishing rations and the effect" this method of harvesting and storing beet tops would have on their feed value.[262]

Then, from 1960 to 1963, he used a new beet top harvester machine developed by Lockwood Grader that was mounted on a tractor and clipped the tops at the crown of the sugar beet prior to root digger.[263] "You can't

grow beets without tops," Harris observed, "and up 'til now the tops have been largely waste."[264]

Beet tops were chopped and blown into a trailing wagon. Next, they were ensiled in piles or cribs on sloping ground to permit drainage of excess liquid.[265] Then, 25,000 pounds of beet top silage were mixed in a ration with cumulative amounts of various components, including 5,000 pounds of grain mixture consisting of equal parts of corn and beet pulp, 2,500 pounds of dehydrated alfalfa and 500 pounds of soybean meal.[266] By the end of his research, Harris had determined that lambs fed beet top silage gained weight faster and more efficiently than those fed corn silage when both silages were supplemented with either dehydrated alfalfa or hay alfalfa.[267]

With the help of the Lockwood beet top harvester, Harris was able to conclude that the efficiency of sugar beet farming can be improved by feeding beet top silage to livestock.[268] Incorporating sugar beet byproducts into livestock diets today is based primarily on economics, local availability, feasibility of storage and handling.

Aerial view of the original Lockwood Grader Company on the 1800 block of Seventh Street in Gering. *Courtesy of the Legacy of the Plains Museum, the Lockwood Collection.*

"Home of Lockwood Since 1935" can still be seen on the north side of the original Lockwood Grader Company. Today, the family-owned sign company Creative Signs by Cozad, founded by Tom Cozad in 1978, operates out of much of the original Lockwood building. *Photo taken by co-author Jody L. Lamp.*

Other diversifications came when Lockwood purchased the Hydrocycle Division of the Hydro-Corporation of Dalhart, Texas, and aggressively entered the center-pivot irrigation industry. Further company manufacturing expansions included producing equipment for the dry-edible bean and pecan industries.

Through the 1980s and mid-1990s, the Lockwood Corporation headquarters and manufacturing facility had about eight hundred employees. Its 500,000-square-foot complex was now located on eighty acres in Gering along Highway 92. After numerous changes in ownership, the company name and assets were sold to Crary Company, which doubled in size when it moved the Lockwood product line to West Fargo, North Dakota, in 2001. The original Lockwood Grader buildings on Gering's Seventh Street still stands today. Tom Cozad's Creative Signs and his antique Ford garage now occupy the space. Across the street is land from which T.J. Lockwood donated five lots to the City of Gering for the schools in 1945. Gering Junior High and Memorial Stadium are there now, where Gering High School plays its home football and soccer games.

Tractor Trails. Courtesy of Gene Roncka, Willow Point Gallery, Ashland, Nebraska.

A SAMPLING

CELEBRATING NEBRASKA'S TOP COMMODITIES

N ebraska ranks number one in the United States for Great Northern bean production and is the second-largest producer for pinto beans and light red kidney beans. The state's Panhandle climate, water resources and soils make it a desirable location for growing this rotational crop.

Nebraska's Dry Bean Industry

Chester "Jim" B. Brown

Nebraska's dry bean industry and the Kelley Bean Company trace their roots back to Chester B. Brown, a farmer in Scotts Bluff County who planted the first field of Great Northern beans north of Morrill in 1923. After multiple trips to Idaho and Montana to study the crop, Brown recognized the similar climatic and growing conditions of western Nebraska and decided to give the crop a try.

Planting a new bean crop that had never been grown in Nebraska before may have been a risk to some, but not to Chester Brown, whose life had been spared at two years old on September 25, 1893, when he fell out of the jockey seat of the Brown family's covered wagon and onto the tongue before his mother could pull him back up. The Olmstead (O.B.) Brown family

first came to Scotts Bluff County, Nebraska, in 1886 and took preemption under the Tree Claim Act of 1872. Drought and insects prevailed after their arrival, and O.B. decided to head back east with his wife, Cartha, and children, including young Chester, to Osceola in central Nebraska to open a photograph gallery. And yet, still longing to own land in western Nebraska, O.B. waited about seven years before moving again and filing a homestead in Sioux County.

In her diary describing the covered wagon trip back to western Nebraska along what would have been the ruts of the Oregon Trail, Mrs. Cartha Brown journaled on September 27, 1893, about the North Platte River and the area they had camped in near Scotts Bluff County:

> *The bluffs came clear down to the river, and we had to cross them. They are very peculiar. One was all of white sand, another close by of red clay and gravel, and still another has several different colors with small pines on top. We watered and fed on the banks of the river, and the range cattle came down to drink while we were there. We are actually on "range." It is very sandy here and has been all day long. "And we were lone and thirsting in a land of sand and pines" has often repeated itself to me today. I wondered as I rode over those bluffs who the scout could have been that took the first immigrants over this trail. Perhaps 'twas Robert Carnes, that uncle of whom we know so little. Perhaps Colonel Cody chased buffalos over these hills. At any rate, 'twas brave spirits that first undertook to explore them, and with an Indian peering around most any rock or wild animals crouching ready to spring. Bish spoke with a man today who had just passed through Scotts Bluff County, and he spoke very encouragingly of Gering and vicinity.*[269]

Upon their arrival, the O.B. Brown family resided in a sod house on East Ninth Street in Scottsbluff until Chester was fourteen years old. On Sundays, Chester was expected to stay inside with his father reading the Bible and learning the application of strict Baptist doctrines by which he had been raised. Realizing that his youthful ambitions would eventually combust under the confines of their sod house, Mrs. Brown encouraged Chester to leave home and find himself in the "great wild country."[270]

Chester Brown saddled a horse and rode north to the once thriving gold boomtowns of South Dakota—Deadwood and Lead. He only made it a few miles north of Scottsbluff when he rode past a cave that had been dug out of a hillside, serving as the headquarters of some "wild, tough rustlers"

with the last name of Ashbaugh. Young Chester adopted their last name as his own and called himself Jim Ashbaugh until he married Susie Rush at the age of twenty-six in 1917. He had been riding on roundups when he came upon the Rush Ranch on Lame Johnny Creek, where it empties into the Cheyenne River in southwestern South Dakota. He met Susie at her family ranch when he rode in sick with typhoid fever. His future sister-in-law, Catherine (Kitty), nursed him back to health. After that, he traveled back to Scottsbluff several times to visit his mother and the homestead in Sioux County. He revealed his birth name, Chester Brown, to the priest on March 12, 1917, his wedding day. As newlyweds, Chester and Susie Brown settled on the Sioux County homestead and started farming.

Chester worked eighteen-hour days trying to raise sugar beets and potatoes, the principal crops of western Nebraska at the time. After a year yielding eleven thousand pounds of potatoes that he could not sell, Brown investigated other options. Having defied death several times during his life, thirty-two-year-old Chester's next defining moment was to plant a relatively unknown crop in his western Nebraska soil. Montana, Idaho and Colorado farmers were already having success growing dry beans. So, in 1923, Brown decided to give the bean seed a try.

One of the first mentions of dry bean production in western Nebraska was noted in 1895, when Charles Stroud raised one and a half acres near Bayard. The beans were harvested by pulling by hand and beating the hulls out with a pitchfork. This first attempt only yielded seventeen bushels.[271] In 1896, an Alliance, Nebraska grocer advertised the desire to purchase beans: "300 Bags of Beans—100 Pounds Each."[272]

The Beginning of Nebraska's Dry Bean Era

By 1917, establishing dry edible bean production in the North Platte Valley had begun to show promise. The John H. Allen Seed Company of Sheboygan, Wisconsin, started contracting with American farmers to grow seed beans. The agreement between the seed company and the farmers included furnishing handpicked seeds of different varieties, providing a threshing machine and sacks and paying five dollars per one hundred hundredweight for the beans.[273]

George G. Brown, the youngest child and son of Chester and Susie Brown, recorded in the story about his family that in 1923, the year he was born, his father's first attempt to grow and harvest dry edible beans required the help

of the family's friend and neighbor. "At that time Chester was so poor that our great friend and neighbor, George Munroe, hauled the bean crop in burlap sacks to the railroad where they were shipped to northern Colorado to be cleaned and sold," wrote Brown. "George Munroe would never charge my dad for hauling the beans to the railroad, for which the entire Brown family will always be grateful."[274]

Inspired by his successful first year, Chester recruited four neighboring farmers to plant some of the Great Northern beans from his previous year's crop. In the early years, beans were harvested with a threshing machine. Chester took the initiative to build and patent the first motor small planter, beet puller, planter and cultivator. By 1926, he had made and sold six of his inventions. The next year, Chester rented part of the Garret Brothers' potato cellar warehouse in Morrill and installed a small clipper cleaner powered with a Model T Ford engine. International Harvester later produced a refined version of Brown's homemade machine.[275]

Brown purchased the warehouse, which became part of the plant along the south side of the railroad tracks a block from Morrill's Main Street. From

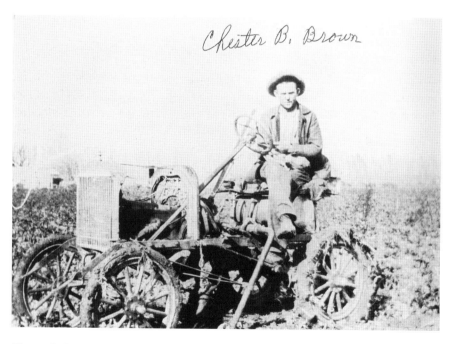

Chester B. Brown began growing dry edible beans in western Nebraska's North Platte Valley in the early 1920s with many of his own inventions, including this homemade tractor. Image circa 1926. *Courtesy of Kelley Bean Company.*

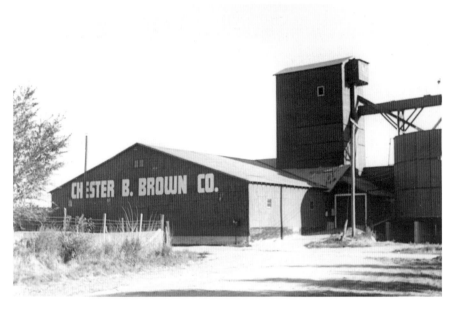

The first dry edible bean processing plant and warehouse of Chester B. Brown Company, near downtown Morrill. *Courtesy of Kelley Bean Company.*

this genius, foresight and ingenuity came the bean industry to the North Platte Valley, which resulted in the building of processing plants at Morrill, Gering and Bayard, Nebraska, with buyers in Torrington and Fort Laramie, Wyoming.[276] "By 1927, the United States Great Northern Bean production was 1,200,000 cwt and Pinto Bean production stood at 1,600,000 cwt. Nebraska wasn't listed as a bean producing state until the following year when it was listed as growing 15,000 cwt of Great Northern beans."[277]

By 1930, the company had partnered with an experienced bean man, Ray Hursh, from Michigan.[278] Ten years after Brown began his commercial operations, Nebraska dry bean producers averaged fifty thousand acres of beans planted per year, with an average yield of 1,280 pounds per acre. As planted acres and yield continued to grow, so did the Chester B. Brown Company business. The once farmer and now entrepreneur Brown hired fieldsmen to sell seed in outlying areas and, when warranted, built new facilities to handle the growing bean acres and yields. He eventually expanded to Minatare, Mitchell and Lyman, as well as Lingle, Wyoming.

Chester Brown became the first farmer in western Nebraska to establish and grow the foundation for the dry edible bean industry and varieties

This page: Retail and bulk packages of Brown's Best Great Northern and pinto beans. Chester B. Brown became the first farmer in western Nebraska to establish and grow the foundation for the dry edible bean industry and varieties known today. *Courtesy of Kelley Bean Company.*

known today. He also was instrumental in bringing bean planters, harvesters and double-cylinder threshing machines to Scotts Bluff County and the region. In 1938, Chester had the first electric bean-sorting machines installed. Described as having almost "human intelligence,"[279] the "eyes" would remove the culls and other foreign matter from the beans as they passed through the machines. Each machine had the capability to sort twenty one-hundred-pound bags per day. Later, he added other mechanical devices, including a stacking conveyor, to help reduce manual labor in the warehouses.

Brown's Morrill plant was located near John R. Jirdon Industries. The small Nebraska community became one of the largest producers and shippers of potatoes, grains, feeds and beans in the North Platte Valley.[280] Although agriculturally diversified, the story told by locals was that Jirdon was not overly fond of dealing with dry edible beans. He helped Brown with some scales and other equipment just to get them off his hands.[281] Jirdon was already an established, thriving agricultural leader in the area. He began operating a grain elevator in the 1920s about the same time Brown began planting beans. Jirdon stored the beans in sacks behind his office counter and for a short time became the local agent for Trinidad Bean Company to buy and store beans.[282] Jirdon later expanded agribusiness in the area by founding nine corporations associated with farming, livestock feeding,

Jirdon Livestock Company. A fading memory of what once was the largest individual lamb feeder in the United States, a few miles south of Morrill, can still be seen today. *Photo taken by co-author Jody L. Lamp.*

This page: Case goods and warehouse stacks of dry edible beans. Across Nebraska, warehouses ready for shipment were a common scene after the passing of the Marshall Plan in 1948. An American initiative to aid western Europe economies after the end of World War II, the plan included sending food, grown by American and Nebraska farmers, for relief. Image circa 1949. *Courtesy of Kelley Bean Company.*

fertilizer, grain, radio stations and banking. Jirdon Livestock Company became the largest individual lamb feeder in the United States. And in 2000, eighteen years after his death, the *Scottsbluff Star-Herald* named Jirdon "Citizen of the Century" for his "significant, lasting and positive contributions to the Nebraska Panhandle."

At the peak of his success, Chester B. Brown died at age forty-eight of a ruptured appendix on October 1, 1939. Survivors included his wife, Susie, of twenty-two years of marriage; son Bernard Brown, twenty; daughter, Katherine Lorraine Brown, eighteen; and son George G. Brown, sixteen. As George G. noted, "Chester succeeded due to hard work, perseverance and an incredible work ethic, in addition to his foresight and desire to succeed. He never for a moment felt that he wouldn't make it."[283]

At the time of Brown's death, he owned ten bean cleaning and processing plants in Nebraska and three in Idaho and worked with two Wyoming railroad shipping buyers. Brown left the bean company in trust for his oldest son, Bernard, and to the Morrill facility plant manager, Robert L. Kelley Sr., who joined the company in 1927 at the age of nineteen. Kelley was promoted to president, and he served that position for the next thirty years.

Compelled to honor Brown's agriculture accomplishments and leadership, well-known Nebraskan historian Addison Erwin Sheldon, at seventy-eight years old in 1939, wrote the following tribute letter to the editor of the *Business Farmer*:

> *Dear Editor,*
>
> *I would like to pay a brief tribute, in my own name, to the memory of Chester B. Brown, founder of the bean industry in the North Platte Valley. It was my good fortune to know Mr. Brown at the very beginning of his remarkable career. He was a discoverer, an inventor and an agricultural leader. In addition, he was a fine example of a model, exemplary citizen.*
>
> *And I take this occasion to put into print what Mr. Brown many times told me on his own motion: that in the creation of this new crop and its market for the farmers of the North Platte Valley, his most helpful advocate and promoter was* The Business Farmer *and its editor.*
>
> *Mr. Brown was a member of the Nebraska State Historical Society, also, and was always very much interested in the preservation of the history of Nebraska.*
>
> *Some day, while we are erecting monuments and markers to the memory of the Oregon Trail, I shall move to erect, in the most appropriate place on*

one of our leading highways in the Valley, a historical monument to Chester B. Brown, creator of a new industry in irrigated western Nebraska.

Most Sincerely,
Addison E. Sheldon[284]

Born in 1861, Sheldon spent eight years in western Nebraska with his first wife, Jennie Denton, as he served as the editor for the *Chadron Signal* from 1888 to 1896. Sheldon recalled his years in Chadron as "among the best years of life," living in the area he called "Mountain Nebraska."[285] His career as a newspaperman in western Nebraska is noted because he was able to help shape public opinion and keep homesteaders informed through his real-life experiences. Sheldon eventually left the Sandhills for Lincoln and pursued a master's degree in history at the University of Nebraska–Lincoln. After Jennie passed away in 1897, Sheldon married a woman named Margaret E. Thompson from Beaver Crossing in 1907.[286] He earned a doctorate degree in history from Columbia University and became the superintendent of the Nebraska State Historical Society in 1917. He served as the editor of the state historical society's magazine until 1928. Sheldon believed that historical details were not only important to remember, but that they also must be written down. He noted in his book, *History and Stories of Nebraska* (1913), "The pioneer days are past, but their witnesses are in our midst. It is well for us to recount their deeds while they are still among us."[287]

The Kelley Bean Company

The Chester B. Brown Company was reorganized into a limited partnership and later incorporated. To meet industry demands and increase the marketability of its products, the bulk of Great Northern crop was marketed to Kansas City for distribution, with another portion going to the Otoe Food Products Company in Nebraska City for canning. By the late 1930s, other bean businesses had entered the market in western Nebraska and Wyoming, including the Farr-Wyoming Company, Henry Chapman of Mitchell, Lupher and Sons of Minatare, Leon Moomaw of Bayard, Midwest Bean Company of Gering and Peterson Bean of Scottsbluff. As production acres increased, markets continued to open throughout the Midwest, including Illinois, Indiana, Kentucky and Tennessee.

The total bean acreage in Nebraska grew on a steady basis, reaching twenty-seven thousand acres by 1941. During World War II, from 1942 to 1943, bean-growing acres had increased in the North Platte Valley and averaged at sixty-seven thousand acres for the next twenty-four years.[288] By the 1950s, the Chester B. Brown Company had entered the export market, as bean production acres reached a high of eighty thousand. Other bean companies in the Platte Valley included Berger (a division of ConAgra), Trinidad Bean and Jacks Bean Company.

By 1969, Robert L. Kelley Sr. had decided to leave Chester B. Brown and form Kelley Bean Company. He retained ownership of his one-third share of the Chester B. Brown corporation stock.[289] His sons Gary and later Robert Jr. (Bob) joined him to help run the family's new business. Kelley died in 1974, leaving Gary as president and general manager and Bob as executive vice-president and operations manager. On June 30, 1982, the Brown brothers sold the bean company with fifteen plants,

Left to right: Gary Kelley, oldest son of Robert L. Kelley Sr., and Wayne Snyder stand outside the Chester B. Brown Company. Image circa 1966. *Courtesy of Kelley Bean Company.*

cleaners and buying stations to the Kelley Bean Company, with headquarters in Scottsbluff, under Gary Kelley and Robert Kelley Jr.'s leadership, to form a reunited Kelley Bean Company Inc.

In 2006, under Bob Kelley's leadership, Kelley Bean acquired ConAgra's remaining dry bean operations. Eleven other acquisitions over the years have formed one of the largest originators and processors of dry beans in the United States. Today, the company is led by third-generation Kevin Kelley. The Kelley Bean Company family and its employees have had the support of several generations of dry edible bean growers to be one of the largest originators and marketers in the United States. "None of this would have been possible without the dedication and hard work of the world's best group of employees and growers," said Kevin Kelley, Kelley Bean Company president. "We are mindful of our history and

Portrait of Robert L. Kelley Sr., who joined the Chester B. Brown Company in 1927 at age nineteen. He was promoted to president and served that position for thirty years before starting the Kelley Bean Company in 1969. *Courtesy of Kelley Bean Company.*

the responsibility we have to our employees and customers in safely and affordably feeding the world right here from Nebraska."

While reminiscing and sorting through stacks of Kelley family photos, albums and company memorabilia for the pages of this book, brothers Gary and Bob shared stories interchangeably and often finished each other's sentences. In no particular order, each picture they held sparked special memories for them of the family and businessman they knew their father to be.

Robert L. Kelley Sr. married Frances Fox, the daughter of a doctor in Morrill, in 1933. The couple had four children: Gary, born on January 13, 1935; Judith Kay Kelley (Hinze), born on October 16, 1938; Susan Jane Kelley, born on September 13, 1941; and Robert (Bob) Jr., born on December 6, 1945. Gary joined the Chester B. Brown Company business in 1960 and founded the Kelley Bean Company in Henry with his dad in 1969. Two years later, Gary became president of the newly formed Kelley Bean Company. Bob joined the company in 1972. They learned from their

Remnants of the old Chester B. Brown plant along the Scottsbluff/Gering Highway can be seen today behind the Kelley Bean Company sign. *Photo taken by co-author Jody L. Lamp.*

dad, who exemplified hard work ethic, the ability to surround themselves with good people. After decades of milestones and events that shaped the company's history, Gary and Bob were honored for their own hard work and contributions when they were inducted into the Nebraska Business Hall of Fame in 2007:

> *Kelley Bean's reputation for quality and service has enabled them to expand their markets globally into every continent except Australia. The Kelley Brothers pride themselves on their relationships with grower and dealers at home and abroad. The company delivers quality at every level of bean production through the Kelley Bean Vertical Integration system of research, production, processing, distribution, culminating with the end consumer. They partner every company initiative with quality control for the customer. Their mission is to understand and deliver superior value with absolute integrity.*
>
> *The brothers maintain a strong sense of loyalty and commitment to the North Platte Valley area that headquarters their six-state operation with 28 plants. They both credit the company's success to the outstanding employees and management team at Kelley Bean. Today, a third generation family management is in place and poised to lead a team of outstanding employees into the future.*[290]

The Kelleys—Gary and son Kevin, as well as Bob along with sons Bryce and Chris—have held and continue to hold various local, regional positions and national leadership roles in trade commissions within the U.S. dry bean industry. Their international travels have taken them to countries and continents far from the comforts and familiarities of their western Nebraska upbringings. "People who consume beans in the world know the Kelley Bean brand and they know Nebraska," said Bob Kelley, explaining that the company has been exporting its products since right after World War II.

In 2005, Bryce, who serves Kelley Bean in business development and sales, was part of a ten-member trade delegation led by former Nebraska governor Dave Heineman. The group included Nebraska Department of Agriculture director Greg Ibach and other representatives from the Nebraska Farm Bureau, as well as the state commodity organizations. The delegation traveled to Cuba to meet with Fidel Castro, who was governing the Republic of Cuba as president at the time, to negotiate a deal for Nebraska to export $17 million in agricultural goods to the communist nation. A decades-old U.S. embargo against Cuba had been lifted, and Nebraska agriculture leaders aimed to seize a new export market opportunity. Bryce represented the Nebraska bean industry when the deal was inked to include selling Cuba five thousand tons of Great Northern beans, three thousand tons of pintos and black beans and other agriculture products.[291]

Other crops included in the Cuba deal that trip were millions of dollars of Nebraska beef, corn, wheat and soybeans. But more than a decade later, the promising trade deal has all but disappeared as the embargo enters its fifty-sixth year. While it's legal to sell U.S. crops and food to Cuba, it's not easy for individual states to sell and work with the Cuban government directly, as the current U.S. law requires Cuba to pay upfront for all goods, with a bank in a third country serving as the middle person. Proponents for trading with Cuba say that this process is different from how products are sold to almost every other country in the world.[292]

The Kelley Bean Company buys Great Northern, small red, pinto, small white, pink, light red kidney, dark red kidney, navy and black beans directly from contracted growers. Under the Brown's Best and La Rosa brands, as well as some private labels, Kelley Bean Company markets a full array of dry beans, peas, lentils, rice and popcorn nationwide to export markets around the world. International markets include Africa and the Middle East, Central and South America, the Caribbean, the Mediterranean, Mexico, the Pacific Rim and western Europe.

Bob Kelley said that Iraq currently is one of the company's biggest export customers. However, getting the beans to Iraq citizens and Syria refugees posed challenges in 2013 through 2014. The Great Northern bean market was nearly halted when Islamic State militants (ISIS) began killing truckers transporting the products through Turkey.[293] Buyers from Turkey had signed lucrative contracts with American processors, including Kelley Bean, to feed refugees. According to USDA data, U.S. dry bean farmers planted 107,000 acres of Great Northern bean acres in 2014, compared to 75,500 in 2013. After the 2014 harvest, the plan was to haul the contracted beans to the West Coast, load the beans onto ships destined for Turkish ports and then pack them on to trucks to get to the refugees. After ISIS started assassinating truck drivers, Turkish traders "reneged on their contracts," leaving American processors holding the surplus.[294] Additionally, Russian military forces annexed Crimea from the Ukraine, which caused the United States and the European Union to impose sanctions. The Russian government retaliated by banning all food exports from the countries, affecting the market for Nebraska beans once again.

Facing a near market crash in 2015 as processors stopped buying beans from farmers, the Nebraska Dry Bean Commission and other industry leaders solicited the help of Nebraska governor Pete Ricketts to lobby the USDA to buy 25 million pounds of dry edible beans using a food purchasing program that dated back to the Great Depression, called Section 32, part of the Agricultural Adjustment Act of 1935.[295] As of late 2015, the USDA authorized the purchase of about $14.5 million on the Great Northern and pinto beans surplus for distribution to schools and community charities for food banks and disaster relief.

Despite facing yearly domestic and international market fluctuations, the Kelley family and their business remain committed to their customer farmers. The company serves wholesale and retail markets domestically and abroad through a system of brokers, agents, warehouse and direct sales. With headquarters in Scottsbluff, the company has twenty-seven domestic plants in Colorado, Idaho, Michigan, Minnesota, Nebraska, North Dakota, Texas, Washington and Wyoming. Domestic sales offices are located in Illinois, Texas, Michigan, Florida, Minnesota and Nebraska. Most recently, Kelley Bean acquired the Yellowstone Bean Company in Bridger, Montana.

In 2015, the Kelley family was awarded the Oregon Trail Community Foundation Ag-Award for their contributions to the agricultural success in the Panhandle. Owen Palm, CEO of 21st Century Equipment and chair of the selection committee, commended the Kelley family for their "immeasurable

contributions" to agriculture:[296] "The Kelley family's strong commitment to the communities where they live and work, combined with their tremendous growth locally, nationally and internationally, make them our unanimous choice for receiving the 2015 Oregon Trail Community Foundation Agri-Recognition Award."[297]

Nebraska Dry Bean Commission

Beans have no peers among foods when they are properly prepared. In addition, they are a symbol of thrift; they are the poor man's beef; a warm cloth against the economic cold and probably the most American of all foods.

—*excerpt from* The Bean Bag *(spring 1989)*[298]

Classified as a "pulse crop" like its lentil, dry pea and chickpea friends, dry edible beans provide a supplemental and sustainable protein option around the world for a desirable high-fiber, low- to no-fat, nutrient-dense diet. For individuals who medically require or desire a sodium-, cholesterol- and gluten-free diet, pulse crops provide an affordable alternative to traditional animal protein.

Since 1987, the Nebraska Dry Bean Commission (NDBC) has served an important role in providing leadership for the state's dry bean producers and processors to advance the industry through research, international and domestic marketing, publicity and education. The year 2016 was declared as the International Year of Pulses by the sixty-eighth session of the United Nations General Assembly on December 20, 2013. During the 2016 International Year of the Pulses, the NDBC participated in industry promotions to celebrate dry bean production and consumption during the campaign. Pulse crops traditionally require little to no irrigation and help enrich the soil where they grow, making them a good rotational crop for growers.

For nearly a century, Nebraska's North Platte Valley and High Plains Panhandle dry bean producers have planted, harvested and marketed some of the highest-quality dry edible beans in the world, consistently ranking first and second in the United States for Great Northern and pinto beans production, respectively. Courtney Schuler, chairwoman of the NDBC, said that the commission continually looks for opportunities

to increase public awareness and educate consumers about dry beans' nutrient-dense benefits: "A new focus for NDBC is to increase our promotional activities to demonstrate how important Nebraska's agriculture is to our state's economy. Every generation, fewer individuals are directly related to agriculture, and it's critical for us to continue to tell our story."

With the bulk of the state's crop predominately grown in western Nebraska, it makes sense for the NDBC and the Nebraska Dry Bean Growers Association offices to be at the Panhandle Research and Extension Center in Scottsbluff. However, with most all the state crop agencies, executive directors and producer/grower associations based in Lincoln, the dry bean commission and association are the farthest west location of all the state agriculture agencies. The association was founded in 1982 after a steering committee of twenty bean growers, in cooperation with processors and the UNL Panhandle Extension Staff, worked together for nine months to organize the association and adopt bylaws. The association board of directors represents districts and meets regularly to stay on top of issues affecting supply and demand.

In 2014, Nebraska dry bean farmers produced 3.8 million hundredweight (one-hundred-pound bags) of dry-edible beans valued at $120 million to rank the state third nationally in overall dry edible bean production.[299] The U.S. Department of Agriculture and Nebraska state crop reports estimate 2016 Nebraska dry bean production at 2,964,000 hundredweight down from 2015 production of 3,177,000 hundredweight with harvested acres estimated at 130,000 acres.

"Although current USDA crop reports estimate 2016 production numbers to be down from 2015, dry beans will continue to be a significant rotational crop in our region for irrigation management, soil fertility, pest management and market volatility," Schuler said. "And our producers' dry beans will be sought out by customers worldwide because of their consistent superior quality."

The University of Nebraska–Lincoln Dry Bean Breeding Program

Former senator Ben Nelson stated, "The USDA says Nebraska accounts for the majority of the U.S. Great Northern crop which means if you're eating baked beans in Boston, Senate Bean Soup in Washington, a cassoulet in Paris, a vegetarian stew in San Francisco, or white bean chili in Dallas, and

they're made with Great Northern Beans, chances are they were grown in Nebraska."[300]

Each year, Dr. Carlos Urrea and his crew at the University of Nebraska Panhandle Research and Extension Center carefully place various beans and seeds in numbered packets and sort in planting boxes. After each variety is planted and harvested, results are logged and documented to track traits like yield potential, disease resistance, water-use efficiency, drought tolerance and overall seed quality. Each bean has a name, a story and a family tree. Urrea smiled as he intimately acknowledged their generational lineage—Great Northern, pinto, small red, black, light red kidney, cranberry—through years of research and trials from the Nebraska Dry Bean Breeding Program. The beans grown and adapted in western Nebraska help to feed the world and sustain the diverse growing regions, climates and soil conditions.

Through financial support from the Nebraska Dry Bean Commission and the Nebraska Department of Agriculture, Urrea set up trials under greenhouse conditions where hundreds of plants are all labeled and arranged according to the tests they are going through. Some look better than others as plants experience the stages of disease exposure and other adverse growing conditions in the temperature- and moisture-controlled environment.

As a dry bean breeder specialist, Urrea came to the Panhandle Research and Extension Center in 2005 from the University of Nebraska–Lincoln, when the program moved from the Lincoln campus more than four hundred miles west to be closer to the plots that were started by plant breeder Dermot Coyne in 1961.[301] Nebraska leads the world in production and research development for the dry bean. More than twenty-six counties in Nebraska provide the majority of acres of production of the dry beans. Of those, eleven counties in the Panhandle account for the largest share of the crop, with Scotts Bluff, Box Butte and Morrill Counties alone making up nearly half of the state's bean production.[302]

The annual North Platte Project Water Tour—sponsored by the Scottsbluff/Gering United Chamber of Commerce, North Platte Resource District and many other vested partners—gives a firsthand experience about how western Nebraska's dry bean farmers utilize the famous canal and irrigation water system, projects and engineering feats that provide the ample moisture to feed the North Platte Valley crop acres. The soil, elevation, climate and moisture provide one of the best growing environments in the world for dry bean production.

Dr. Urrea and his staff also help demonstrate research results on educational posters they share comparing dry bean production across the United States

Dr. Carlos Urrea, a dry bean breeder specialist at the Panhandle Research and Extension Center in Scottsbluff, continually tests and documents dry edible bean trait trials to help increase yield potential, disease resistance, water use efficiency, drought tolerance and overall seed quality. *Photo taken by co-author Jody L. Lamp.*

to validate Nebraska as a leading producer for black beans, Great Northern beans, light red kidney beans, navy beans, pink beans, pinto beans and garbanzos. Worldwide, dry beans are the second most important legume after soybeans, but they are the first one for direct consumption.[303] The dry bean is seen as a powerhouse for nutritional health and food security.

The Beef State

Beef production is the largest sector of agriculture in Nebraska with the industry generating more than $7 billion in annual cash receipts. Cattle outnumber people in Nebraska more than three to one.[304]

Nebraska's position as the nation's leading cattle state has been synonymous with its declaration of existence. From modern-day Nebraska motorists using recognizable, state-issued "The Beef State" license plates to the legendary horseback cattle drives to Ogallala, the end of the Texas Trail; the development and dismantling of Omaha's Union Stockyards; and meat companies like Omaha Steaks®, which produces the quality of corn-fed

beef, Nebraska has become known to American and worldwide consumers. It's hard to dispute the perfection that creates the greatest natural cattle country in the heartland of America. With a hearty combination of natural attributes and outstanding husbandry of its cattlemen and women, Nebraska richly ranks and claims to be the "Best Cow State in the World."

Historically, Nebraska ranchers have remained humble and unpresuming about their impact and contributions to Nebraska's agriculture history. For example, Robert "Bob" Howard, who served as the editor for the *Nebraska Cattleman*, the official publication of the Nebraska Stock Growers Association from 1949 to 1988, was once asked in the early 1950s if he was starting to run out of material for his publication, as he had already been writing an article every month for nearly five years.[305] Bob answered that the people "well-worth writing about" could continue his monthly articles for twenty-five more years and could come from Cherry County alone. During his tenure with the association, Howard went on to interview pioneer cattle families, resulting in 225 articles under the title "Hello There." His vast knowledge of the industry and association with the *Nebraska Cattleman* prompted nationally known Nebraska State Historical Society historian and author Nellie Snyder Yost to collaborate with him and others in 1966 to write *The Call of the Range*, a factual history of Nebraska's cattle industry and trials and triumphs of its pioneers.[306]

Howard, who later penned his own obituary before his passing at age ninety-five in 2013, shared this quote from Dr. Alan Swallow as he wrote to describe Yost in the "About the Author" section of *The Call of the Range*: "This project is turning out most impressively. Mrs. Yost, exactly the right author for this work, has written not a history merely of the Association, but has taken the opportunity to write a truly full-bodied history of the growth of the cattle industry in its largest manifestation in the United States."[307]

When Nebraska became a charter member of the National Cowboy Hall of Fame upon its founding in Oklahoma City in 1955, Earl Monahan, another Hyannis-Sandhills native, was named chairman and Colonel Arthur Weimar Thompson of Lincoln served as honorary chairperson. Monahan, who was serving as director of the American Herford Association at the time, was recognized as one of the leading livestock men in the country, while Art Thompson had already established himself as perhaps the best-known livestock auctioneer in America.

The Capitol, the Colonel, the Cattle

You men are the backbone of America. Burn all the cities down—you farmers and ranchers will live. Tear up the farms and ranches—that's the end for everybody.[308]

—*Colonel Arthur Weimar Thompson*

Nebraska's tribute to its agriculture ancestral roots, citizens and character soars more than four hundred feet and has seized the capital city skyline since 1932. The product of a nationwide design competition won by New York architect Bertram Grosvenor Goodhue in 1920,[309] Nebraska's state capitol intentionally and symbolically represents agriculture throughout its structure as the foundational cornerstone on which life in Nebraska commenced. The present building was the third to be erected on the site, between H and K Streets and Fourteenth and Sixteenth Streets in Lincoln. Built in four phases from 1922 to 1932, Bertram Goodhue selected Lee Lawrie, sculptor; Hildreth Meiere, tile and mosaic designer; and Hartley B. Alexander, thematic consultant for inscription and symbolism.[310]

Throughout its exterior and interior, the capitol depicts Nebraska's grain crops of corn or maize from the state's original inhabitants, the Native Americans, and the wheat that the pioneers were known to bring with them. The nineteen-foot-tall *Sower* stands on top of the golden dome and faces the western horizon to represent agriculture as the source for all civilization:[311] "Once people were freed from the constant need to find food by the ability of agriculture to produce surpluses, civilizations began to flourish, the arts and philosophy expanded, governments developed and people began to work together for a more noble life."[312]

Below the *Sower* is a mosaic Native American symbol called the "Thunderbird" to signify rain and water, on which Nebraska's first and present-day farmers remain dependent for all its agriculture production. Inside, on the second-floor courtyard hallways to the north and south of the legislative chamber,[313] the Nebraska Hall of Fame officially recognizes twenty-five of the state's most prominent individuals with busts of each on limestone plinths. When established in 1961, the Hall of Fame's criteria selection honored people who:

Recognized by the *World's Who's Who* as the "leading purebred livestock auctioneer in the United States and Canada," Arthur W. Thompson, born on a farm near Bradshaw in York County, called more 7,500 livestock sales by 1950, for a tally equaling $250 million worth of cattle sold in North America. *Courtesy of Art Thompson, grandson of Arthur W. Thompson, Lincoln, Nebraska.*

- were born in Nebraska,
- gained prominence while living in Nebraska or
- lived in Nebraska and whose residence in Nebraska was an important influence on their lives and contributed to their greatness.[314]

In the southeast corridor between the bust of Harley Burr Alexander, the thematic consultant to the Nebraska state capitol, and Dwight P. Griswold, Nebraska's twenty-fifth governor (1941–47), is the bust of "Dean of American Auctioneers," Arthur Weimar Thompson. Recognized by the *World's Who's Who* as the "leading purebred livestock auctioneer in the United States and Canada," Thompson called more than 7,500 livestock sales from New York to California and from Canada to Mexico in his forty-six-year career.

Born on a farm near Bradshaw, York County, on August 21, 1886, to Elwood and Sarah Weimar Thompson, young Art spent his childhood

walking "thousands of miles" behind a horse-drawn cultivator on his parents' farm. When the plowing, corn picking and other chores were done, twelve-year-old Art was occasionally allowed to accompany his father and older brother, Edgar, to the local farm auctions. Those rhythmic mellow tones from the auctioneer's cadence resonated with Arthur and sustained his dreams between auction visits as he trudged through the field. "As I walked those hot weary miles under the Nebraska sun around and around those fields, I resolved then and there that someday I was going to have a job where I could get a drink of water anytime I wanted it,"[315] Thompson was quoted in a 1949 interview with the *Hereford Journal*.

Arthur stayed at that family farm, where he masterfully perfected "corn shucking" and proclaimed himself to be the "best cornhusker in York County." When he could find time to get away from the farm, Art would attend York College and later Lincoln Business College. The thought of becoming a railroad man became reality when he accepted a job in the railway mail service. The Burlington line route would take him from Lincoln to Billings, Montana. But a brief conversation with a friend who was in the mail service changed his life forever. "Don't do it, Art," his friend pleaded. "Don't make that run. If you do you'll be stuck there for life. You got better things ahead of you."[316]

And so he didn't. Thompson credited that ten-minute conversation with forever alternating his life's path. Rather than joining the railway, Art went back to York County and rented a farm from Charleston farmer N.B. Swanson, whose daughter, Viola, later became Mrs. Arthur Thompson.

In 1906, Art started in the auction business. He continued to attend area farm and livestock auctions and read journals to learn and perfect his auctioneering craft.[317] Under a three-year apprenticeship with local York farm auctioneer T.W. Smith, Thompson finally got his break when Smith was appointed warden of the state penitentiary. Up until then, Thompson had attended purebred cattle auctions but only on occasion got to sell a few horses if a farmer had a few extra toward the end of the sale. For three years, Art worked the auctions without pay while he continued to work on the farm. Now, on his own, Thompson was at the helm of the auction stand for 130 times that first year. He prided himself on keeping the tone, language and stories during the auction clean—meaning no off-color stories and no offensive language. He noted one of his auction success stories when he sold his neighbor's purebred

sow. The young auctioneer spent weeks familiarizing himself with the animal's history and pedigree. Thompson practiced his opening speech and perfected the "persuasive eloquence of skillful salesmanship" to bring a $100 figure in for the farmer.[318]

Another success story was when a man, who had brought his young son, came to a hog sale and came up and congratulated Colonel Thompson on having conducted such a fine auction. Thompson told the man he hadn't considered it a fine auction at all because he was disappointed in the prices. The man explained that the sale, in his estimation, was fine because it was suitable enough for his son's young ears, and he could share with his wife when they got home that the boy hadn't heard any crude talk that often accompanied such events. "That," said Colonel Art Thompson, "remains as one of the finest compliments I have received in 42 years on the auction stand and I have tried never to forget the reason for it."[319]

While the places, personalities and animal antics occasionally make for humorous anecdotes and commentary, auctions are a serious venue of business for both sellers and buyers. Thompson set the standard by conducting every transaction with his commanding professionalism. He believed in the value of auctions, the concept of "True Price Discovery" and the effects each sale could have on the entire industry for breeders to obtain premiums for their top specimens. On January 1, 1922, the thirty-five-year-old placed his picture and first advertisement in the *Hereford Journal*:

> *Selling Purebred Livestock is my business.*
> *Years of experience enable me to give efficient and satisfying service.*
> *I respectfully solicit a share of your sales. Terms moderate.*
> *A.W. Thompson, York, Neb.*[320]

Backed by a solid sales history and knowledge of purebred livestock, Thompson's auctioneering career grew expeditiously. Hereford breeders quickly recognized his ability to bring high dollar for their bloodlines, and soon he was booking sales from coast to coast and from Canada to Mexico. The 1930s were lean years for America's farmers and ranchers, and Thompson occasionally found himself auctioning dispersal sales that yielded so little that he would not accept a fee for his time. Instead, he was known to hand the commission back to the farmer and rancher and tell them to go buy groceries for their families.[321]

The Chicago International Exposition recognized Colonel Arthur W. Thompson of Nebraska in 1951 with an official Saddle and Sirloin Club portrait to honor his work in the American livestock industry. Today, the portrait is displayed with others at the Kentucky Exposition Center in Louisville, Kentucky, home of the North American International Livestock Exposition (NAILE). *Photo of portrait courtesy of Art Thompson, grandson of Arthur W. Thompson, Lincoln, Nebraska.*

Even in the darkest days during the Great Depression, Thompson kept his faith in good livestock and the future of agriculture. "It is better to light a candle than to curse the darkness," he would say as he encouraged genetics and quality breeding to uplift the sagging market.[322]

By the mid-1940s, Thompson was choosing to narrow his auction work exclusively to selling Hereford cattle, which was welcome news to those breeders.[323] The industry reached a pinnacle point in herd improvements, which attracted quality buyers. From 1945 to 1947, Thompson had the distinction of selling Hereford bulls at various livestock shows and public sales that topped the market at $50,000, even up to $65,000 a head. At the time, only eight, and later ten, Hereford bulls had ever been sold for more than $50,000, and it was Colonel Thompson who had auctioned them.

On April 24, 1947, after three years of being an inactive club because of World War II, the Block and Bridle Club of the University of Nebraska

College of Agriculture honored Thompson as its seventh inductee by hanging his portrait in the Animal Husbandry building. He was known to advocate for modern methods of animal husbandry and worked closely with the University of Nebraska–Lincoln College of Agriculture (Institute of Agriculture and Natural Resources). He encouraged youth at the annual 4-H sales at the Nebraska State Fair (where the Nebraska Innovation Campus is located now), and for twenty-six years, beginning with the first one, he conducted the baby beef sales there without a charge or fee for his time.

In his lifetime, Thompson called sales at principal venues such as the Chicago International Stock Show, the Denver Stock Show, the Kansas City American Royal, the San Francisco Cow Palace and the National Ram Show in Salt Lake City, Utah.[324] He set a world record at the Denver National Western Show when he sold 316 carloads of feeder cattle in one day. By 1950, his sales tally equaled $250 million worth of cattle sold at more than seven thousand sales across North America.

In 1951, the Chicago International Exposition honored Thompson among the portrait gallery at the Saddle and Sirloin Club, a distinction to honor leaders in all facets of the American livestock industry. The collection was established at Chicago's Union Stock Yards in 1903 but was later moved in 1976 to the Kentucky Exposition Center in Louisville, Kentucky, home of the North American International Livestock Exposition (NAILE).

Thompson and his wife, Viola, established the Arthur W. and Viola Thompson Scholarship at University of Nebraska–Lincoln to award outstanding second-semester sophomore or junior animal science majors.[325] They had one son, Elwood Nelson "Jack" Thompson. Thompson's brother, Edgar, stayed connected in the cattle business in both York County and Bassett, Nebraska.

Even toward the end of his career, Colonel Thompson reportedly never regretted his choice. "But I'll admit," he said, "that if I could have foreseen the long trips, the sleepless nights, the cold and rain, the long absences from home, and a few other things…I might have thought better of that walking cultivator."[326]

In his opinion, Thompson believed that a successful auctioneer must retain these qualities: "Pleasing personality, strong physique, alert mind and eye, ability to make instant decisions, a pleasant and strong voice, pleasant disposition, ability to express oneself well, ability to appraise values."[327]

Thompson has probably done more than anyone else to make Herefords the highest-priced cattle breed.[328]

How Iowa Beef Processors Revolutionized the Beef Industry

We must rebuild an industry and rebuild and reshape its economic pattern.
—*Currier J. Holman, co-founder, IBP*

Our goal is to be the lowest cost producer in the beef industry.
—*Robert L. Peterson, president and chief operating officer, IBP*

Iowa Beef Processors (IBP) Inc. began in Denison, Iowa, in 1961 with a single meat processing plant. The owner had a goal of bringing a new approach to both the mechanics and economics of processing cattle: "Our concept of the changes necessary to alter the profit pattern in the meat industry after two decades of complacency involves always keeping in mind—plant location, plant construction and people."

The first step in becoming a low-cost producer proved to be going to the source of the supply. Creating a "cluster" of plants located near the strategic center of various cattle feeding areas helped eliminate the cost of freight and other cost prohibiting factors. To IBP and its buyers, the one-hundred-mile radius around every processing plant was "one giant stockyard and every farm in the area a stockpen." In locating its plants closest to the source of supply, IBP recognized and identified three separate and distinct feeding areas of the United States, which includes Iowa, Nebraska and Kansas.[329] IBP relied on the cattle buyers to bridge the link between feeders and farmers. With strategic locations of IBP's plants in the identified three states, most cattle buyers were able to purchase their cattle within a one-hundred-mile radius of their homes.

Secondly, the construction of a plant was geared toward building a "beef factory" to include adequate refrigeration and chilling of the beef carcass to prevent shrinkage. And lastly, the emphasis was placed on recruiting highly respectable people with more than 280 combined years of meatpacking experience.

IBP initiated the concept of processing beef into different cuts, which were then shipped in boxes to meet the various specifications of customers throughout the country. Before IBP, beef was shipped from the Midwest to the East Coast, and then certain cuts not popular in the East were shipped all the way back to California—and vice versa. The boxed beef concept helped eliminate waste.

The next major development to revolutionize the industry was the necessity of developing an airtight package capable of preserving open surfaces with no loss of moisture during the shipping process. Beef consumers benefited from the innovations and efficiencies made by IBP, as boxed beef helped create lower beef prices and improved meat quality at the counter. A major move toward processing beef came in 1967 with the construction of a new plant in Dakota City, Nebraska, part of the Sioux City, Iowa/Nebraska/South Dakota metropolitan statistical area.

In 1976, IBP entered the pork business with the purchase of Madison Foods at Madison, Nebraska. Now known as Tyson Fresh Meats, the pork processing plant remains the largest single employer in Madison with 1,100 full-time employees.[330]

To celebrate, connect and unite the agricultural and business communities, the Madison and nearby Norfolk Area Chambers of Commerce began the tradition of hosting the Northeast Nebraska Agriculture Appreciation Banquet: "To promote today and tomorrow's agriculture and its importance to the Northeast Nebraska economy....Agriculture is one of our area's leading industries. The Ag Appreciation Banquet offers an evening of fabulous food, entertainment and camaraderie for people in and out of the Ag industry. Along with the presentation of numerous awards, an Ag-related guest speaker rounds out the evening. The Agri-Business Council members appreciate our area farmers and ranchers for their economic contributions to the Madison area."[331]

Although a sequence of events from 1967 to 1970 led to dark times for IBP, a 1978 study by a Harvard Business group described IBP as "the most successful firm in the meat packing industry."[332] At the same time, a Fairbury native, Dale C. Tinstman, served as IBP's president and as a member of the executive committee from 1976 to 1977, vice chairman from 1977 to 1981 and co-chairman of the board of directors from 1981 to 1983. Dale met his wife, Jean "Sunny" Sundell, in 1938 while they were attending the University of Nebraska–Lincoln. Dale graduated with a bachelor of science degree in 1941 and earned his juris doctor degree from the UNL College of Law in 1947. Jean graduated with a bachelor of science degree, majoring in nutrition, and before marrying Dale, she served as the assistant director of the Nebraska Dairy Association in 1942. Dale served two tours of active duty in both World War II and the Korean War, taking the couple to Texas, Kansas, Maine and Louisiana before returning to Lincoln to raise their son and two daughters.

From his Lincoln office, Tinstman advised, directed and witnessed IBP founders Holman and Peterson as they revolutionized America's beef

industry with the concept of centralized processing plants, boxed beef and vacuum packaging. Technology advancements in the late 1970s would further transform the industry with electronic marketing of cattle. From its beginnings, IBP was built on the concept of adding value, not cost, to its products. "Out of our past—anguished at times, buoyant at others—comes the shape of this enterprise," Holman stated. "The truth is that IBP is a team of enthusiastic, innovative people who have a realization that they are building an institution which will make a mark in our society. Shape and character, after all, will tell the tale of what is to come much more accurately than numbers, data projections or any of the other traditional tools that are used to evaluate an enterprise."[333]

In 2001, Tyson Foods acquired IBP Inc., the largest beef packer and the second-largest pork processor in the United States, for $3.2 billion in cash and stock.[334] Tyson Fresh Meats Inc. announced in March 2015 its plans to invest $47 million on a new, expanded boxed beef warehouse as part of its commitment to the continued success of its Lexington plant.[335] Tyson Fresh Meats is the beef and pork unit of Tyson Foods Inc., which employs almost nine thousand people in Nebraska. In addition to Lexington, the company also has facilities in Dakota City, Madison and Omaha.

After a forty-year relationship with IBP, Dale retired from the board in 2000. He served on countless boards, foundations and associations and was inducted into the Nebraska Business Hall of Fame. The authors are grateful to have met and interviewed Dale before his passing on February 16, 2017.

Herefords in My Heart

Raised in Nebraska and a proud University of Nebraska–Lincoln alumni, co-author Jody Lamp said that of all the cattle breeds, she naturally favors the bald-faced, red-bodied Hereford, thanks in part to the kindness of Mr. Jack A. Tucker, of Tucker Herefords near Mullen. As a fourth grader in 1979 at Lake Minatare School District No. 64, Jody Price (Lamp), along with her classmates, was asked by her teacher to pick a town on the Nebraska map, write a letter to the town's chamber of commerce, ask for information about the town, write a report and then share the findings with the class. Jody looked on the map in the area of the Sandhills and picked what she thought was a town called Eclipse. Here are the contents of the letter she received and still has to this day:

JACK A. TUCKER
TUCKER HEREFORDS
MULLEN, NEBRASKA 69152

March 28, 1979

Dear Jody,

Thank you for inquiring about Eclipse. I will give you a brief history.

Eclipse is an Episcopal church and cemetery located 30 miles southwest of Mullen, Nebr., on the Tucker Hereford Ranch. It got its name from an original post office located on our ranch in the early 1900s, which was ran by my grandmother.

The cemetery was here first—the first burial being a small child from homesteaders in the area in 1887. The church was built in 1916 and still stands as originally built, and is used often for services, funerals and there has been several weddings here.

It is unique in that it is 30 miles from any town and it is the only church and cemetery in the state of Nebr. that I know of that are together in one fenced location. The land was donated by the Tuckers and as expansion is needed, I give more land to this venture.

Jody, we do not have tourist maps, guides, or museums but if you, your class or family are ever in the area we would be very honored to show you this famous little landmark in the center of the Sandhills.

Sincerely,
Jack A. Tucker

P.S. Thank you for writing. I will send you a picture when I find one.

Eclipse Church sits as a landmark in the center of the Nebraska Sandhills country on the Tucker Herefords ranch near Mullen. The photo was mailed to co-author Jody (Price) Lamp by Jack A. Tucker on April 2, 1979.

Mr. Jack Tucker kept his promise. In a white envelope with a postmark of April 2, 1979, from Mullen, Nebraska, Jody received a black-and-white photo of Eclipse Church and Cemetery. Nearly forty years later, she prays that if anyone from the Tucker family reads this story and contents of this book, the invitation to see their "landmark in the center of the Sandhills" still stands today.

Dinner Is Served. Built in 1874–75 by Israel Beetison from limestone quarried in nearby Ashland, the Beetison Mansion stands as a reminder of early Nebraska history along the Ox Bow Trail. Four generations of Beetisons lived in the home as farmers and raised livestock. The family was honored in 1974 with the Nebraska Pioneer Farm Award as a century-old farm. Placed in the National Register of Historic Places in 1977, the home has remained vacant since 1999. *Courtesy of Gene Roncka, Willow Point Gallery, Ashland, Nebraska.*

A TRIBUTE TO EAST CAMPUS

[N]o other human occupation opens so wide a field for the profitable and agreeable combination of labor with cultivated thought, as agriculture.
—*Abraham Lincoln, September 30, 1859*

What kind of crop can be harvested at the end of a growing season when no seeds are planted? Logic tells us that if we plant nothing, we will reap nothing. However, consider this: plant nothing and reap even less than nothing. Less than nothing? Yes, the act of doing nothing can not only put an individual, organization or industry behind and strapped with the possibility of never catching up, but it can also cause the byproducts of apathy and complacency. So, think of this: every year, plant a seed in the ground—or, metaphorically, plant the seed of agriculture education in the minds of our youth. With a little time, patience, cultivation, nurturing and guidance, you can expect an ample new crop of career-minded, agriculture-educated advocates every year. Agriculture education needs to start and continue with our youth to develop agriculture leaders who will ensure the future of agriculture in Nebraska, our nation and our world.

Certainly the support and interest for agricultural education has endured its hardships. While Nebraska was still a territory, the mere thought of agriculture "book learning" prompted a scathing rant from *Nebraska City News* editor Milton W. Reynolds. On March 12, 1859, he stepped up to the top of the editorial platform to debunk the thought of

building agricultural colleges all over the country, saying it was, at best, "one of the most visionary, impractical, unnecessary and useless schemes for the political self-aggrandizement that was ever thought of." Milton's discontentment continued: "We want the sturdy bone and sinew, the strong arms and stout beard, to cultivate our soil, not gentlemen farmers, kid-gloved, cologne-scented and pampered gentry, with a smattering of science—with a strong compounded laziness."[336]

The Morrill Act

Despite Reynolds's protest, two years after Nebraska attained statehood, the Nebraska state legislature on February 15, 1869, passed a bill entitled "An Act to Establish the University of Nebraska." The Morrill Land-Grant Act approved by the United States Congress and signed by President Abraham Lincoln, effective on July 2, 1862, provided a federal grant of thirty thousand acres of public land for each senator and representative in Congress. To take advantage of the provisions afforded in the Morrill Act, Nebraska had only three years after attaining statehood to pass appropriate legislation to create a university and only two years after that to erect a building and open the university. As stated in the act:

> [E]ach State which may take and claim the benefit of this act to the endowment, support, and maintenance of at least one college, where the leading object shall be, without excluding other scientific and classical studies and including military tactics, to teach such branches of learning as are related to agriculture and the mechanic arts in such manner as the legislatures of the States may respectively prescribe in order to promote the liberal and practical education of the industrial classes in the several pursuits and professions in life.

In establishing the University of Nebraska, which celebrates its 150th anniversary in 2019, the Act of 1869 provided that the university consist of six colleges, including the College of Agriculture. The board of regents asked the Nebraska legislature to deed 480 acres of saline lands to the university for the purpose of a model farm, which would be under the direction of a superintendent. The College of Agriculture was formally established by the board of regents in June 1872, and by that fall, Samuel R. Thompson had been elected to the "chair of agriculture."

Avoiding extremes, the new agricultural college tried to find a middle ground between the theoretical and practical courses of study.[337] Two courses of study were offered—one of four years and a shorter course that could be completed in three to six terms. Even with courses in place, there were no regular students attending the first few years.

To fulfill the "model farm" requirements set forth by legislation, ground was broken at the new university campus and trials of corn, oats, wheat and four kinds of sugar beets were planted by summer 1873. With the first $1,000 appropriated for improvements, the regents approved another $2,000 for Professor Thompson to buy implements and hire a farmer. From there, Thompson secured a thorough and extensive trial to test the capabilities of Nebraska's climate and try to produce beets suitable for manufacturing sugar. He presented the subject to the State Board of Agriculture, where newly elected Governor Robert Wilkinson Furnas served as the board's president. Thompson received immediate cooperation and stated in his report that Governor Furnas ordered a quantity of seed from Europe, which was to be distributed to interested persons throughout the state. The general public received notice of the opportunity through the press, and in response to the requests, Professor Thompson distributed seeds to more than one hundred people in twenty counties.[338] In exchange, people receiving the seed agreed to cultivate and send the beet specimens back to the agricultural college for analysis.

W.C. Broadbent heads the front team of horses pulling sugar beet wagons to the Roach Beet Dump, about three and a half miles north of Morrill. Image circa late 1920s. *Courtesy of the Jim Duncan family, Morrill, Nebraska.*

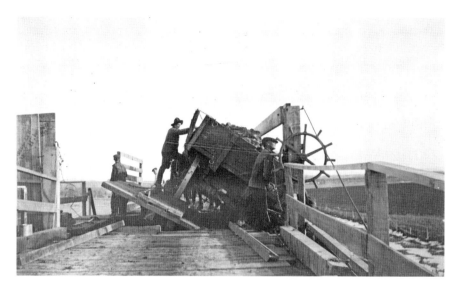

Horses hauling wagons full of sugar beets were maneuvered up ramps to awaiting railcars below. The Schoval Beet Dump was near the Broadbent/Duncan farm northwest of Morrill. *Courtesy of the Jim Duncan family, Morrill, Nebraska.*

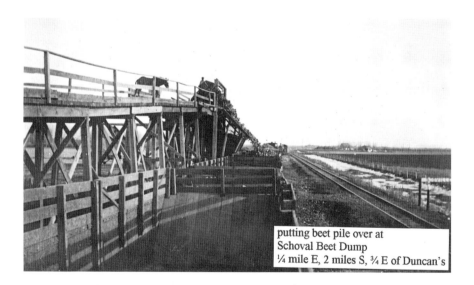

putting beet pile over at
Schoval Beet Dump
¼ mile E, 2 miles S, ¾ E of Duncan's

These trials marked the beginning of agricultural experimental work at the University of Nebraska and set the stage for the sugar beet industry in Nebraska's North Platte Valley. Today, Nebraska generally ranks fifth in the nation for sugar beet production and averages more than 1.3 million tons in production.[339]

With a new template in mind, Professor Thompson believed that a beautiful, harmonious, neat and tidy "model farm" would not ensure the agricultural college's future success or guarantee students: "Shall we arrange for an experimental farm, where it shall be our main business to discover new agricultural truth, rather than to exhibit what is old? The model farm will make the best showing to the general public and will incur less expense, but in the long run the latter will be of more real service to the State."

Determining that the original land set aside for the "model farm" was not particularly desirable for farming, efforts were made to secure another farm east of the downtown campus. On September 1, 1874, the board of regents purchased 320 acres of the Moses M. Culver farm northeast of downtown Lincoln, the present site of UNL's East Campus. A house was erected on the new farm in the autumn of 1875 that helped provide housing for the agricultural students at reasonable rates. By the end of that year, Professor Thompson was reporting that fifteen students had

On September 1, 1874, the University of Nebraska Board of Regents purchased the 320 acres of the Moses M. Culver farm northeast of downtown Lincoln, the present site of UNL's East Campus. *Archives & Special Collections, University of Nebraska–Lincoln Libraries, 520200-ECz1920.*

entered the agricultural course of study.[340] The new university "state farm" proved ideally located, "far enough from the city to be out of the way of its temptations to idleness and worse, and yet be near enough to enjoy all its literary and public advantages."[341]

The Farmers' Institute, the "Old State Farm"

In its first attempt to carry university instruction and agriculture education to the people of Nebraska and to secure more students, the College of Agriculture sponsored the Farmers' Institute. The idea came from Allen R. Benton, the university's first chancellor. The Nebraska Farmers' Institute sought to assist in promoting larger agricultural production and higher standards of living, "so that the boys and girls will love farm life, seek an agricultural education, and return to their homes upon the land, rather than be swallowed up and lost in the crowded cities."[342] Topics of discussion included crop production, soil tillage and fertility, livestock, poultry, fruit growing, road making, home economics and other similar subjects.

In its earliest days, the Farmers' Institute served as a vital force connecting the university to hundreds of Nebraska communities, as "instructions" were held in the village church, village hall or a schoolhouse. In *These Fifty Years: A History of the College of Agriculture of the University of Nebraska*, Robert Crawford described the turnout to events as "often packed to the doors by the people of the surrounding county, who considered the coming of the institute an event as great as or greater than the county fair or the circus."[343]

Benton believed that the Farmers' Institutes acted as an "extension" of the College of Agriculture. In his annual report to the board of regents for the year ending June 25, 1873, Chancellor Benton recommended that it was the university's responsibility to gain trust among Nebraskan citizens and allow for free interchange of views between agricultural professors and the farmers of the state. "I do not see why such an extension of our work would not be entirely legitimate," he reported, "and if zealously and efficiently done it would undoubtedly redound to the advantage of the University, and confer lasting benefit on the localities where they may be held."[344]

As instructed by Chancellor Benton, one of the duties of the "Professor of Agriculture" during the winter term of 1873–74 was to hold agriculture institutes at various identified locations, including Dorchester, Saline County; Palmyra, Otoe County; Seward, Seward County; and Lowell, Kearney

County. It was reported that the attendance at Dorchester's event so filled the large school room that many had to be turned away.

Although Professor Thompson resigned from his position at the agricultural college in 1875, he took various state and public instruction positions in Nebraska before his death on October 28, 1896. In a tribute upon his death, the dean of the University Industrial College, Charles E. Bessey, expressed, "As I look over the country and compare the work done by Professor Thompson in this young University, with that accomplished by men in similar positions in other institutions I am constrained to say that Nebraska was very fortunate in having the services of so cultured a man."[345]

Honoring Dr. Ruth Leverton

When we aren't writing books or strategic plans for our clients, we, as women who both love to grocery shop and cook for our families, can relate to the practicality, necessity and yet the universal symbolism that food and its traditions have communicated through generations. Food preparation and cooking family recipes have been preserved and passed down through our ancestors and cultures. Writing about agriculture history allows us to recall our own memories of spending time with our homesteading grandmothers. Melody has vivid memories of her grandmother's kitchen, pantry and washroom, complete with one of the first washing machines and a hand washboard that she displays today in her own laundry room. Jody recalls family reunions when grandmothers from both sides of the family would encourage everyone attending to try and determine whose potato salad tasted better—Grandma Price's or Grandma's King's? Generally, food becomes the focal point for most family and holiday gatherings and allows childhood memories pondering why everything at Grandma's house tasted so good.

Through an enormous amount of archival research and multiple interviews in writing this book, the question was asked, "Who do you think is the most notable Nebraskan woman who contributed to the state's agriculture advancement and history?" To no fault of the intellectualism and memory of the male and female recipients asked, the authors more often than not received the same perplexed stare and answer: "Hmmm…. Good question! I'm going to have to think about that one."

While the lack of an immediate reply to the question did not discourage the authors' survey, it did mean that the task of asking shifted to the task of telling, sharing and reminding—there were great contributions made by Nebraskan women who contributed to and shaped the state's agriculture significance.

Who were the mothers, wives, sisters and aunts of Nebraska's most noble founding agricultural fathers? Even more defined, who as a woman, by her own character, God-given spirit and courage, contributed to and sacrificed for the advancement of Nebraska's agriculture as a consumable product? In our humble opinion and after our own query of state librarians and historians and research within the halls of the Home Economics Building on the University of Nebraska–Lincoln's East Campus, we concluded that few women, or even men, could be credited with shaping our national food and nutrition science policy more so than Dr. Ruth Madeville Leverton.

Thanks to the contributions of Dr. Leverton and others, we appreciate the privilege to have an ample food supply and abundant variety when we go to the market. We recognize that in Nebraska and all over the United States, we are blessed to be able to select from the world's safest and most nutritious food and give thanks to those who have advocated before us. At the turn of the century, with the advent of refrigeration and other food storage devices, it makes sense that the early 1900s saw food production increasingly aligned with new incentives to cook, preserve and prepare food. The kitchen continued as the hub of the home, and the dining room table served as the pivot point around which family life rotated. As communities and commodities developed, so were other modern conveniences being introduced to the home. Electrical service expanded in the 1930s, making the price and availability of appliances for homemaking more affordable and readily available.[346] Who can remember hearing their parents' and grandparents' stories about when electricity first arrived at the family farm to illuminate the house or run the new icebox?

As technology advanced in Nebraskans' kitchens, the study of home economics became a more recognizable and reputable field at the once heavily male-dominated University of Nebraska Agricultural College. The science of food created a revolution in the student body as more women began to enroll, and the university science labs were looking at new nutrition methods.[347] Establishing the trend, the Department of Nutritional Science and Dietetics began in 1892 with chemistry professor Rosa Bouton, who updated the program in 1898 for developing a food and nutrition course called "domestic chemistry" to train the mind and develop character in

An early picture of Dr. Ruth Leverton, who is credited with bringing the "laboratory right into the kitchen" to analyze food to protect the nutritional value of it. The Food and Nutrition Building at the University of Nebraska on East Campus was dedicated as Ruth Leverton Hall in May 1978. *Archives & Special Collections, University of Nebraska–Lincoln Libraries, 421202-00997.*

the kitchen as well as in the laboratory.[348] It was here that the principles of cooking were taught, as well as the economy of cooking and methods for creating nutritious, healthy and appealing food. In 1907–8, the home economics building was erected. By 1919, the course of study emphasis had shifted to encompass training in dietetics, institutional management and teaching, and in 1921, the Division of Food and Nutrition was initiated.[349]

Among those to take a vested interest was Ruth Leverton, a 1924 high school graduate from Deadwood, South Dakota, who enrolled at the University of Nebraska the following year when her family moved to Lincoln. Leverton embraced bringing chemistry to the food laboratories to determine how to keep food more nutritious, thus focusing on the issue of malnutrition. The documentary video *Ag College Dreams: The Real Cornhuskers*, produced by the Institute of Agriculture and Natural Resources, the University of Nebraska–Lincoln, gives credit to Leverton for bringing the laboratory right into the kitchen. Her concerns visualized ways to analyze food to protect the nutritional value of it.[350]

Leverton earned her bachelor of science degree in home economics in 1928. She taught in Nebraska's small-town public school systems before leaving to attend the College of Agriculture at the University of Arizona to earn a master's degree in nutrition. Next, she moved to Illinois to pursue her doctorate in nutrition from the University of Chicago. In 1937, she returned to Nebraska and accepted a teaching position at the University of Nebraska College of Home Economics for seventeen years. Leverton became known for her laboratory research and used East Campus's Love Memorial Hall, a residential cooperative for young women enrolled in home economics, as her testing site. She also lobbied for a larger building for nutrition research. In 1941, construction began on campus to build the Food and Nutrition Building. It was completed in 1943 during the middle of World War II. The building was first used for dormitories and classrooms for the military to channel new recruits to appropriate educational situations under the STAR program (Specialized Training, Assignment and Reclassification).[351] Leverton's research in nutrition also helped provide the military with better food and rations for the servicemen.

In 1957, she was hired by the United States Department of Agriculture (USDA), Human Nutrition Research Division. She served as one of the highest-ranking women within agriculture for the groundbreaking nutrition work she developed. Her research, achievements and roles with the USDA took her around the world, where she promoted proper nutrition. Among her many memberships in national organizations and

professional nutrition and dietary societies, Leverton was the first woman in the history of the University of Nebraska to receive an honorary doctor of science in 1964. Additionally, she was the first woman selected by the UNL students to participate in their Master's Week and was selected to address the honors convocation.

In 1977, Leverton was given a Federal Woman's Award for her leadership in providing better diets for Americans and for people around the world.[352] That same year, the American Dietetic Association awarded Leverton with the Medallion Award for her years of outstanding service in the field of dietetics.[353] In May 1978, the Food and Nutrition Building at the University of Nebraska–Lincoln's East Campus was dedicated as Ruth Leverton Hall.[354]

If you're still wondering how Ruth Leverton made an impact on your life, simply think of her the next time you are in the grocery store. Leverton advocated for the nutrition labels on our food and helped pioneer the concept of what is known as our RDA system—the Recommended Daily Allowances.[355] Those early years of Leverton research and dedication are a legacy that touches us every day.

A Personal Story: East Campus Grows Agricultural Advocate

Co-author Jody Lamp credits her living and working on the University of Nebraska–Lincoln's East Campus for her interest, pursuit and success of an agriculture journalism career. Although all her journalism classes were in Avery Hall on "City Campus," Jody chose to live at Love Memorial Hall on East Campus, where the surroundings and agriculture community–minded students reminded her of home in western Nebraska. She worked as a news assistant in the Department of Agriculture Communications at the Institute of Agriculture and Natural Resources (IANR) under the guidance and leadership of Richard "Dick" Fleming, who wrote the prologue of this book.

Jody recalls that it was the beginning of her junior year during her advanced reporting journalism class when "J-School" professors Richard (Dick) Streckfuss and Alfred "Bud" Pagel asked their budding crop of new student future reporters to "pick a beat." Once assigned a beat for the semester, the students would cover and contribute to the in-house, student designed and led newspaper, the *Journalist*. Each student was instructed to

pick his or her top three choices out of nearly a dozen selections. But to be clear, out of the three choices, each student would typically only be assigned to one beat. The professors assured their young scholars that they had the final say with any ties or disputes of the assignments. The categories ranged in topic like Campus News, Entertainment, Cornhusker Sports, Fashion and Politics, as well as the one on the end—the one on the farthest end of chalkboard, like an afterthought—Agriculture.

Jody envisioned each choice before writing down her top three. Entertainment sounded, well, entertaining. She would write that one down first. Then, scanning the chalkboard, let's see, what else? Hmmm…how about Campus Police! That sounded exciting, adventurous and maybe even a little dangerous! Okay…down to the last one. What's left? Cornhusker Sports? Nah, every guy in the room will pick that beat because he'll want to cover the football season. The Cornhuskers are looking good and will probably go to the Orange Bowl too. Oh this is hard, she thought. What should she choose for her last beat?

"Okay, everyone, turn your choices in," said Streckfuss. "Hand them to the person in front of you and pass them all to the front."

"Ugh…okay," Jody thought, as she secretly felt rushed to make her final selection. "Oh geez! The pressure! Okay, okay, okay, ugh!! I'll just write down….Agriculture! Whew, glad that's over!"

As the advanced reporting students waited to hear their assigned beat, Jody calculated the odds and wondered, "What if I actually get the Agriculture beat?! I certainly can't be as qualified to cover that beat as these other students, can I?"

Jody's aspiration to become an agricultural journalist was not completely impractical. However, because she hadn't been raised on a farm or ranch as a lifestyle to sustain a family and home like many of her childhood friends, Jody suspected that her limited hands-on experience would prove more challenging than advantageous. She didn't discount that being raised on forty-five acres with alfalfa, sweet corn and enough pasture to ride horses wasn't something from which to glean knowledge, but the practicality seemed trivial to her at the time. As a 4-H-er in Scotts Bluff County, Jody showed club lambs and stocker feeders. She didn't consider herself an expert of agriculture, but she loved her rural Nebraska upbringing.

Her mind wandered ten years earlier to her childhood home north of Lake Minatare and to her thoughts of what she wanted to be when she grew up. It was Christmas morning 1982 when Jody's parents surprised her with a gift that she had only dreamed about owning: a Kodak Brownie Starmatic

Camera with a detachable flash unit. Considered a high-end part of Kodak's Brownie Star series and made between April 1959 and August 1963, Jody didn't know or care that the camera was already obsolete. She finally had a camera of her own! Once Eva Price helped her second-oldest daughter load the camera's 127 film into the supply chamber, Jody sprinted out the door in her pajamas to capture the family's bay mare, Ladybug, and registered Quarter Horse sorrel gelding, Rocky, eating their daily dose of hay and oats.

With the morning sun glistening on Ladybug and Rocky's frosty backs and a row of evergreen trees as the backdrop, Jody captured her first agriculture subjects. She believed that something magical happened that Christmas morning: a light, a spark, a confirmation of her purpose and what she would strive to achieve for the rest of her life. Jody realized that photography and sharing agriculture through the lens of a camera would be a part of her everyday existence.

Prior to the camera, Jody's first love had been the family's horses—an adoration created by watching Thoroughbred horse racing with her dad and a desire to ride freely through the pasture and dream. Too young and short to maneuver the hefty western Colorado leather saddle her dad rode, Jody often resorted to walking Ladybug up to the side of the old, claw-foot bathtub used as a water trough for the horses, grabbing ahold of the mare's mane and hoisting herself up on her back. She and Ladybug would stroll through the pasture riding parallel to the fence line, checking posts for any loose barbed wire. Just a girl and her horse contemplating life. Jody spent most of her childhood outdoors with her dad—caring for the horses and other family pets, burning tumbleweeds from the ditches every spring, irrigating the alfalfa field, driving the 1972 Ford 150 "old yeller" truck to help pick up and haul hay bales and, the most fun, driving to the Harold Becker dairy every Saturday morning to collect the family's weekly six-gallon allotment of fresh cow's milk. Fatefully, what Jody discovered on Christmas morning 1982 may never have come to pass had she not been sitting in that advanced reporting journalism class, with Professors Dick Streckfuss and Bud Pagel, at the University of Nebraska–Lincoln in the fall of 1992.

"Okay, we're done!" exclaimed Streckfuss and Pagel, bringing Jody back to the reality of college life and her next immediate task: covering a beat. Making their grand reentry, the two professors' faces looked relieved, as if revealing that in previous years this "picking a beat" assignment might have been rather painstaking for them and the students. Their demeanor, although not unusual for these two well-loved colleagues, became increasingly jovial. Fifteen sets of eyes now watched Streckfuss walk to the south side of the

room, pick up a piece of chalk and turn to write each student's name. He started in the upper left-hand corner of the board, slowly working his way back toward Pagel, who had stayed near the door, watching each student's reaction upon seeing his or her name. The "yahs!" and "Oh yeahs!" came more frequently, and students high-fived each other expressing their approval of their assigned beats.

Jody watched with anticipation and waited for her assignment. Entertainment? Nope! Campus Police? Nope again! She waited patiently until every student's name had been written down but hers. "Is there even a beat left?" she wondered. "Did they forget to write down my name?"

And then she remembered. At the end of the board, looking as lonely as one word can possibly look—Agriculture! Her widened eyes met the two professors as they smirked, grinned and giggled and then finally proclaimed aloud to the whole class, "And last but not least, the Agriculture beat goes to Jody Price!!"

"What!?" She leaned forward to accentuate her disbelief and begin her dissertation. "Agriculture wasn't even my first choice! Why did I get assigned my third choice, when I'm sure other people got to have their first choice?!" Now all eyes were on her and the professors, darting back and forth between the lively conversation.

"Jody!" Streckfuss said, smiling as he explained loud enough for all the students to hear. "In all the years that Bud and I have been teaching this course, not one student *ever*, and I mean *ever*, has picked the Agriculture beat! We usually have to beg, bribe, barter or do whatever we can to get someone to take the Agriculture beat. When we saw that you had written it down at all, we thought, *Hurray*!!! We're sorry if you don't like it, but you got it! You got the Agriculture beat!"

Well, okay then, Jody thought, now with a sense of pride. "I just did something that no other student in the history of Dick Streckfuss and Bud Pagel's advanced reporting class at the University of Nebraska–Lincoln has ever done! I picked the Agriculture beat! Yes, I did! That's what I wanted in the first place—Agriculture! I'm going to go write about agriculture!"

And so, by default, by choice or by divine assignment, Jody's agricultural journalism career was launched in 1992. During her final semesters at UNL, she worked on East Campus as a news assistant in the Department of Agriculture Communications at the Institute of Agriculture and Natural Resources (IANR). Graduating in December 1993 with a bachelor's degree in journalism/news-editorial, Jody's first job out of college was serving as the agriculture reporter/photographer for the *Beatrice Daily Sun*. She

covered and produced the ag news for southeast Nebraska before being recruited and hired by an agriculture-based public relations and advertising agency in Wisconsin. In 2009, Jody opened her Lamp Public Relations & Marketing business with a focus on agriculture promotion and education. After eighteen years of living in Montana with her husband, Mike, and two children, Mark and Jessie, the Lamp family "moved back" to Jody's Nebraska agriculture roots.

East Campus Points of Interests

THE UNL DAIRY STORE: We can say without exaggeration that *no trip* to East Campus is complete without visiting the UNL Dairy Store. Since 1917, the UNL Dairy Store at 114 Food Industry Complex has been providing premium-quality dairy products for the University of Nebraska–Lincoln staff and students. Anyone can visit and indulge in the popular handmade ice creams, meats and cheeses. New ice cream flavors are featured daily, along with lunch specials. One of the best parts was that each sandwich and scoop gives UNL students jobs and supports their education. Stop by or visit www.dairystore.unl.edu to order your Dairy Store favorites.

As noted on a plaque on the building:

> *The Institute of Agriculture and Natural Resources fulfills the land-grant university mission of the University of Nebraska as mandated by the Morrill Act of 1862 by offering academic degrees through the College of Agricultural Sciences and Natural Resources, conducting research through the Nebraska Agricultural Experiment Station created by the Hatch Act of 1887, and educating Nebraska citizens in all 93 counties through cooperative Extension as required by the Smith-Lever Act of 1914.*[356]

THE PERIN PORCH: Thirteen years after the passing of the Morrill Act, the University of Nebraska and College of Agriculture would become an essential tool for farmers in developing profitable and sustainable agriculture. Captured in an 1898 Fourth of July photo, Laura Helen Courtney Perin and her daughters, Edna and Hazel, holding their dolls, as well as hired girl Katie Buffan, sit on the front porch of the dormitory at the "old State Farm" of the University of Nebraska. Adorned with a red, white and blue banner stretching across each of its pillars and

"Looking Down the Campus," from *These Fifty Years: A History of the College of Agriculture of the University of Nebraska, East Campus,* circa 1925. *Archives & Special Collections, University of Nebraska–Lincoln Libraries, 50years040.*

The oldest and only nineteenth-century building that remains on UNL's East Campus, the Agriculture Experiment Station (now known as Agricultural Communications Building) was constructed in 1899. Co-author Jody (Price) Lamp began her ag-journalism career here in the Department of Ag Communications under the helm of Richard Fleming, Professor Emeritus, University of Nebraska–Lincoln Department of Agricultural Leadership, Education and Communication (ALEC). *Archives & Special Collections, University of Nebraska–Lincoln Libraries, 520200-ECz1919.*

coming together in the middle to form a bow, the porch's décor bore the celebratory occasion of our nation's 122nd birthday. Two American flags extended from the pillars closest to the steps, and four smaller flags flanked the house on either side of the door.

The porch and the dormitory housed the University of Nebraska's State Agriculture Farm students and S.W. (Senator Willis) "Dad" Perin's family from its earliest days until it was torn down in 1923. A century after it was built, Wilbur "Bud" Dasenbrock of Lincoln, who served as resource manager and horticulturist for the Nebraska Game and Parks Commission and as director of both the UNL Landscape Services and the UNL Botanical Garden and Arboretum, and his crew helped build a replica of the porch to be used as an interpretive tool for East Campus history. The Perin House and its porch served as a focal point for the college's first agriculture students and can still be enjoyed today.

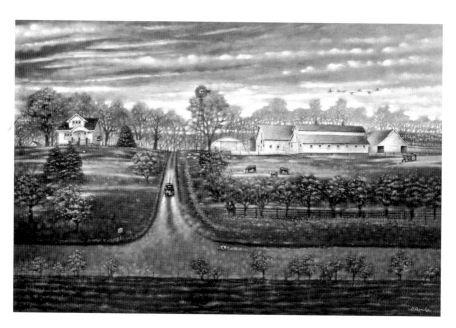

Sunset on the Sandahl Home Place. Courtesy of Gene Roncka, Willow Point Gallery, Ashland, Nebraska.

PART VI

NEBRASKA'S AGRICULTURE FUTURE

Agriculture's Significance to You

If you've come this far along in this book and thought to yourself, "Why am I reading or should care about Nebraska's agriculture history? I don't farm or ranch for a living. And neither did my parents or my grandparents. How is any of this relevant to me?" we may need to go back to your great- or great-great-grandparents before we could find the branch of your family tree that created your ancestral connection to Nebraska's land. But it's there. It's been there and it will always be there.

The innovations and inventions that catapulted agriculture to being something we had to know and grow to survive also created the disconnection from our food supply. When we no longer had to grow our own food to sustain our existence, we became emotionally detached. Every facet of our lives is connected to animal and crop production agriculture. But what makes husbandry and horticulture relevant to us if we aren't the people responsible for raising or growing the end products? Just simply ask yourself, "Did I eat today?"

Nearly every food, fiber, fuel and feed consumer in our state, nation and the world is connected to Nebraska's bountiful yearly harvest of crops, livestock and all the byproducts derived from such. And all are made readily available and accessible. Safe, abundant, affordable—agriculture producers and promoters are told that these words no longer resonate with the general non-agriculturally raised public because they evoke no emotion. Before

contemplating why and how agriculture works and the crops grow, what does growing a crop take in today's climate, market and regulatory environment? How many years of trial and sophisticated, methodical and lengthy scientific research precede the farmer's seed before it's ever placed in the ground?

As a relatively young country and even younger state, we can admire our Nebraska ancestors' agrarian discipline and determination. In comparison, when popular historian Stephen E. Ambrose wrote, "Nothing like it in the world" about the building of the transcontinental railroad, we are reminded of America's remarkable ability to rise above insurmountable circumstances in spite of unfavorable odds. Ambrose "drives the spike" of necessity home and clearly defines for us what had been done with detailed precision, aptitude and limited resources.

Ambrose reintroduced us to one of America's finest leaders, Grenville Mellen Dodge, who by the nature of his assignment was instrumental in the development of Nebraska when he accepted the position of chief engineer for the Union Pacific Railway. When Dodge requested a leave of absence from the army to work for the Union Pacific, General William Tecumseh Sherman replied with these words: "I consent to your going to begin what, I trust, will be the real beginning of the great road."[357]

"The great road" brought industry and motion, and to Nebraska, that meant right down the middle on the 42nd parallel. The building blocks for many of the communities along the Platte River were beginning to be formed and oftentimes were chosen by Dodge himself. Transportation brought a "reassessment of the Plains."[358] New hope and vision surrounded the farmer and cattleman as they saw rich soils, green grass and new rails appear to ship goods and services. By the early summer of 1866, the Union Pacific was well on its way through Nebraska's territorial tapestry, creating the map that would become the future state's well-known cities and agricultural hubs.

After becoming the thirty-seventh state of the Union in 1867, Nebraska community founders and residents established themselves in their sometimes not-so-hospitable environments, far away from home and the familiar. Survival meant overcoming adversities and challenges. A visit to the Plainsman Museum and Hamilton County Historical Society in Aurora, thirty-three miles east of Grand Island off U.S. Highway 34, proves how "adaptability" in Nebraska evolved over time. Catch a glimpse of "pioneer know-how" from George L. Levee, who homesteaded in Hamilton County in 1873. As a blacksmith by trade, Levee found his factory-made plow unsuited for turning and breaking the tough "wirey" buffalo grass sod because it didn't fall right in the furrow.[359] He solved the problem when he invented

the first official "grasshopper plow." Others in the neighborhood recognized the success and asked to have one for themselves. Although Levee never patented the design, he manufactured three hundred plows and employed six men to help make them.

Agribusiness: Working Cooperatively

"Working together" became the building block for solutions to events that were affecting the new farmers daily. This concept was demonstrated in the early 1900s in Aurora when twenty-five farmers wanted to change the price they were being paid for grain. To them, it didn't seem right that the prices at the terminal market were considerably better than the prices paid to local farmers.[360] To change the price, they needed to improve the way they marketed their grain. They needed to form a cooperative, officially banding their entrepreneurial best interests.

Cooperatives brought a new way of thinking and doing business in farming communities. Many of the first cooperative members committed themselves to seeing their livelihoods through the prosperous and challenging times together. They wanted and needed more say and control to be able to succeed and adapt when necessary. Being dedicated to and supporting one another ensured a loyal membership that fostered growth and nurtured the environment to proactively face constant change.

On February 15, 1908, the Aurora Elevator Company was formed. The articles of incorporation were sent to the secretary of state with a money order for $11.50 and then filed with the State of Nebraska for $20.75.[361] The members immediately went to work, and within weeks and months, they had the funds to "raise" a 31,000-bushel wood cribbed elevator. The collaborative step changed the Aurora skyline, landscape and the farmers there forever. By the end of that first year, the elevator company had handled 128,721 bushels of grain—much of that was wheat—and saved members $1,876.19, with accounts receivable at $3.00.[362] Early members were pioneers who saw the organization through hardship, drought, depression, growth and constant change. The word *Cooperative* was officially added in 1943, and the name was changed to Aurora Cooperative Elevator Company.

By the time the organization reached its 100th anniversary in 2008, Aurora Cooperative had grown into a $475 million business thanks to great leadership and management over the years. The company's

centennial annual report reflected record sales in 2007 and total net earnings of \$23.5 million, while serving members and patrons in forty-three locations across Nebraska and Kansas.[363] The company continues to be a financial leader in the industry as one of National Cooperative Bank's top one hundred cooperatives.[364] With its corporate headquarters in central Nebraska, Aurora Cooperative serves its customers from eighty locations in seven states.

Aurora Cooperative provides a culturally relevant business environment to refer to when talking about the future of agriculture and agri-business. The foundational cornerstones serve as reminders to continue to manage, lead, mentor, adapt, innovate, expand and diversify. Change within the agriculture industry has accelerated. Companies like Aurora Cooperative have worked hard to address the "quickening pace" and determine the best and most efficient ways to accommodate growth and expansion. Examining and identifying the risks and requirements to make bold future moves is a balanced approach that involves understanding every aspect and component of the business.

When Grenville Dodge orchestrated building the transcontinental railroad through Nebraska, he faced the new frontier by gathering the best staff and intelligence, the latest technology the industry could provide and investment support both public and private. He knew that to succeed they needed to secure resources, and most importantly, they learned adaptability. Dodge's strategy was proved on May 10, 1869, when the last spike was driven.

Agriculture's new frontier may not be as daunting as building a transcontinental railroad, but the challenges and demands for the best faculties and acumen are here. Navigating new horizons requires agriculture producers and agri-business leaders to persevere with sharp insight, solid information and good judgement—just like the founding members of the Aurora Cooperative, who benefited from well-informed decisions that allowed them to take "level-headed chances."[365]

Dawn Caldwell, director of Aurora Cooperative's Government Affairs, explained how the company's leadership from its central Nebraska headquarters office prepares for the future. The new facility opened its doors in December 2013 on the same campus as the Leadership Center, owned and operated by the Nebraska Vocational Agricultural Foundation and used for youth leadership training, including for Nebraska Future Farmers of America (FFA). One of Aurora Cooperative's core values includes a commitment to integrating youth and agriculture. Employees take an active

role in the FFA and 4-H programs as they interact with youth from all over Nebraska and participate in ag-sponsored activities and events.

Future expansion is evident when walking through the forty-one thousand square feet of space purposed to meet the demand for Aurora's anticipated growth. Several areas throughout the building are designed to handle a "working communication session." Caldwell shared that the environment fosters interaction between older generations that have more experience, history and knowledge and the younger millennial-age farmers who may be new to agribusiness. Both groups can learn from each other as the generation gap between baby boomers and millennials statistically widens. Understanding and appreciating each group's skills and strengths is an important investment that Aurora Cooperative leadership makes a priority. Recently, Aurora Cooperative formed a "generational advisory committee" to be a "sounding board where multigenerational employees can discuss internal operations and means by which the over-all organization could improve."[366]

Aurora Cooperative's headquarters conference rooms reflect today's standard of integrated, open communication needed in a precision production world. Producers strive to surround themselves with the best technology the industry can provide and gain a variety of livestock nutrition and grain information from specialists, agronomists and technicians to help throughout the year. The ability to hold private or smaller group conversations or set up for a meeting with an entire board is easily accommodated in a creative, progressive and ergonomic environment.

While work environments improve, the "bottom line" agriculture business model over the last 150 years remains the same: move product to the marketplace and receive a fair price for your goods and services. Staying informed about marketing options and solutions to deliver maximum results puts Aurora Cooperative as one of the nation's top agronomic leadership and management companies. In 2006, the company launched Aurora West, a project to prepare for future demands of handling large volumes of grain projected for the emerging biofuels market. In true pioneer spirit and visionary leadership, Aurora West, the 142-acre agri-business endeavor, was the start of a visionary, ag-bio research and development campus with the potential to develop what hasn't even been dreamed up yet.[367]

CONCLUSION

Nebraska agriculture is about the future. We believe that as Nebraska and American farmers, ranchers and agribusinesses evolve, more engaging ag-related youth programs will develop to cultivate and grow the "non-traditional agriculture" individual. Alleviating the disconnect from one generation to the next will help the young and old stay rooted with a sense of pride for the values demonstrated over the past 150 years. The early pioneers are the men and women who helped settle and create the great state of Nebraska, and the following generations are the ones being entrusted with that special legacy.

During our time spent traveling, researching and writing this book, we had the privilege to be engaged in many innovative conversations. While we were respectfully honoring the past, we were delighted to be included in the dialogue about the future of agriculture. As the backbone of our great nation, the agriculture industry still continues to rise to the challenge to feed, clothe and provide shelter for its citizens while supplying goods for markets around the globe. We count it a blessing to have had the opportunity to visit and meet so many people and tour agri-businesses, special projects, museums, libraries, interpretive centers and historical events, as well as, in many cases, to have been invited into your homes. Thank you for showing us Nebraska…the Good Life.

EPILOGUE

The foresight of those who came before us makes this an engaging commemorative book of the past 150 years of Nebraska's agriculture since the beginning of statehood in 1867. These stories and narratives of generation after generation making commitments and discoveries with dedicated fortitude for the advancement of agriculture productivity are our lasting legacy. At first, it was trial and error. Each failure and each season brought new understanding for adaptability methods. Developments in science, research experiments and technological advancements yielded in growing crops and strengthening livestock breeds that would survive our elements and adjust to different climates and environments. Soon Nebraska farmers and ranchers were able to produce a sustainable food supply to feed their families and also meet the supply and demand of the emerging community markets surrounding them.

That same dedication and resolve meets the challenges of today. Nebraska's agriculture community has grown to reach an international market where the state's producers are among the most productive in the world, continually breaking yield records. Truly remarkable accomplishments.

I come from a long line of ranchers and farmers and have heard firsthand the stories of my ancestors and the challenges and triumphs they experienced in their lifetimes. These pages have provided the opportunity to pause, remember and be encouraged by stories of our direct agricultural roots. The American Doorstop Project helps us preserve our agricultural heritage and honor that dedicated pioneer spirit. This, in true epilogue fashion, is what will help us move our vision forward for the next 150 years.

—Greg Ibach, Director, Nebraska Department of Agriculture

NOTES

Introduction

1. Robert N. Manley, *Town Builders: The Historical Focus of Stuhr Museum* (Grand Island, NE: Prairie Pioneer Press, 1985), 2.
2. Ibid., 3.
3. Mrs. Georgene Morris Sones and Mrs. Cindy Steinhoff Drake, *History of Nebraska Centennial Farms* (Dallas, TX: Curtis Media Corporation, 1978), 17.
4. Peter Stearns, "Why Study History?," Student's Friend World History and Geography, http://www.studentsfriend.com/aids/stearns.html.

Part I

5. Lewis and Clark History Louisiana Purchase Treaty (1803), transcript, http://www.lewisandclarktrail.com/legacy/sold.htm, 2011.
6. Donald R. Hickey, *Nebraska Moments: Glimpses of Nebraska's Past* (Lincoln: University of Nebraska Press, 1992), 2.
7. Ned Eddins, "Robert Stuart," Fur Trade Role in Western Expansion, http://thefurtrapper.com/home-page/robert-stuart.
8. Diana Lambdin Meyer, *Off the Beaten Path Nebraska: A Guide to Unique Places* (N.p.: Morris Book Publishing, 2010), 117.
9. David J. Wishart, ed., *Encyclopedia of the Great Plains Indians* (Lincoln: University of Nebraska Press, 2007), 17.

10. Ibid.
11. Melvin R. Gilmore, *Uses of Plants by the Indians of the Missouri River Region* (Lincoln: University of Nebraska Press, 1977), 15.
12. Ibid.
13. Ibid., 7.
14. Ibid., vi.
15. Ibid. 1.
16. *Nebraska Trailblazer* 9, "Fort Atkinson," Nebraska State Historical Society.
17. *Nebraska Trailblazer* 7, "Early Settlers," Nebraska State Historical Society.
18. Ibid.
19. Ibid.
20. Stephen Ambrose, *Nothing Like It in the World* (New York: Simon & Schuster, 2000), 17.
21. Ibid.
22. Ibid., 23.
23. *Frontier University Dreams*, Nebraska ETV documentary, March 31, 2009.
24. History of Sangamon County, Illinois, "The Kelly (Kelley) Family," posted on October 21, 2013, by editor, http://sangamoncountyhistory.org/wp/?p=1895.
25. The History Place, "Abraham Lincoln," http://www.historyplace.com/lincoln.
26. United States Department of Agriculture, "USDA Celebrates 150 Years," http://www.usda.gov/wps/portal/usda/usdahome?navid=USDA150.
27. National Park Service, "About the Homestead Act," https://www.nps.gov/home/learn/historyculture/abouthomesteadactlaw.htm.
28. Ibid.
29. National Archives, Founders Online, "From Thomas Jefferson to John Jay, 23 August 1785," http://founders.archives.gov/documents/Jefferson/01-08-02-0333.
30. Doris Lawrence, "Daniel W. Keethler," in Sones and Drake, *History of Nebraska Centennial Farms*, Section F, no. 99, 173.
31. Ancestry.com, "U.S. GOVERNMENT LAND LAWS IN NEBRASKA, 1854–1904," http://www.rootsweb.ancestry.com/~nesgs/Ancestree/vol08/v08n4pe4.htm.
32. Ibid.
33. Plaque award to Daniel Keethler Family Farm, Knights of AKSARBEN.
34. William Stolley, *History of the First Settlement of Hall County, Nebraska* (Grand Island, NE: Hall County Historical Society, 1982), 79.
35. Ibid., 83.

36. Ibid., 85.
37. Nebraska State Historical Society Foundation newsletter (January/February 2004), http://www.nebraskahistory.org/foundatn/newsletr/jan04.htm.
38. Ibid.
39. Ancestry.com, "U.S. Government Land Laws in Nebraska."
40. Margaret Ellen Nielson, "Samuel Clay Bassett: Farmer, Historian," *Buffalo Tales* 3, no. 9 (October 1980), Buffalo County Historical Society.
41. Ibid.
42. Ibid.
43. Addison E. Sheldon, "Nebraskans I Have Known, III: Samuel Clay Bassett," *Nebraska History Quarterly Magazine* 20, no. 34 (July–September 1939): 159–68.
44. *Nebraska Agriculture*, brochure, Nebraska Department of Agriculture, 14, http://www.nda.nebraska.gov/publications/ne_ag_facts_brochure.pdf.
45. Nielson, "Samuel Clay Bassett."
46. Samuel Clay Bassett, Gibbon, Nebraska founder and first president of the Nebraska Dairymen's Association, speaking before a meeting of the Nebraska State Horticultural Society on January 19, 1916, in Paul D. Riley, "The Nebraska Hall of Agricultural Achievement," *Nebraska History* 53 (1972): 87.
47. Ibid.
48. Ibid.
49. Paul D. Riley, "The Nebraska Hall of Agricultural Achievement," *Nebraska History* 53 (1972): 87.
50. Ibid., 89.
51. Nielson, "Samuel Clay Bassett."
52. Sheldon, "Nebraskans I Have Known," 159–68.

Part II

53. Robert D. Kuzelka, *Flat Water: A History of Nebraska and Its Water* (Lincoln: University of Nebraska, 1993), 2.
54. Ibid., 10.
55. Ibid.
56. Thomas Buecker, *Water Powered Flour Mills in Nebraska* (Lincoln: Nebraska State Historical Society, 1983), introduction, v.
57. Ibid., ix.

58. Ibid., x.

59. Ibid., chapter 1, 4.

60. Thomas Buecker, *Flour Milling in Nebraska*, Educational Leaflet No. 17 (Lincoln: Nebraska State Historical Society, n.d.), 3.

61. Buecker, *Water Powered Flour Mills in Nebraska*, 21.

62. Ibid., 38.

63. Kuzelka, *Flat Water*, 14.

64. Joseph Kinsey Howard, *Montana: High, Wide and Handsome* (Lincoln, NE: Bison Books, 1943), 30.

65. Ibid., 31.

66. Ibid.

67. Ibid., 33.

68. James C. Olson, *History of Nebraska* (Lincoln: University of Nebraska Press, 1966), 5.

69. Howard, *Montana*, 32.

70. Kevin Burkman, "John Wesley Powell and the Arid Empire of the American West," *Bloustein Journal*, May 16, 2014.

71. Ibid., 2.

72. Ibid.

73. U.S. Bureau of Reclamation, "The Bureau of Reclamation: A Very Brief History," www.usbr.gov/history/borhist.html.

74. Ibid.

75. Ibid.

76. USBR, "Pathfinder Dam Interpretive Trail," Wyoming Office.

77. Ibid.

78. Ibid.

79. James Aucoin, *Water in Nebraska: Use, Politics, Policies* (Lincoln: University of Nebraska Press, 1984), 5.

80. North Platte Project, USBR, "Inland Lakes," Wyoming Office.

81. Ibid.

82. Ibid.

83. North Platte Project, USBR, "Managing the West," April 2013.

84. Ibid.

85. Kuzelka, *Flat Water*, 14.

86. Robert Sobel and John Raimo, eds., *Biographical Directory of the Governors of the United States, 1789–1978*, vol. 3 (Westport, CT: Meckler Books, 1978).

87. W.R. Mellor, "Nebraska State Board of Agriculture," in *History of Nebraska* (Lincoln, NE: Western Publishing and Engraving Company), 470.

88. *State Board of Irrigation of the State of Nebraska for the Years 1885 and 1896*, 11.

89. Kuzelka, *Flat Water*, 17.

90. G.L. Shumway, *History of Western Nebraska and Its People* (Lincoln, NE: Western Publishing and Engraving Company), 477.

91. Kuzelka, *Flat Water*, 21.

92. *State Board of Irrigation of the State of Nebraska for the Years 1885 and 1896*, 12–13.

93. Ibid., 14.

94. Ibid.

95. Kuzelka, *Flat Water*, 25.

96. Ibid.

97. Ibid.

98. Ibid., 28.

99. Kuzelka, *Flat Water*, 2.

100. Nebraska State Irrigation Association, "About Us," www.nebraskastateirrigationassociation.org/about.html.

101. Chris Dunker, "Dempster Had a Long History in Beatrice," *Beatrice Daily Sun*, July 29, 2013.

102. Jeremy Kirkendall, "The Kregel Windmill Factory Museum," *Prairie Fire*, December 2013.

103. Kregel Windmill Factory Museum, "About Us," https://www.kregelwindmillfactorymuseum.org/about.

104. Axtell Area Chamber of Commerce, "History of Axtell," www.axtellne.com/#history/c1gcn.

105. Nebraska Power Review Board, "Chapter 2: Historical Perspective: History of Public Power in Nebraska," http://www.powerreview.nebraska.gov/prbmanual/2.html.

106. Kuzelka, *Flat Water*, 90.

107. Cozad Chamber of Commerce, "Nebraska Plastics: 70 Years in Cozad," *Lexington Clipper Herald*, August 2, 2015.

108. Ibid.

109. Wessels Living History Farm, "Gated Pipe," York, Nebraska, http://www.livinghistoryfarm.org.

110. Hastings Irrigation Pipe Company, www.hastingsirrigation.com.

111. Paul J. Hohnstein Obituary, www.lbvth.com/Archives/2004/Set04/hohnstein.htm.

112. Kuzelka, *Flat Water*, 91.

113. Shellie Mader, "Center Pivot Irrigation Revolutionizes Agriculture," Fence Post, May 25, 2010, 3, www.thefencepost.com.

114. Kuzelka, *Flat Water*, 93.

115. Summer Rain Sprinklers, "History of the Lawn Sprinkler Systems," August 7, 2014, www.summerrainsprinklers.com.

116. Robert Morgan, *Water and the Land: A History of American Irrigation* (Fairfax, VA: Irrigation Association, 1993), 11–12.

117. Sprinkler Irrigation Association, "Formation in 1949," www.irrigationmuseum.org/iahistory.aspx.

118. Ibid.

119. Mader, "Center Pivot Irrigation Revolutionizes Agriculture," 3.

120. Ibid.

121. Ibid.

122. Kuzelka, *Flat Water*, 133.

123. Mader, "Center Pivot Irrigation Revolutionizes Agriculture," 4.

124. Kuzelka, *Flat Water*, 133.

125. Ibid.

126. Mader, "Center Pivot Irrigation Revolutionizes Agriculture," 4.

127. Ibid., 8.

128. Weebly's Living Farm Website, 68366334.weebly.com/frank-zybach.html.

129. Jim McKee, "Frank Zybach Revolutionizes Agriculture Worldwide," *Journal Star*, http://journalstar.com/news/local/jim-mckee-frank-zybach-revolutionizes-agriculture-worldwide/article_f9343795-06ed-504a-98a3-7d74015c3a9e.html.

130. Kuzelka, *Flat Water*, 133.

131. Reinke, "A Company Profile," 11, http://skoneirrigationredesign.townsquareinteractive.com/files/2016/02/Reinke-Company-Profile-2015.pdf.

132. Aucoin, *Water in Nebraska*, 33.

133. Ogallala Aquifer Initiative 2011 Report, USDA, NRCS, June 2012, 1.

134. *National Geographic*, "Ogallala Aquifer" (August 2016): 87.

135. Ibid., 105.

136. Ibid., 94.

137. T-L Irrigation History, http://tlirr.com/company/t-l-irrigation-history, 2016.

138. Ogallala Aquifer Initiative 2011 Report, USDA, NRCS, June 2012, 4.

139. Aucoin, *Water in Nebraska*, 7–13.

140. Nebraska's Natural Resources Districts, "NRD Information," www.nrdnet.org/nrds.

141. Hazel M. Jenkins, comp., and Robert B. Hyer, ed., *A History of Nebraska's Natural Resources Districts* (Lincoln: Nebraska Department of Natural Resources, 1975), introduction.

142. Ibid.

143. Ibid.

144. Associated Chambers of Commerce of the North Platte Valley, *The Fertile North Platte Valley: America's Valley of the Nile*, brochure, circa 1926, 2.

145. Tracy Cross, "Far-Sighted Pioneers Saw Need for More Water," *Business Farmer*, March 16, 1984, 14.

146. Ibid.

147. *Nebraska Water Center Annual Report, 2015*, 10–11.

Part III

148. Nebraska Studies, "How Do I Get My Free Land?: The 'Proving Up' Form," http://www.nebraskastudies.org/0500/frameset_reset.html?http://www.nebraskastudies.org/0500/stories/0501_0204.html.

149. Kuzelka, *Flat Water*, 10.

150. *Nebraska Farmer* 90, no. 1 (January 3, 1948): 28.

151. *Republican Argus* 1, no. 2 (January 22, 1898).

152. Twin Platte Natural Resources District, "1997 Conservation Award for Keith-Arthur Counties, Geisert Family Farm, Ogallala, Nebraska," http://www.tpnrd.org/geisert.htm.

153. Bernie Camp, assistant extension ed., *Nebraska Farmer* (January 3, 1948): 29, University of Nebraska.

154. Tractor Test Lab, http://tractortestlab.unl.edu.

155. Carol Bryant, "Sale Barn Reopens," *Grand Island Independent*, December 6, 2002, 1A, 6A.

156. Robert Pore, "A Thing of the Past," *Grand Island Independent*, January 22, 2005, 3A.

157. Clara O. Wilson, Alice M. Cusack and Rosalie W. Parley, *A Child's Story of Nebraska* (Lincoln, NE: University Pub. Company, 1969), 19.

158. International Museum of the Horse, Kentucky Horse Park, Lexington, Kentucky, http://imh.org/exhibits/current/draft-horse-america.

159. Stolley, *History of the First Settlement*, 1.

160. International Museum of the Horse.

161. City of Grand Island, Nebraska, "The Pioneer Spirit," http://www.grand-island.com/about-grand-island/the-pioneer-spirit.

162. International Museum of the Horse.

163. Joe Christie, *Seventy-Five Years in the Saddle* (N.p., n.d.), 7.

164. *Grand Island Independent*, September 21, 1906.

165. A.F. Buechler and R.J. Barr, *History of Hall County, Nebraska* (Lincoln, NE: Western Publishing and Engraving Company, 1920), 281.

166. Alton Kraft, trans., *Der Herold*, May 25, 1883.

167. Caroline Langman Converse, *I Remember Papa* (Sunland, CA: Cecil L. Anderson, 1949), 71.

168. Ibid., 74.

169. Ibid., 75.

170. Fred Langman Sr., obituary, *Grand Island Independent*, December 27, 1924.

171. Converse, *I Remember Papa*.

172. *Grand Island Independent*, December 8, 1906.

173. Christie, *Seventy-Five Years in the Saddle*, 7.

174. Buechler and Barr, *History of Hall County, Nebraska*, 585.

175. Ibid.

176. Thomas R. Buecker, *Fort Robinson and the American Century, 1900–1948* (Norman: University of Oklahoma Press, 2002), 24.

177. N.B. Critchfield, *Timely Hints to Horse Breeders*, Commonwealth of Pennsylvania, Department of Agriculture, Bulletin No. 181.

178. *Grand Island Daily Independent*, February 7, 1911.

179. Ibid.

180. Buechler and Barr, *History of Hall County, Nebraska*, 580.

181. Ibid., 252.

182. *Grand Island Daily Independent*, January 7, 1914.

183. Ibid.

184. *Grand Island Daily Independent*, March 29, 1915.

185. Christie, *Seventy-Five Years in the Saddle*, 62.

186. Timelines of History, http://www.timelines.ws/20thcent/1916_1917.HTML.

187. *Grand Island Daily Independent*, January 28, 1916.

188. Ibid.

189. Christie, *Seventy-Five Years in the Saddle*, 68.

190. Ibid.

191. Ibid., 69.

192. Robert Perry, *Sheep King: The Story of Robert Taylor* (N.p.: Prairie Pioneer Press, 1986), 89.

193. Gene Budde, "Hall County's Renowned Sheep Rancher," *Grand Island Independent*, July 15, 2004.

194. Perry, *Sheep King*, 4.

195. Ibid., 37.

196. Budde, "Hall County's Renowned Sheep Rancher."

197. Perry, *Sheep King*, 61.

198. Ibid., 58.

199. Ibid., 2.

200. Ibid., 80.

201. Jim Hewitson, *Tam Blake & Co.: The Story of the Scots in America* (UK: OrionTrading Company UK, 1993), 45.

202. Buechler and Barr, *History of Hall County, Nebraska*, 574.

203. Ibid.

204. Christie, *Seventy-Five Years in the Saddle*, 91.

205. *Grand Island Independent*, "Big Business Continuing, Local Market for Horses and Mules Is Maintained Since War," November 25, 1924.

206. *Grand Island Independent*, "Mules Purchased for Activitis [*sic*] in Egypt," October 3, 1925.

207. Buechler and Barr, *History of Hall County, Nebraska*, 653.

208. Bradstreet's Horse and Mule Anniversary Banquet Program, March 6, 1935.

209. Jack Bailey, "Livestock Ring at Grand Island," reprinted from *Omaha World-Herald*, January 3, 1943.

210. Dorothie Erwin, "Jim Webb Came to Grand Island 45 Years Ago; Now One of City's Noted Citizens," *Grand Island Daily Independent*, August 4, 1953.

211. Bailey, "Livestock Ring at Grand Island."

212. Erwin, "Jim Webb Came to Grand Island 45 Years Ago."

213. Chris Kotulak, *Jack: From Grit to Glory* (N.p.: Bluestem Publications, 2013), 5.

214. Ibid., 9.

215. Ibid. The John Washington Torpey family verifies that the correct name on page 9 should read John Washington Torpey instead of John Charles Torpey.

216. Ibid.

217. Ibid., 11.

218. Ibid., 13.

219. Ibid., 19.

220. National Museum of Racing and Hall of Fame, "Marion Van Berg," https://www.racingmuseum.org/hall-of-fame/marion-van-berg.

221. Ibid., "Jack C. Van Berg," https://www.racingmuseum.org/hall-of-fame/jack-c-van-berg.

222. Letter to Frank Slattery, Caldwell, Idaho, from John Torpey, October 7, 1938. A personal letter shared with the authors by the family of John Torpey.

223. *Grand Island Independent*, "Friends Throng Cathedral for Torpey Rites," April 25, 1940, 4.

224. Information from John Joseph Torpey, Thursday, August 25, 2016.

225. *Grand Island Independent*, "John Torpey Succumbs to Heart Attack," April 22, 1940, 1.

226. Jack Bailey, "Wind-Fanned Flames Destroy Entire Block," *Grand Island Independent*, December 2, 1959.

227. Carol Bryant, "97-Year-Old Third Street [*sic*] Livestock to Hold Its Final Sale," *Grand Island Independent*, February 14, 2002.

228. Welcome to Boone County, Nebraska, http://www.co.boone.ne.us/webpageshistory/history.html.

229. NP Dodge Real Estate, "About," http:/www.npdodge.com/about.

230. *Encyclopedia of World Biography*, "Grenville Mellen Dodge" (N.p.: Gale Group Inc., 2004).

231. Wikipedia, "Iowa in the American Civil War," https://en.wikipedia.org/wiki/Iowa_in_the_American_Civil_War.

232. Michael Vogt, curator, Iowa Gold Star Military Museum, "Grenville M. Dodge: An Iowa Hero," Iowa Pathways, www.iptvorg/iowapathways.

233. Find-a-Grave, "Grenville Mellen Dodge," http://www.findagrave.com/cgi-bin/fg.cgi?page=gr&GRid=12605.

234. Cozad, Nebraska, "History," http://cozadnebraska.net/city/history.

235. 1907 History of Pottawattamie County, "Nathan Phillips Dodge," March 5, 2010, www.iagenweb.org/boards/pottawattamie/biographies/index.cgi?review=268857.

236. Shumway, *History of Western Nebraska and Its People*, vol. 3, 33.

237. Mildred Swanson, *Kimball County, Nebraska: 100 Years* (N.p.: Charles Elmer Lockwood, n.d.), 556.

238. "Staff (2010-07-09)," "National Register Information System," National Register of Historic Places, National Park Service.

239. Olson, *History of Nebraska*, 270.

240. Lisa Bourlier, *Kimball County, Nebraska 100 Year History Book*, Plains Genealogical Society of Kimball County.

241. Wheat Growers Hotel site file, http://wheatgrowershotel.com.

242. Perry, *Sheep King*, 93.

243. Noel Vietmeyer, *Our Daily Bread, The Essential Norman Borlaug* (N.p.: Bracing Books, 2011), 5.

244. Swanson, *Kimball County, Nebraska*, "Potatoes," T16.

245. Ibid.

246. H.O. Werner, horticulturist, College of Agriculture, *For Superior Seed Potatoes* (Lincoln: University of Nebraska, n.d.), 7.

247. Nebraska Department of Agriculture Fact Card, February 2016.

248. Margaret Lockwood, *Gering Nebraska: The First 100 Years* (N.p., n.d.), Section F, no. 286, 367.

249. *50 Years of Innovations in Manufacturing, 1935–1985*, Lockwood Company Newsletter.

250. Former and Present Residents of Kimball County, *Kimball County, Nebraska: 100 Years*, comp. Plains Genealogical Society of Kimball County (Dallax, TX: Curtis Media Corporation, 1988), Section F, no. 626, 561.

251. Ibid.

252. Sandra Hansen, *Scottsbluff Star-Herald*, Pride 2000, May edition, 3.

253. Ibid., 2.

254. Ibid., 3.

255. *50 Years of Innovations*, 2.

256. Lockwood Grader Company, *News and Views*, 1958, 13–14.

257. *50 Years of Innovations*.

258. *Potato Horizons* (September 1959): 2.

259. *Potato Horizons* (December 1958): 12.

260. Western Growers Association, "Our Mission and Vision," https://www.wga.com/about.

261. *Potato Horizons* (November 1960): 15.

262. Lionel Harris, D.C. Clanton and M.A. Alexander, "Sugar Beets Tops and Modern Sugar Beet Production," *Journal of the American Society of Sugar Beet Technologists* 13, no. 5 (April 1965): 445.

263. *Potato Horizons* (February 1961): 3.

264. Ibid.

265. Harris, Clanton and Alexander, "Sugar Beets Tops," 432.

266. *Potato Horizons* (February 1961): 3.

267. Harris, Clanton and Alexander, "Sugar Beets Tops," 445.

268. Ibid.

Part IV

269. George Brown, "The Story of Our Family Bean Business," 9–10. This is a personal family account about the Chester B. Brown family, written by his son George Brown. The authors were allowed to borrow the copy given to the Kelley family. To their knowledge, it is not available for public reading.

270. Ibid., 15.

271. Leon Moomaw, *Pioneering in the Shadow of Chimney Rock* (N.p.: Courier Press, 1966), 240.

272. Brown, "Story of Our Family Bean Business," 15.
273. Ibid.
274. Ibid., 26.
275. Sandra Hansen, "The Man Who Brought the Bean to the Panhandle," *Star-Herald*, Pride 2000, June edition, 6.
276. Brown, "Story of Our Family Bean Business," 29.
277. Ibid., referencing a newspaper article "State Bean Industry in 50th Year," March 26, 1977, 37.
278. Hansen, "Man Who Brought the Bean to the Panhandle."
279. *Business Farmer Special*, North Platte Valley Edition, October 1940, 6.
280. Ibid., 15.
281. Sandra Hansen, "John R. Jirdon—Citizen of the Century," *Star-Herald*, Pride 2000, June edition, 6.
282. John R. Jirdon, "Early Town of Morrill," October 21, 1975, reprinted in the *Mitchell Index*, Wednesday, August 6, 2008.
283. Brown, "Story of Our Family Bean Business," referencing a newspaper article "State Bean Industry in 50th Year," March 26, 1977, 37.
284. Brown, "Story of Our Family Bean Business," referencing "Letter to the Editor" in *Business Farmer*, October 1939, 48–49.
285. Christine Pappas, "Addison Erwin Sheldon," in *More Notable Nebraskans* (Lincoln, NE: Media Productions and Marketing, 2001), 118.
286. Ibid.
287. Ibid., 120.
288. Chester B. Brown, "Part 1: The Bean Bag," in *History of Dry Beans in the North Platte Valley*, July 10, 1985, updated for use by Greg Hinze, spring of 1989, 14.
289. Sandra Hansen, "From Chester Brown's Brain-Child to Kelley Bean the Company," *Star-Herald*, Pride 2000, June edition, 6.
290. Nebraska Business Hall of Fame, http://cba.unl.edu/about-us/nebraska-business-hall-of-fame.
291. Kevin O'Hanlon, "Cuba Ups Nebraska Trade Deals to $30 Million," Associated Press, August 21, 2005.
292. Ibid.
293. Nicholas Bergin, "Nebraska Great Northern Beans Recover from Complete Market Collapse," *Lincoln Journal Star*, September 15, 2016.
294. Ibid.
295. Ibid.
296. Stephanie Holsinger, "Kelley Family Recognized for Contributions to the Valley, Ag Business," *Star-Herald*, April 18, 2015.

297. Ibid.

298. Brown, "Part 1," 15.

299. Jessica Mozo, "International Year of the Bean," *Nebraska Agriculture and You* 4 (2016): 33.

300. Nebraska Dry Bean Grower Association, "Dry Edible Beans," http://www.beangrower.com/about-dry-beans.html.

301. Dr. Carlos A. Urrea, *Centennial Profile: Dry Bean Breeding Program*, University of Nebraska–Lincoln, Panhandle Research and Extension Center, 1910–2010, 33.

302. Ibid.

303. Poster, United States Dry Bean Council, 2008.

304. Nebraska Department of Agriculture Fact Card, February 2016.

305. National Cowboy Hall of Fame and Museum publication, Nebraska Division, circa 1950s, A.

306. *High Plains Journal*, "Howard Receives Nebraska Cattlemen Industry Service Award," January 3, 2005.

307. Dr. Alan Swallow, Denver, Colorado, quote from "About the Author" in *The Call of the Range* (November 1966).

308. *TIME*, "On the Block" (September 25, 1950): 91.

309. Nebraska State Capitol, "History of Nebraska's Capitols," http://capitol.nebraska.gov/index.php/building/history/nebraska-capitols.

310. Ibid.

311. *Guide to Exterior Art and Symbolism, Nebraska State Capitol* (Lincoln: Office of the Capitol Commission, Nebraska State Capitol, 2006).

312. Ibid.

313. Wikipedia, "Nebraska Hall of Fame," https://en.wikipedia.org/wiki/Nebraska_Hall_of_Fame.

314. State of Nebraska, "Legislative Bill 693," *Laws* (Lincoln, NE: Frank Marsh, Nebraska Secretary of State, 1961), 1,118.

315. H.H. Boggs, "Sold! 42 Years in the Auction Stand with Arthur W. Thompson," *Hereford Journal*, July 1, 1949.

316. Max Coffey, "Dean of Auctioneers Retires—Art Thompson of Lincoln Has Set Many Records in 46 Years," *Omaha World-Herald Magazine* (April 26, 1953): 4G.

317. Boggs, "Sold!"

318. Ibid., 164.

319. Ibid.

320. Ibid., 166.

321. Coffey, "Dean of Auctioneers Retires," 4G.

322. Ibid.

323. Boggs, "Sold!," 170.

324. Lincoln Community Foundation, "'Col.' Arthur W. Thompson," http://www.lcf.org/page.aspx?pid=897.

325. Ibid.

326. Boggs, "Sold!," 184.

327. Coffey, "Dean of Auctioneers Retires," 4G.

328. *Time*, "On the Block," 91.

329. Iowa Beef Processors Inc., "A Short History and Profile of the Company," personal copy, Dale C. Tinstman, 37.

330. Tyson Foods Inc., "Locations," http://www.tysonfoods.com/Our-Story/Locations.aspx.

331. City of Madison, "Ag Appreciation Banquet," http://www.madison-ne.com/recreation/ag-appreciation-banquet.

332. Iowa Beef Processors Inc., "Short History and Profile," 65.

333. Ibid., 70–71.

334. *New York Times*, "Tyson to Acquire IBP in $3.2 Billion Deal," January 2, 2001.

335. Tyson Foods Inc., "Tyson Fresh Meats on Invest $47 Million in Lexington Beef Plant," press release, March 17, 2015.

Part V

336. Elvin F. Frolik and Ralston J. Graham, *The University of Nebraska–Lincoln College of Agriculture: The First Century* (Lincoln: University of Nebraska–Lincoln, 1987), 7.

337. Thomas R. Walsh, "Charles E. Bessey and the Transformation of the Industrial College," *Nebraska History* 52 (1971): 385.

338. Robert Platt Crawford, *These Fifty Years: A History of the College of Agriculture of the University of Nebraska* (Lincoln: University of Nebraska, College of Agriculture, 1925), 24.

339. Nebraska Department of Agriculture Fact Card, February 2016.

340. Ibid., 22.

341. Walsh, "Charles E. Bessey," 387.

342. "From the First Report on Nebraska Farmers' Institute, 1906," in Crawford, *These Fifty Years*, 34.

343. Ibid.

344. Ibid., 35.

345. Ibid., 38.

346. *Celebrate the Century: A Collection of Commemorative Stamps, 1930–1939* (Washington, D.C.: United States Postal Service, 1998), 23.

347. *Ag College Dreams: The Real Cornhuskers*, documentary, 2006, www.ianr.unl.edu.

348. College of Education and Human Sciences Nutrition and Health Sciences, "History," http://cehs.unl.edu/nhs/history.

349. Ibid.

350. *Ag College Dreams*.

351. "Ruth Leverton Hall History," interpretive sign located in Leverton Hall, East Campus.

352. Jeffrey S. Hampl, Department of Family Resources and Human Development, Arizona State University, and Marilynn I. Schnepf, Department of Nutritional Science and Dietetics, University of Nebraska–Lincoln, "Ruth M. Leverton (1908–1982)," *Journal of Nutrition* 129 (1999): 1,771. American Society for Nutritional Sciences.

353. Ibid.

354. "Ruth Leverton Hall History," interpretive sign.

355. *Ag College Dreams*.

356. Plaque on the UNL Dairy Store, University of Nebraska–Lincoln, 114 Food Industry Complex.

Part VI

357. Ambrose, *Nothing Like It in the World*, 17.

358. Ibid., 169.

359. *The Grasshopper Plow*, exhibit, Plainsman Museum, Aurora, Nebraska, www.plainsmanmuseum.org.

360. *A Century of Progress*, brochure, Aurora Cooperative, Centennial History, 4.

361. Ibid., 20.

362. Ibid., 4.

363. Robert Pore, "Aurora Cooperative Celebrates 100th Anniversary," *Grand Island Independent*, July 20, 2008.

364. 2015 NCB Co-Op 100 List, Publication 100, www.ncb.coop.com.

365. *Century of Progress*, 8.

366. Molly Shaw, "Aurora Cooperative: Growing Agricultural Opportunities and Prosperity through Generations in Nebraska," *US Business Executive* (2015).

367. *Century of Progress*, 14.

ABOUT THE AUTHORS

When you think of how a person's life comes full circle, JODY LAMP's career in agriculture journalism certainly reflects that example. Her story begins in Nebraska. Born and raised in Scotts Bluff County, Jody earned her bachelor of journalism degree from the University of Nebraska–Lincoln in December 1993 and has minors in psychology, anthropology and history. She worked as a photographer for the *Daily Nebraskan* and as an agriculture writer for the Department of Ag Communications with the Institute of Agriculture and Natural Resources.

After college, she was hired as the agricultural reporter and photographer for the *Beatrice Daily Sun* and later was recruited by Bader Rutter & Associates, the leading agricultural-based public relations and advertising agency in the United States. She moved to Milwaukee, Wisconsin, and lived there for three years before moving to Montana, where she continued to work for the agency. In 2009, Jody opened Lamp Public Relations & Marketing and continues to maintain the office she started at Billings Livestock Commission. Jody and her husband, Mike, recently moved to Mitchell, Nebraska, in May 2015 and are the proud parents of Mark and Jessie. In 2016, Jody was selected to join the Humanities Nebraska Speaker's Bureau.

Jody began collaborating on local and national projects with Montana native Melody Dobson, and together the team created a strategic planning program called "Your One Powerful Voice," designed to help businesses, organizations and individuals collaborate to create a credible resource of influence. Lamp and Dobson worked as the national strategic plan

developers for the U.S. Custom Harvesters Inc. and as the national executive co-coordinators for the *Great American Wheat Harvest* documentary film— coordinating the strategic plans, fund development for production and public awareness—before launching the American Doorstop Project on July 1, 2015.

MELODY DOBSON served as a signature event coordinator for the National Lewis and Clark Bicentennial's "Clark on the Yellowstone Signature Event" and the "National Day of Honor" from 2004 to 2007. The events commemorated the 200th Anniversary of Captain William Clark signing his name at Pompeys Pillar. Clark's signature remains as the only physical evidence of the Lewis and Clark Trail as it was recorded in the journals. The signature and history is preserved at Pompeys Pillar National Monument, located along the Yellowstone River just east of Billings, Montana. Melody served as a member of the Pompeys Pillar Historical Association Board of Directors and was inducted on October 1, 2016, into the "Honor Garden" for her dedication to the development and preservation of the monument.

Melody comes from a fourth-generation farm and ranch in northeastern Montana and raised her four children—Sheldon, Christopher, Scott and Elizabeth—with her late husband, Terry D. Dobson, in Billings. She has experience in network radio on-air management, as a personality and as news director, as well as in sales. She received her bachelor of communications arts degree from Montana State University–Billings, formerly Eastern Montana College.

ABOUT THE ARTIST

Growing up in Omaha the son of a graphic printer, Gene Roncka's love for art began at an early age. After attending the University of Nebraska–Lincoln and majoring in art, he spent five years furthering his art education at the Art Center in Los Angeles, graduating with honors. He traveled east to New York and joined the prestigious group New York Artist League, dedicated to developing art projects for some of the leading corporations there.

Roncka completed his post-graduate education at Cranbrook Academy of Art in Michigan, which led him to creating design and paint ideas for Chrysler Corporation and General Motors. After winning numerous awards throughout his career, including the Distinctive Merit Award for *Time* magazine and the General Motors Outstanding Award for a Sequence of Paintings, Roncka returned to his native Nebraska to paint portraits for ConAgra and animal paintings that have appeared in publications and documentaries, including *Wild Kingdom*.

Other awards include winning the Nebraska First of State Habitat Stamp competition, Artist of the Year for Nebraska Ducks Unlimited, Artist of the Year for *Wings Over the Platte*, Best of Show for the Oklahoma and Kansas Ducks Unlimited and creating the winning design for the Nebraska Veterans Memorial.

Roncka and his wife, Mary, live in Ashland and own Willow Point Gallery/ Museum at 1431 Silver Street. The art gallery and the Archie Hightshoe Wildlife display he designed there have been recognized by Nebraska

Travel and Tourism. His distinct style of subtle, soft-muted colors and an ethereal quality transports his admirers into his richly painted canvases. Gene described his work as "capturing a moment in time that all of us have experienced, either in fact or fiction."

Gene's original paintings of the Beetison Home near Ashland in Saunders County and his design of the Ox Bow Saline Ford Crossing monument celebrate Nebraska's history and have sparked a renewed interest in the area's past. Roncka's fascination with the history of Ashland—founded in 1870 and the childhood hometown of Nebraska's only NASA astronaut, Clayton C. Anderson—has brought attention from the National Park Service, U.S. Department of the Interior.

"The Gene Roncka Signature Series" includes ornament designs from the Homestead National Monument of America that were displayed on the White House Christmas tree in December 2007; the painted mural at the Homestead National Monument's Education Center in Beatrice; the Nebraska Easter Seal Society, University of Nebraska–Lincoln Husker program; NASA for Nebraska Astronaut Clayton C. Anderson; and other fundraising organizations.

Visit us at
www.historypress.net
..
This title is also available as an e-book